American Wildlife Painting

by Martina R. Norelli

Published in association with the
National Collection of Fine Arts,
Smithsonian Institution, Washington, D.C.

WATSON-GUPTILL PUBLICATIONS/NEW YORK

PHAIDON PRESS LIMITED/LONDON

Copyright © 1975 by Watson-Guptill Publications

First published 1975 in the United States and Canada by Watson-Guptill Publications,
a division of Billboard Publications, Inc.,
One Astor Plaza, New York, N.Y. 10036

Published 1976 in Great Britain by Phaidon Press Limited,
5 Cromwell Place, London SW7 2JL
ISBN 0-7148-1736-8

Library of Congress Cataloging in Publication Data
Norelli, Martina R
 American wildlife painting, 1720–1920.
 Bibliography: p.
 Includes index.
 1. Painting, Modern—United States. 2. Painting,
American. 3. Painters, American. 4. Birds in art.
5. Animals in art. I. Title.
ND1382.N67 759.06 75-15856
ISBN 0-8230-0217-9

Manufactured in U.S.A.

First Printing, 1975

Edited by Claire Hardiman
Designed by Bob Fillie
Composed in 12 point Bodoni Book by Gerard Associates/Graphic Arts, Inc.

To Michael, Bettie Ruth, and my family
for their very special love.

To Lynne, John, Meg, Paul, Carolyn, Jim, Lou, Fred,
and Lucy for their very special friendship.

To Melvin, just for being.

Acknowledgments

In 1972 while I was working on the organization of the NCFA exhibit *Artist-Naturalists: Observations in the Americas,* I was given considerable assistance by many of the museum staff. As this book is an expansion of the original exhibition, it still owes much to the people who helped me at that time. I am particularly indebted though to my colleagues in the Department of Prints and Drawings, NCFA—Janet Flint, Curator; Charles Booth, Museum Technician; and Carolyn Vacek, Secretary. Their understanding, support, good humor, and encouragement have carried me through the good times as well as the difficult moments.

I would also like to thank the following people who have helped me a great deal, both directly and indirectly, during the past few years: Dr. Francis S. Grubar and Dr. Laurence A. Leite of The George Washington University; and Frank Caldwell, Judith Zilczer, Robin Bolton-Smith, Georgia Rhodes, and Lillian Clagett, all past or present associates at NCFA. They always seemed to have the right words to say when needed, and for that I am grateful.

While doing research for the book I was most fortunate to have met Miss Ruth E. Brown, Librarian at The Academy of Natural Sciences of Philadelphia and Mr. W. Peyton Fawcett, Librarian of the Field Museum of Natural History, Chicago. Neither one could have been more helpful with suggestions and information, in addition to facilitating my research from their collections. Miss Brown was an especially valuable source, and she and her staff were most generous with their time during one of Philadephia's hot August weeks.

I am of course indebted to the many libraries, science and art museums, and collectors who have permitted their paintings, drawings, and prints to be reproduced in the book. I am pleased that many people can now share these exquisite and often rarely exhibited art works.

My final word of thanks is to the editorial and design staff at Watson-Guptill Publications for their efforts in producing this book. I am especially grateful to Claire Hardiman, not only for her resourcefulness in gathering all the pictures I selected, but for her patience and understanding as an editor.

Contents

List of Color Plates, 8

Introduction, 11

Mark Catesby, 55

Alexander Wilson, 81

John James Audubon, 107

Martin Johnson Heade, 143

Abbott Handerson Thayer, 165

Louis Agassiz Fuertes, 187

Bibliography, 218

Credits, 221

Index, 222

Color Plates

Note: In most cases, the original spelling and punctuation of the plate titles has been retained.

Mark Catesby

The Chatterer 34
The Sand Crab 35
The Crested Jay 65
The White Curlew 66
The Sole 67
The Water Frog 68
The Maho-Tree, Phalaena Fusca 69
The Woodcock of America 70
Yellow and Black Pye 71
The Cushew Tree 72

Alexander Wilson

Louisiana Tanager 36
Blue Jay; Yellow-Bird or Goldfinch; Baltimore Bird 89
Cardinal Grosbeak; Female and Egg; Red Tanager; Female and Egg 90
Tyrant Flycatcher; Great crested Flycatcher; Small green crested
 Flycatcher; Pe-We Flycatcher; Wood Pe-We Flycatcher 91
Carolina Parrot; Canada Flycatcher; Hooded Flycatcher; Green, black-capt Flycatcher 92
Pinnated Grous; Blue-green Warbler; Nashville Warbler 93
Little or Saw-whet Owl 94
Black Hawk 95
Black or surf Duck; Buffel-headed Duck, male and female;
 Canada Goose; Tufted Duck; Golden eye; Shoveller 96

John James Audubon

Little Blue Heron 38
Purple Gallinule 113
Chuck-will's-widow 114
Vesper Sparrow 115
Mangrove Cuckoo 116
Magnificent Frigatebird 117
Lesser Yellowlegs 118
Great Gray Owl 119
Western Kingbird; Scissor-tailed Flycatcher; Say's Phoebe 120
Swainson's Hawk 121
Rufous Hummingbird 122
American Flamingo 123
Norway, Brown, or Common House Rat 124

Brown, or Norway Rat 125
Swift Fox 126
Common Mouse 127
American Egret 128

Martin Johnson Heade

Study of an Orchid 39
Hummingbirds with Nest 153
Orchids, Passion Flowers, and Hummingbird 154
Orchids and Spray Orchids with Hummingbirds 155
Passion Flowers and Hummingbirds 156
Brazilian Hummingbirds 157
Brazilian Hummingbirds I 158
Brazilian Hummingbirds III 159
Two Hummingbirds and Spray of Flowers 160

Abbott Handerson Thayer

Peacock in the Woods 40
Blue Jays in Winter 169
Roseate Spoonbills (In Morning or Evening Sunlight) 170
European Flamingo's Head 171
Luna Caterpillar in Position 172
Mirror-Back Caterpillar Reflecting Sky-light, Leaf-green, and a Red Leaf 173
Copperhead Snake on Dead Leaves 174
Male Ruffed Grouse in the Forest 175
Hood Warbler and Sunlit Foliage 176

Louis Agassiz Fuertes

Scissor-tailed Flycatcher and Painted Bunting 33
Western Kingbird 37
Vermilion Flycatcher, male and female 193
Lewis' Woodpecker 194
Western Tanager, male and female 195
Burrowing Owl 196
Short-eared Owl 197
Greater Prairie Chicken 198
Abyssinian Tawny Eagle 199
Pygmy Kingfisher 200

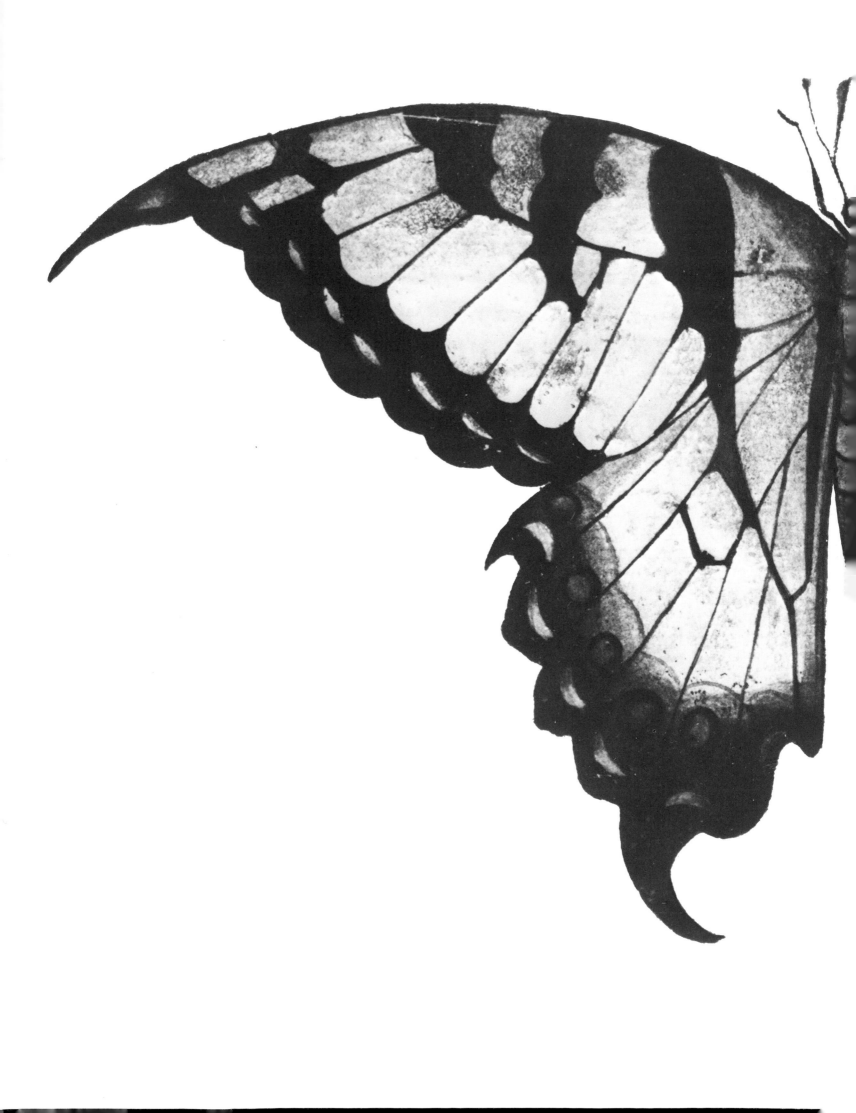

Introduction

I. max.

167

Mamankanois.

Hanc è Virginia
Americana Candidus
ad me Pictor detulit.
1585.

FROM THE earliest, most difficult days of colonization, nature and her products have had a major influence on American life and thought. The incredibly rich abundance of plants and animals and the varied quality of the land itself have provided inspiration for and affected the development of literature, philosophy, religion, art, and science in the New World. In addition, there were individuals whose reactions to the land and to the wildlife it supported broke down the boundaries between science and art—whose contributions toward the understanding of nature contained both accurate scientific observation and beauty. Because of their twofold role, these individuals are called artist-naturalists.

Although very different in their abilities, the artists-naturalists were of one mind in their respect for nature and in their desire to provide a picture of the beauties of America. The paintings, drawings, and prints reproduced in this book are not, by any means, the only such work created by artists-naturalists; they are, however, examples of the best work that was accomplished by men who were firmly rooted in both art and science. Mark Catesby, Alexander Wilson, and John James Audubon provided the basis for all later work in North America. Martin Johnson Heade expanded the interest to South America, while Abbott and Gerald Thayer were responsible for a deeper understanding of animal coloration. Louis Agassiz Fuertes was the forerunner of the modern field naturalist, an observer graced with the uncanny ability to capture in an instant the essence of a living creature. The work accomplished by these men established a foundation upon which future study could build; study in depth on every species, their lifestyles and habits.

Though the land mass of North America was known to Europeans from the last years of the fifteenth century, it was not until the latter years of the sixteenth century that significant attempts to settle the coastal areas were made. The Spanish, Portuguese, English, and French explorers that probed the coast were often not aware of each other's studies. They did not want to tempt other countries with stories of great wealth and resources before the areas were claimed and adequately settled.

Many of the early explorers made extensive written descriptions of the areas in which they traveled. Lists of birds, beasts, and plants were compiled, using Indian or geographical names. These were important records of both distribution and names, but even so, some species are not identifiable from these lists today. During the earliest explorations, the mapmaker was the artist—recording from sketches the land masses and distinctive navigational features, and using real and imaginary creatures to decorate his maps. The French in Brazil and the Spanish in Mexico made serious attempts in the sixteenth century to study and record the natural history of those areas. Some of the first drawings in North America were those of Jacques Le Moyne, a Frenchman who lived in Fort Caroline during 1564–5. Though his work is primarily concerned with Indians and with the mistreatment of the Huguenots in Florida by the Spanish, there are a few wildlife subjects. More work of this type may have been done, but Le Moyne barely escaped the Spanish massacre of 1565 and much of his work may have been lost. His drawings of life in Florida became well known from their use in part two of Theodor de Bry's book *America*.

It was not until 1584 that serious attempts were made by the English to study the land and prepare settlements. A preliminary study of the area between the Spanish settlements in Florida and the Chesapeake Bay was made that year under Walter

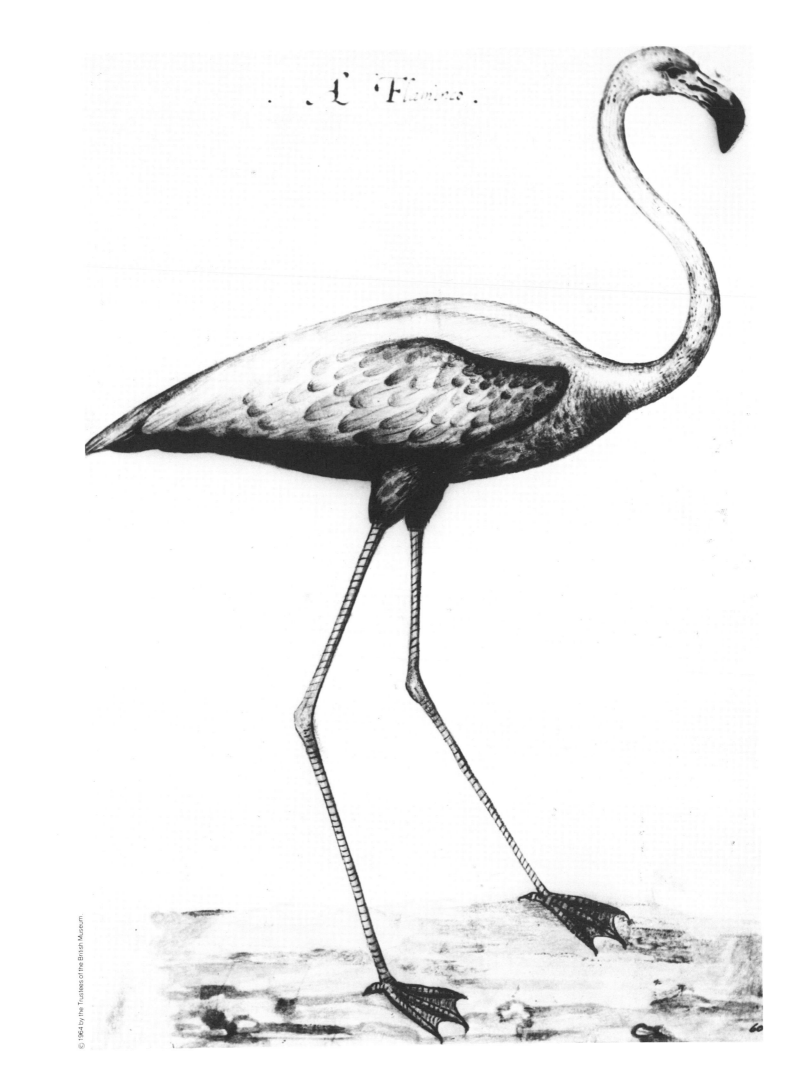

L Flamico

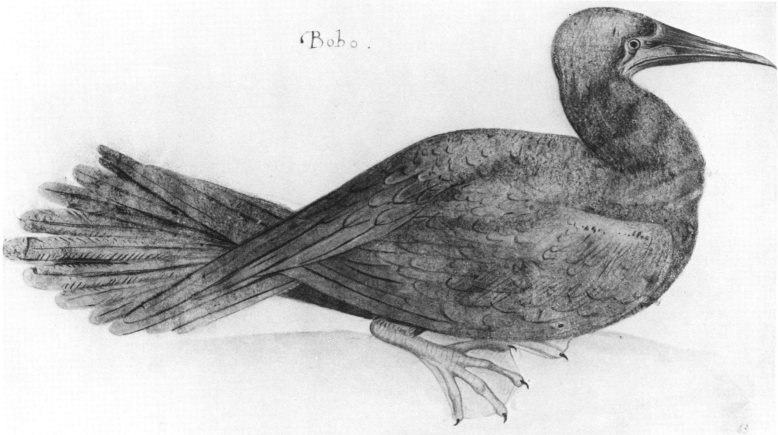

Brown Booby. *Ca. 1585. Watercolor touched with white and ink over black lead, 5 1/8" × 9 1/8". (White)*

Raleigh to assess the suitability of the region for the support of a colony. In 1585 Raleigh's group returned with seven ships and about 600 men. Included in this group were John White, an artist, and Thomas Hariot, a mapmaker. These two men were given the job of mapping out the Roanoke (Virginia) area and evaluating the natural resources they encountered—plant, animal, and human. Though by 1586 this group had left Roanoke due to problems with the Indians and with resupply, another group of Englishmen came to Roanoke under the leadership of John White in 1587, this time accompanied by their families. White had to return to England in 1588 to gather supplies for the group, and when he was finally able to return in 1590, the Roanoke colony had vanished. Included among the missing colonists were his daughter, Eleanor, her husband, and his granddaughter, Virginia Dare, the first child to be born of English parents in America.

Most of the drawings by John White of natural history subjects were done on the 1585 journey he made with Hariot. Many of the sketches note species seen in Puerto Rico or at sea, and many record the American Indians and their way of life. White's work became widely known through Theodore de Bry's engravings in part one of *America*, published in 1588 with the text from Thomas Hariot's *Briefe and true report on the new found land of Virginia*. However, a complete, illustrated account of the natural history subjects was never published, because many of the drawings White made were lost or damaged in 1586 when the colonists returned to England. Some of those drawings that remained intact later appeared in the library of Sir Hans Sloane and were made available through Sloane to Mark Catesby. A number of White's drawings, including the *Swallow-tail Butterfly* (p. 11), were used by Catesby as models for illustrations in the second volume of his book.

John White's work was one of the earliest attempts to systematically record American wildlife; his is one of the few views of the wilderness as it existed before the land was settled and thus changed by European colonists. White's success was based on an ability to approach new and strange experiences and quickly record what he actually saw in the straightforward manner of *Flamingo* (p. 13) and *Loggerhead Turtle* (p. 16). And, the idea of combining drawings and written descriptions proved invaluable for later study; even though names of plants and animals have changed, the illustrative material enables the contemporary researcher to identify the species under discussion.

As colonization increased during the seventeenth century, interest in the discovery of new sources of food and medicine also increased, and so the gathering and listing of botanical and animal specimens was directed toward economic benefits as well as scientific knowledge. Indeed, this dual goal—to understand and to profit from nature—was a major impetus for the support of exploration in North America. Although in this period little new work was done to illustrate American wildlife, a number of reports discussing the natural history of the colonies were published. Captain John Smith's extensive writings are a prime example of the travel accounts that were in vogue during this period. These accounts included not only factual details of the natural history, but anecdotes and legends as well, often incorporating previously published material.

By the early eighteenth century the English colonies were quite settled; regular voyages could be made throughout the year and more serious studies carried out in the American regions. Botanical studies and collecting trips were of special importance at this time, because British science was developing under the influence of the great botanist John Ray. The Royal Society, headed by

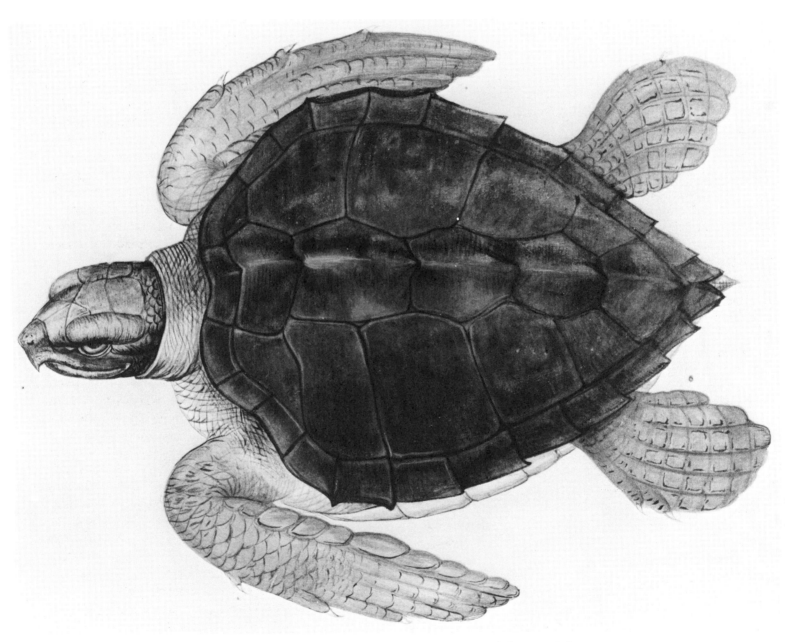

Loggerhead Turtle. *Ca. 1585. Watercolor heightened with white over black lead, 7 3/8″ × 10 1/4″. (White)*

Sir Hans Sloane, was instrumental in raising money to support studies—one of the New England area, and one of the southern colonies. Only the southern study was completed, resulting in the first major illustrated natural history of the Americas. The success of the venture was due almost entirely to the determination, knowledge, and ability of the man the Society chose to send—Mark Catesby. It was his work that firmly established the importance of enhancing written descriptions with correct, detailed illustrations. As Catesby himself wrote: "The Illuminating Natural History is so particularly essential to the perfect understanding of it, that I may aver a clearer Idea may be conceived from the Figures of Animals and Plants in their proper colours, than from the most exact Description without them . . ." Catesby's book set the standard for future illustrated scientific volumes. His work, which is visually satisfying and appealing, had an effect on all further studies in America from the standpoints of both content and style. His major successors in the nineteenth century, Alexander Wilson and John James Audubon, refer often to Catesby's work and occasionally reflect his influence in the arrangement or portrayal of certain species. Catesby's *Natural History of Carolina, Florida and the Bahama Islands* remains a major document detailing the early abundance of wildlife in America, the importance of which can scarcely be underestimated.

Throughout the rest of the eighteenth century, illustrations of American natural history were available only in several editions of Catesby's work or in compilations published by men who often had not traveled in the colonies. George Edwards (1684–1773) was involved in the editing and reissue of Catesby's book, as well as in producing several illustrated books of his own. Edwards' work on American species was done entirely from specimens sent to him and from notes provided by his many correspondents. One of the more important of these was John Bartram, the Quaker from Philadelphia who developed an extensive garden and gave Catesby, Edwards, and other friends in England many botanical specimens, as well as notes on a variety of birds and animals. The latter part of the eighteenth century, particularly the years following the Revolutionary War, produced numerous accounts written by travelers in America; among these were the earliest reports of the local natural history in various states. A well-known example of just such a history/natural history compendium is Thomas Jefferson's *Notes on the State of Virginia*, written in 1781 and published several years later.

In 1791 William Bartram published a book, *Travels Through North and South Carolina*, which was one of the most accurate, literate accounts of American natural history yet produced. William Bartram was raised in an atmosphere of scientific enquiry created by his father John Bartram—their home not only contained a fine natural history library but also was a gathering place for students of natural history and other scientists. Bartram was not a great collector of zoological specimens; he concentrated instead on the examination of natural things in their own habitats. Skilled at drawing natural history subjects, he illustrated his book with several of his own sketches. Through his writing, voluminous correspondence, and personal contacts, William Bartram became most influential in formulating the direction of scientific enquiry during the early nineteenth century.

Probably the person Bartram most influenced was Alexander Wilson—the former's belief that animals should be studied in their habitat coincided with the latter's love of nature and strong attraction to birds. Wilson, upon reading the books on American natural history in Bartram's library and realizing that he already knew many things not included in those books, decided he

American Bison. *Ca. 1731–43.*
Hand-colored etching,
13 3/4" × 10 1/4". (Catesby)

Mergus.

The Round-crested Duck. *Ca. 1727–31. Hand-colored etching, 13 3/4" × 10". (Catesby)*

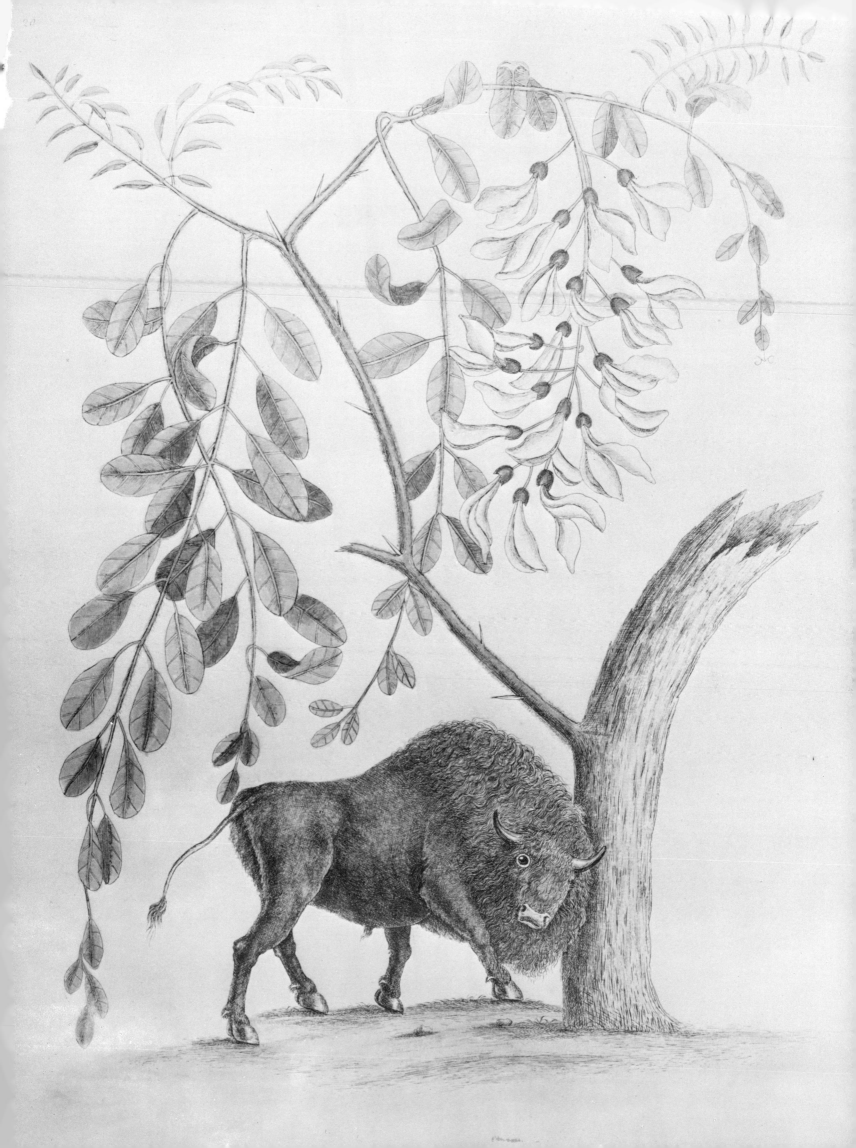

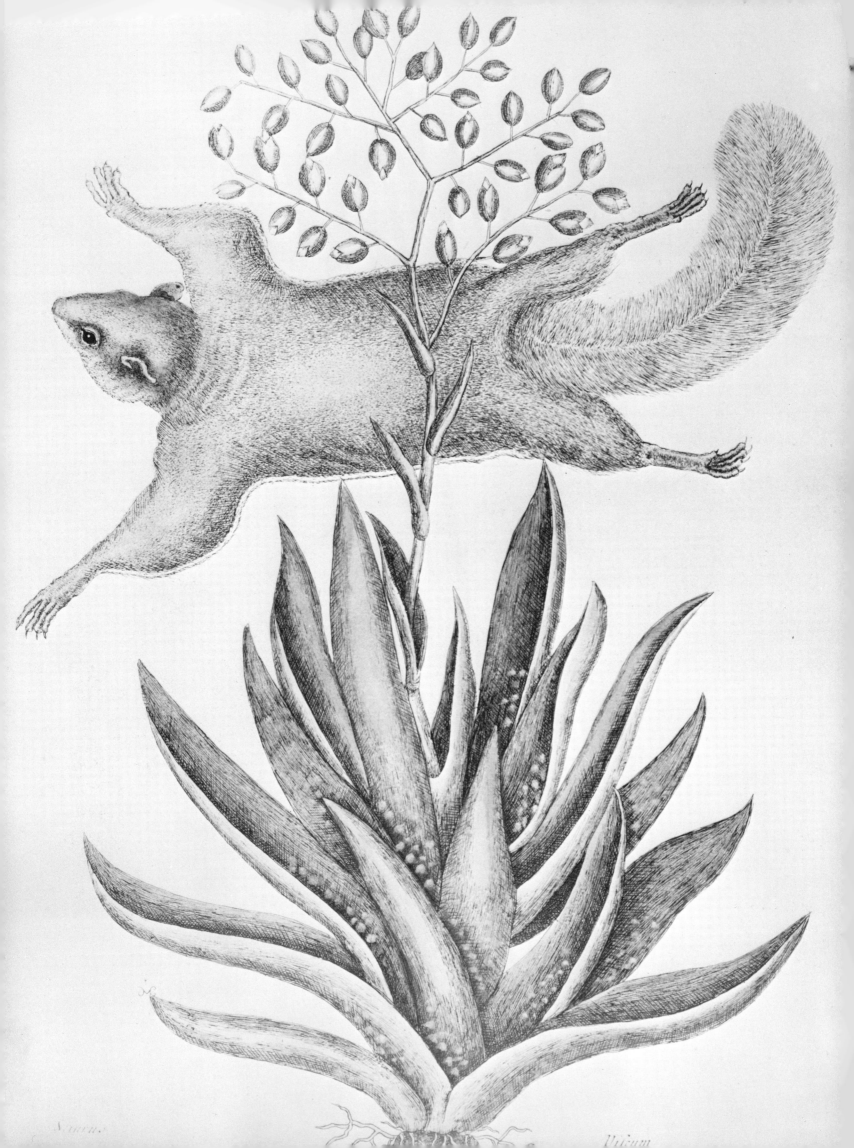

The Flying Squirrel.
Ca. 1731–43. Hand-colored etching,
13 3/4" × 10 1/4". (Catesby)

The American Swallow. *Ca. 1731–43. Hand-colored etching, 10 1/4" × 14 1/8". (Catesby)*

wanted to produce the finest illustrated book possible, covering all the birds in America. Wilson's pioneering effort has been long overshadowed by the work of John James Audubon, but Wilson's book *American Ornithology*, combines depictions of birds with a wide range of factual information concerning their habits not found in Audubon's writings.

That a controversy regarding the work of these two men should have developed is unfortunate though perhaps understandable. Book publishing was an expensive endeavor, particularly for the more lavishly illustrated books. Sold by subscription, Wilson's book cost $120 for each set and Audubon's *The Birds of America* cost $1,000. The problems began when Audubon came to Philadelphia seeking a publisher for his drawings. The Philadelphians were strongly supportive of Wilson's work, and Audubon arrived at about the same time that George Ord, one of the most influential of the city's scientists, was preparing to reissue Wilson's book. The accusations against Audubon, particularly those of plagiarism, came from George Ord using an edited version of Wilson's journal as his source material. Since Wilson's journal was later destroyed, and since Audubon only wrote of the meetings between them twenty years after they occurred, whether any difficulties actually existed between the two men themselves cannot be proven. Perhaps Wilson's visit to Audubon's store implanted or encouraged in Audubon the idea to publish his own bird drawings. What is truly important is that, regardless of their comparative merits either as artists or naturalists, during the first half of the nineteenth century these two men produced, between them, both the most lucid written account and the most artistic renderings of almost all the birds in America. Their achievement is staggering.

Throughout the nineteenth century, considerable work was done by the naturalist and sportsman, as well as the writer, poet, and philosopher, to extend awareness of nature. Large areas of the West and parts of northern New England were still virtually wilderness, providing ample opportunity for study. The variety of the landscape and of the creatures within it were a constant delight and a reaffirmation of man's link with nature. Not only was this the century of William Cullen Bryant, Ralph Waldo Emerson, and Henry David Thoreau, a period in which the emphasis was upon the religious and spiritual experience of man with nature—but also the century during which Americans finally saw where the wanton destruction of certain species was leading and began to organize various conservation and wildlife protection movements.

By mid-century, an interest developed in the exploration of remote lands as one means of better understanding nature at home. Encouraged by the example of his friend Frederic E. Church, the artist Martin Johnson Heade went to Brazil to paint in 1864. This trip was a natural extension of Heade's love of travel and passion for hummingbirds. His paintings of South America manifest his interest in landscapes, hummingbirds, and flowers—and are made doubly captivating by the exotic qualities of a life not familiar to all Americans. The knowledge Heade acquired in studying the habits of hummingbirds he passed on to others through one of the most accessible forums for the transmittal of scientific information—the sports or scientific periodicals of the late nineteenth century. Just as letters played a predominate role in carrying information between Europe and America in the eighteenth century, so the outdoor periodicals such as *Forest and Stream* and the organization journals such as *The Auk*, *Bird-Lore*, and *The Wilson Bulletin* channeled scientific news through their "Letters to the Editor" columns. Numerous amateur and professional naturalists argued points, submitted data, and discussed observa-

M.C.Z. #15

American Sparrow Hawk. *Ca. 1810. Pencil and ink on paper, 10 3/8″ × 9 1/8″ (irregular sheet). (Wilson)*

Belted Kingfisher. *Ca. 1811. Pen and ink, and pencil on paper, 10 7/8″ × 8 15/16″. (Wilson)*

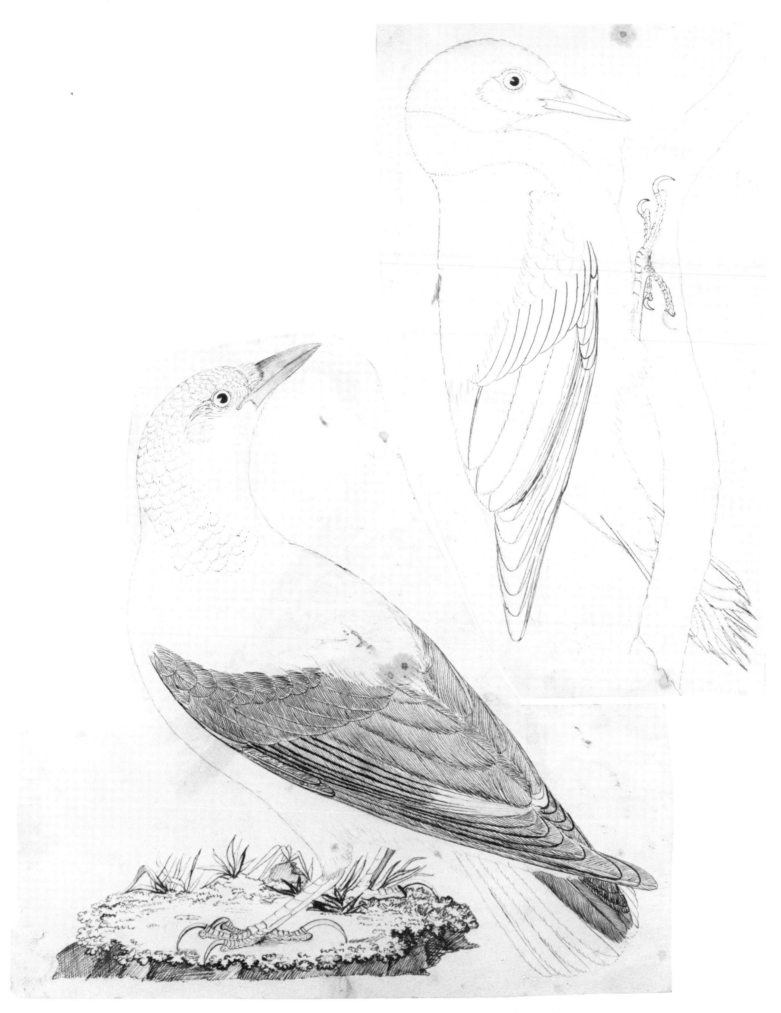

Lewis' Woodpecker and Clarks Crow. *Ca. 1811. Pen and ink, and pencil on paper, 13 3/8″ × 10″ (irregular sheet). (Wilson)*

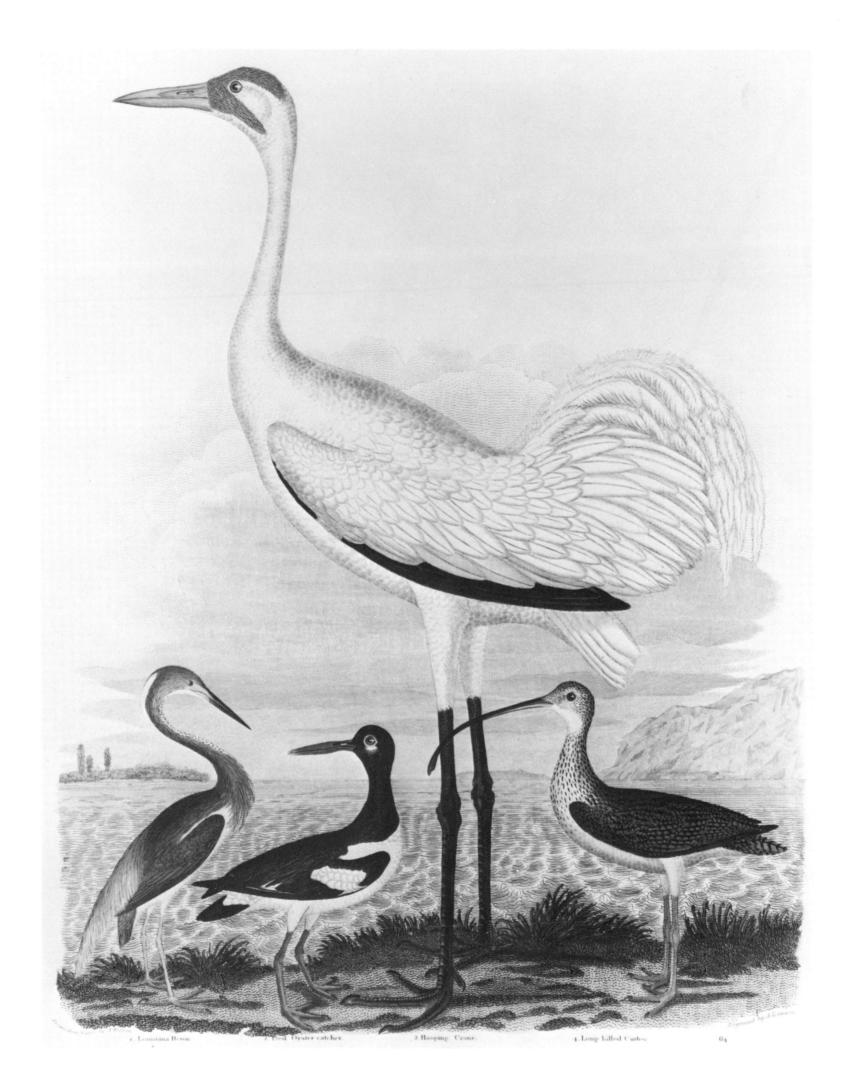

1. Louisiana Heron 2. Pied Oyster catcher 3. Hooping Crane 4. Long billed Curlew 64

Louisiana Heron *(1)*;
Pied Oyster-catcher *(2)*;
Hooping Crane *(3)*;
Long billed Curlew *(4)*.
*Ca. 1814. Hand-colored
etching and engraving,
13 3/8" × 10 3/8". (Wilson)*

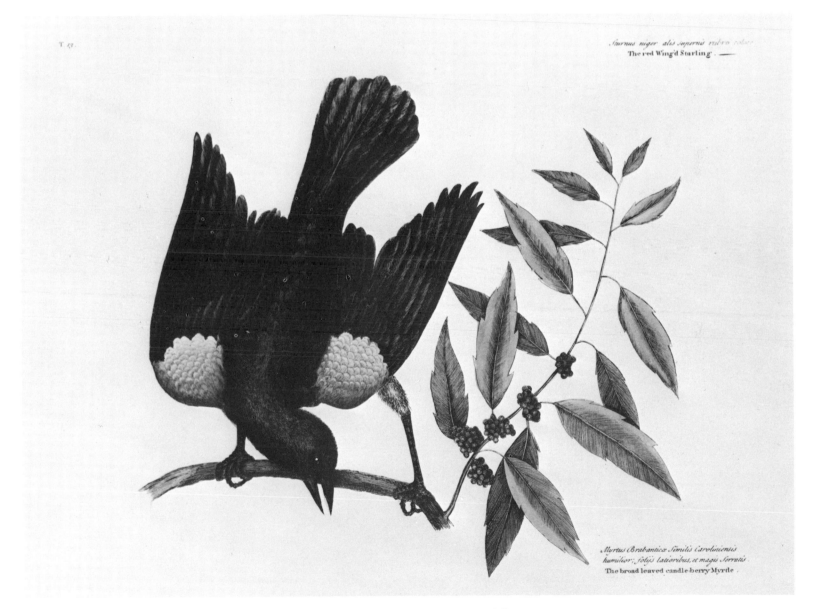

The Red Wing'd Starling. *Ca. 1727–31. Hand-colored etching, 13 3/4" × 10 1/4". (Catesby)*

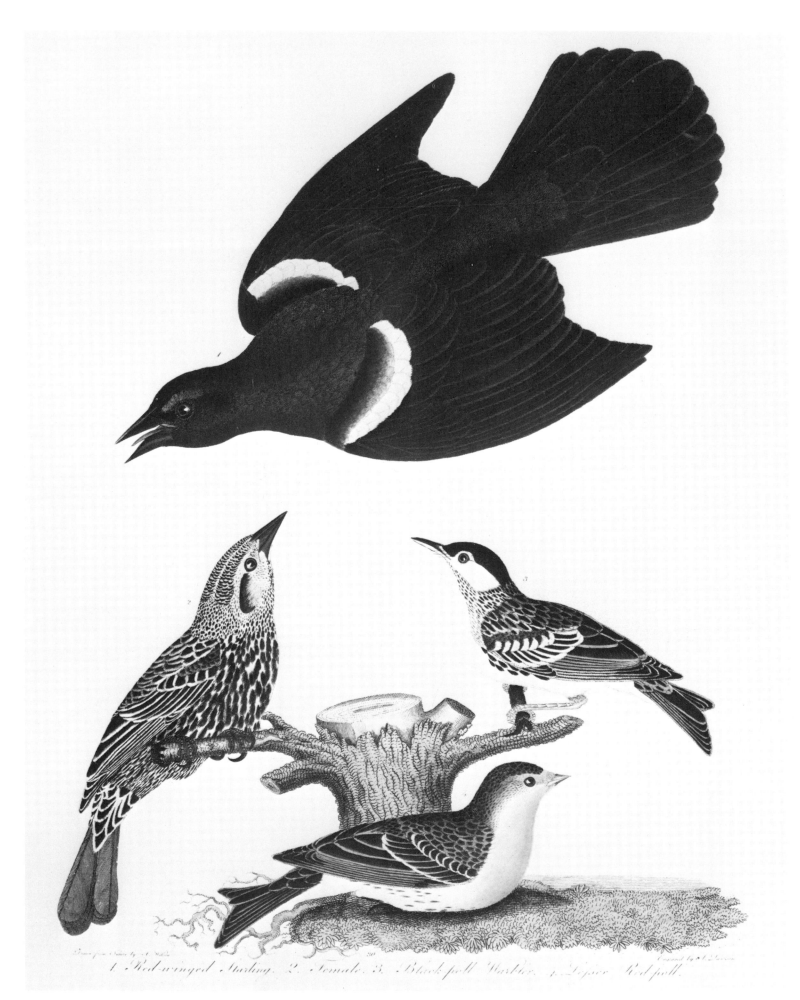

Red-winged Starling *(1)*; Female *(2)*; Black-poll Warbler *(3)*; Lesser Red-poll *(4)*. *Ca. 1811. Hand-colored etching and engraving, 12 7/8″ × 9 7/8″. (Wilson)*

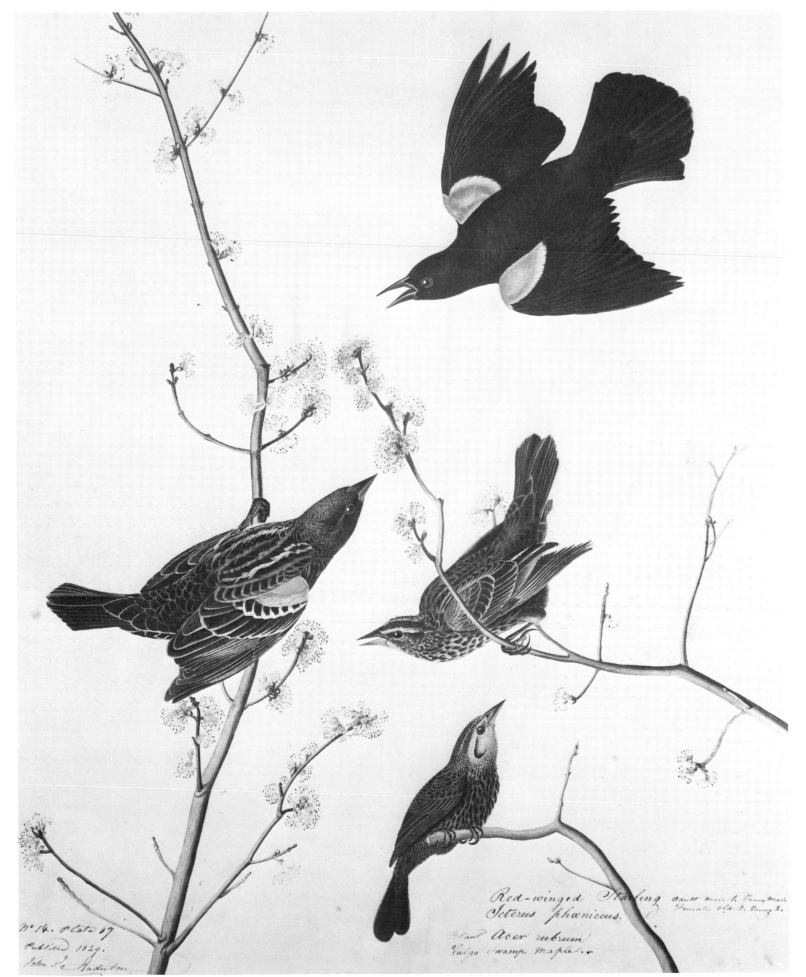

Red-winged Blackbird. *1829. Watercolor on paper, 23 3/4" × 18 3/8".* (**Audubon**)

tions of nature in these weekly and monthly publications.

During the late nineteenth and early twentieth centuries, the artist-naturalist developed into more than a biographer and portraitist. Intensive studies into many aspects of wildlife added further dimensions to man's awareness of nature. Abbott Thayer combined his abilities as an animal portraitist, sportsman, and amateur naturalist with an understanding of animal behavior and the principles of protective coloration. To Abbott Thayer, science and art were two equal sides of his life, and he was as active in organizations such as the American Ornithologists' Union as he was in the formation and leadership of the Society of American Artists. Thayer, his son Gerald, and his second wife Emma, as well as many students and friends, devoted their time to writing and illustrating *Concealing-Coloration in the Animal Kingdom* and conducting demonstrations to explain their theories. During World War I they offered to assist the Allies in developing camouflage techniques for land and sea forces.

Louis Agassiz Fuertes, who worked closely with Thayer and was influenced by his thoughts on protective coloration and by his ability as a painter, was the epitome of the artist-naturalist. A superb artist, Fuertes' popularity was based on his talent for capturing the individual characteristics and personality of each species; a highly trained naturalist, Fuertes spent years in the field carefully observing life styles, habits, and bird songs. He contributed to the public's increasing interest in birds and animals by producing hundreds of illustrations for bulletins distributed by the U.S. Department of Agriculture and the Biological Survey, for articles in *National Geographic Magazine*, for numerous state and regional field guides, and even for a series of cards given away with boxes of baking soda. Fuertes' studies were constantly in demand until his untimely death in 1927.

The contributions made by Mark Catesby, Alexander Wilson, John James Audubon, Martin Johnson Heade, Abbott and Gerald Thayer, and Louis Aggasiz Fuertes span a period of 200 years. Though different in many respects, the men and their work share several characteristics—the most important of which is the ability to convey their excitement and interest in the wildlife they observed. The appeal of their work goes far beyond any scientific intentions into an area of purely visual pleasure. It offers a fresh look at American wildlife and preserves for future generations an enormous and important part of America's natural heritage.

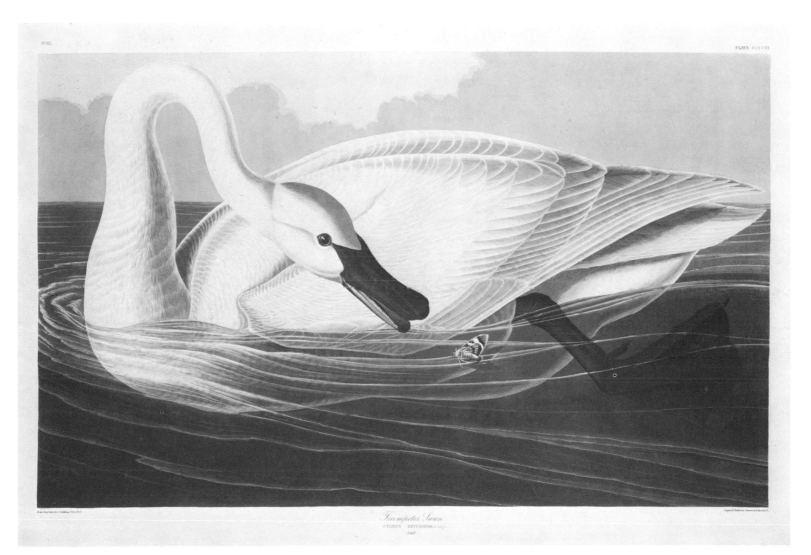

Trumpeter Swan. *1838. Hand-colored engraving and aquatint, 25 1/4″ × 38 5/8″. (Audubon)*

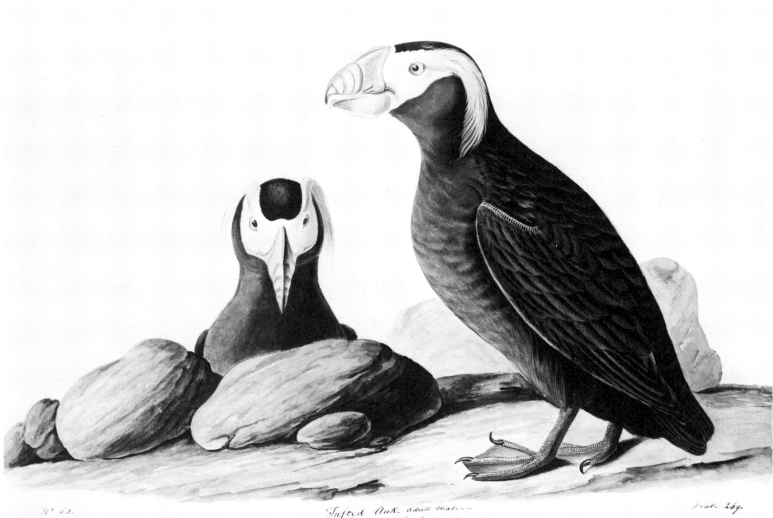

Tufted Puffin. *Ca. 1834–5. Watercolor on paper, 14 5/8" × 21 1/2". (Audubon)*

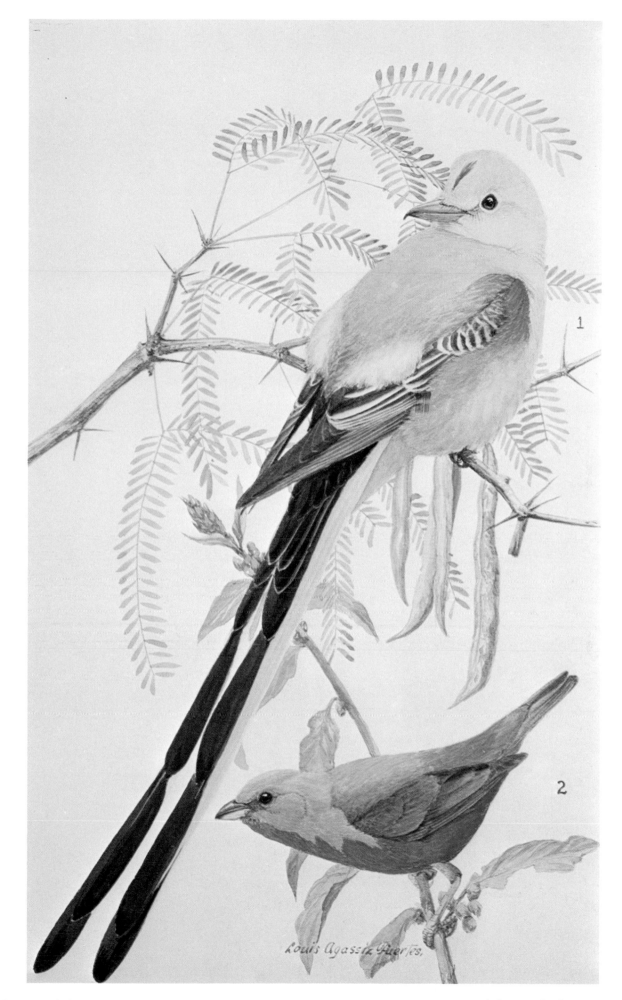

Scissor-tailed Flycatcher and Painted Bunting. *N.D. Watercolor and pencil on paper, 13 7/8" × 8 1/16". (Fuertes)*

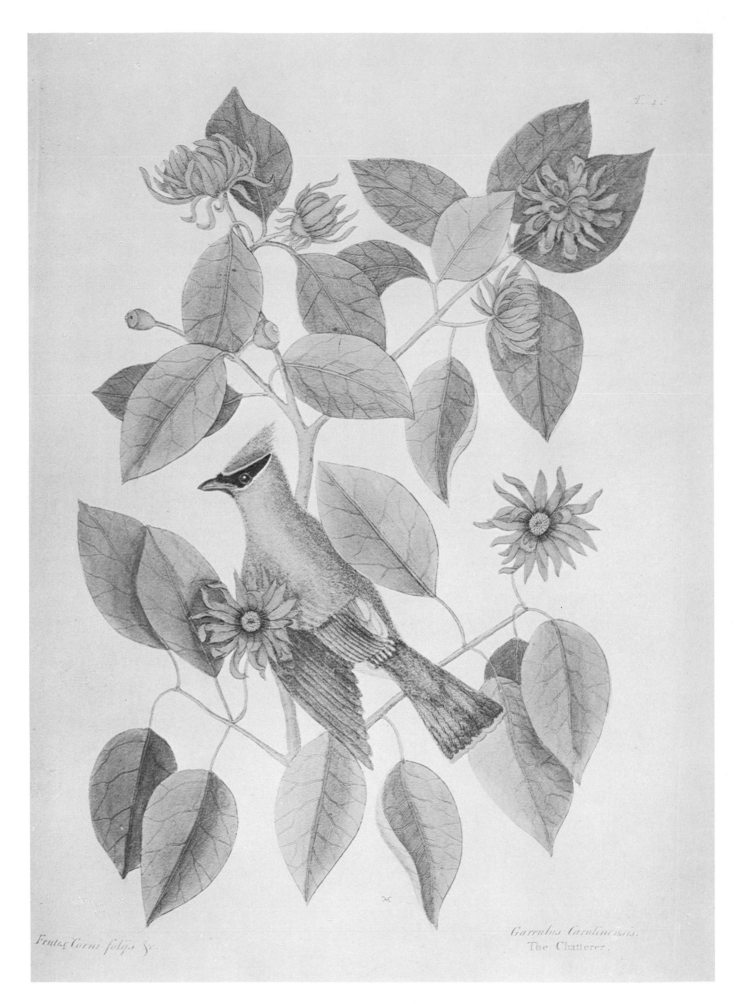

The Chatterer. *Ca. 1727–31. Hand-colored etching, 13 7/8″ × 10 3/8″. (Catesby)*

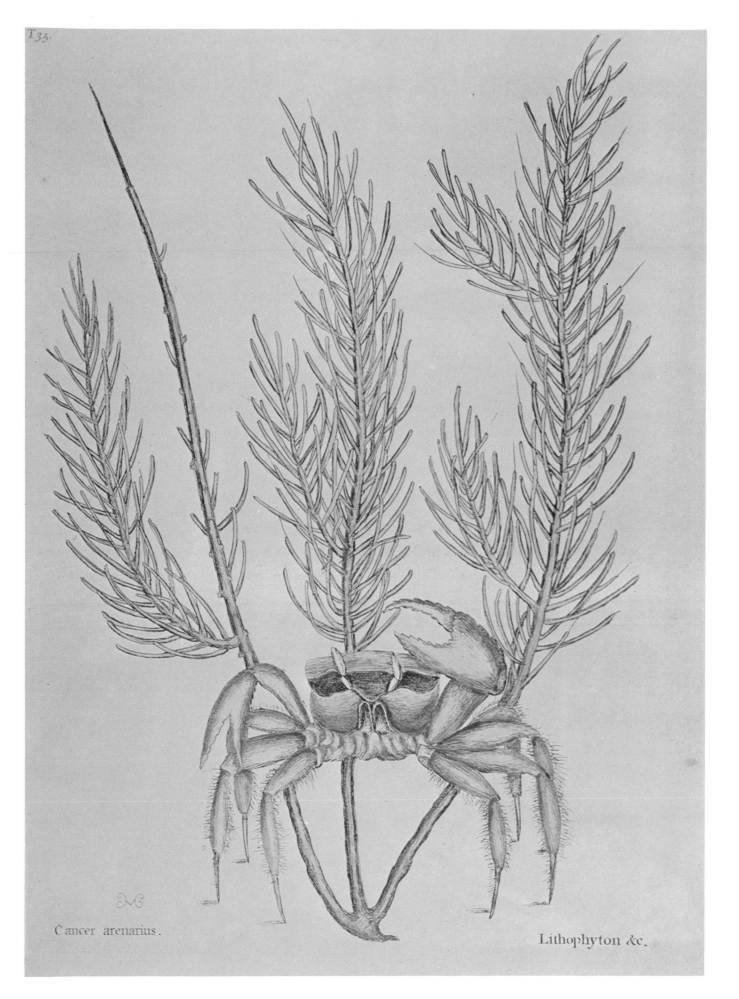

The Sand Crab. *Ca. 1731–43. Hand-colored etching, 13 7/8″ × 10 1/16″. (Catesby)*

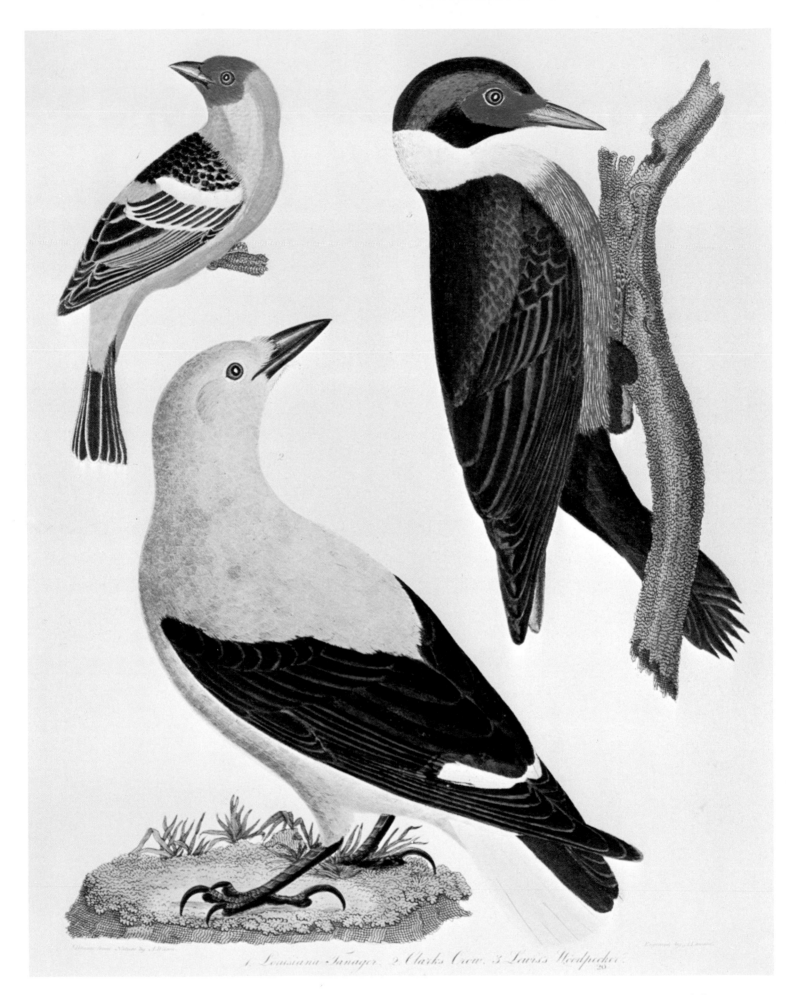

Louisiana Tanager *(1)*; Clarks Crow *(2)*; Lewis's Woodpecker *(3)*. *Ca. 1811. Hand-colored etching and engraving, 12 7/8″ × 9 7/8″. (Wilson)*

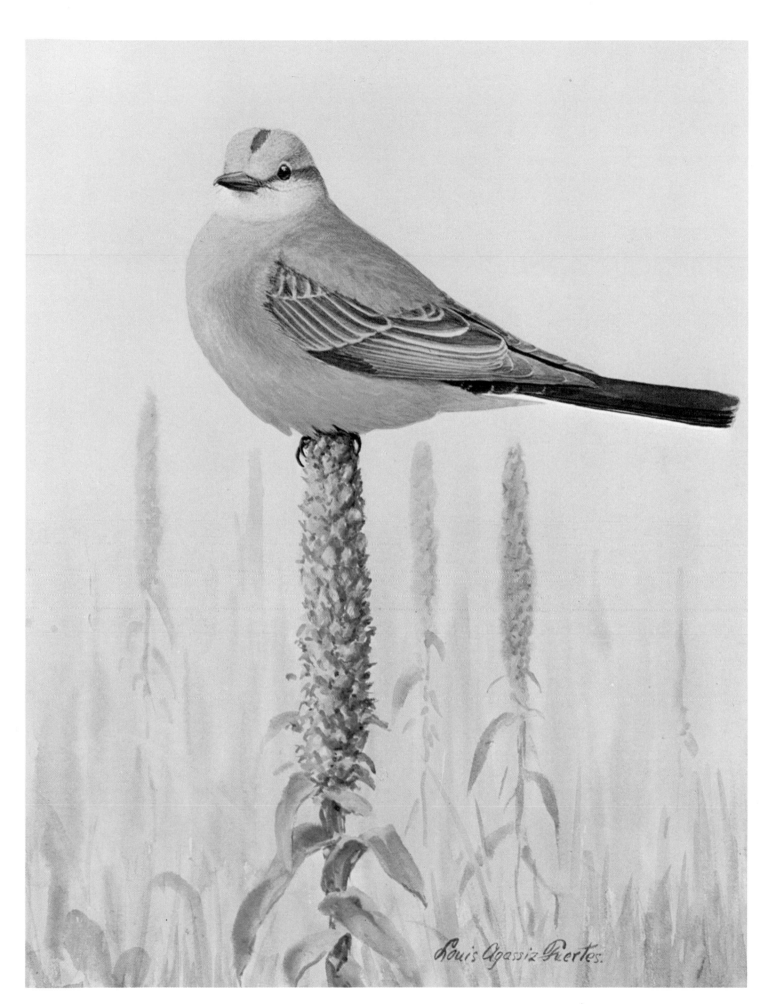

Western Kingbird. *Pub. 1910. Watercolor and pencil on paper, 12 1/4" × 8 15/16". (Fuertes)*

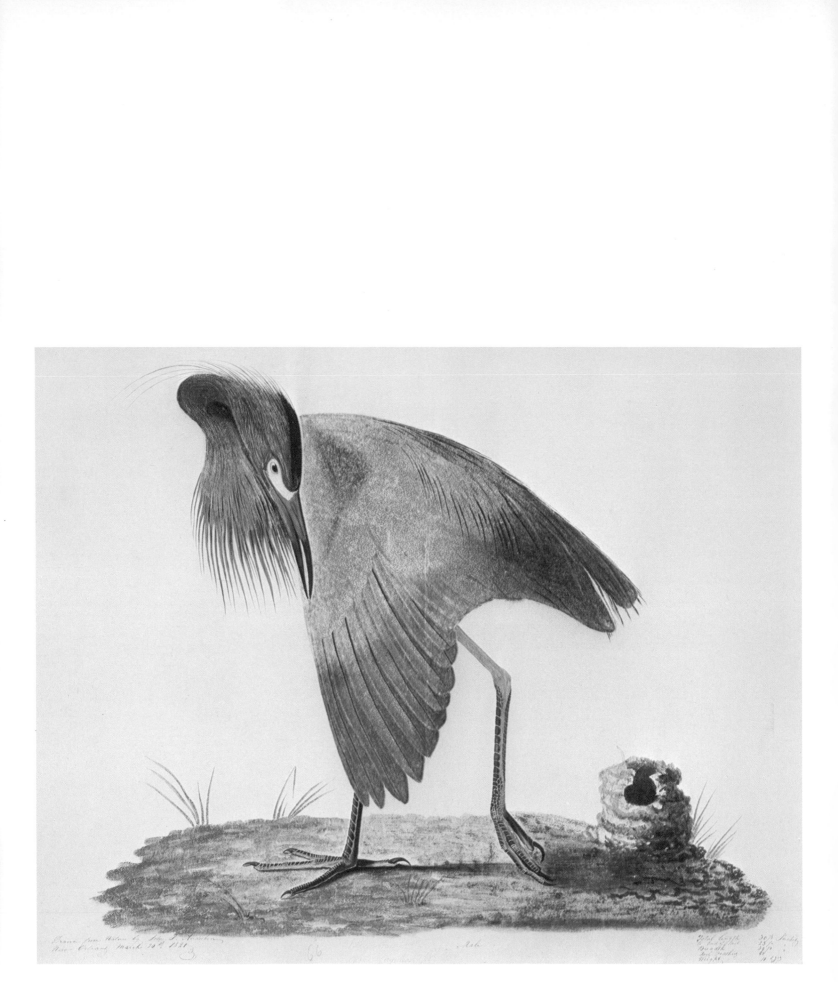

Little Blue Heron. *1821. Watercolor on paper, 18 11/16″ × 23 1/4″. (Audubon)*

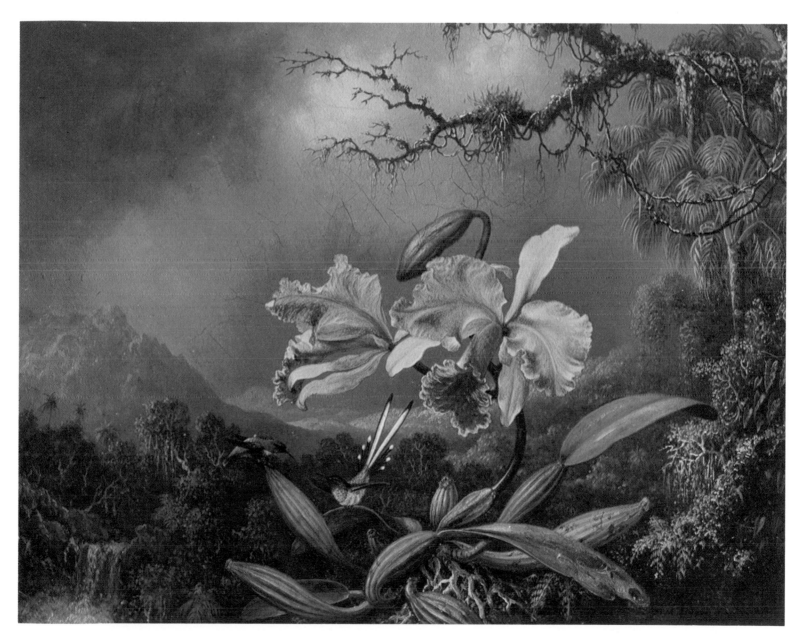

Study of an Orchid. *1872. Oil on canvas, 18″ × 23″. (Heade)*

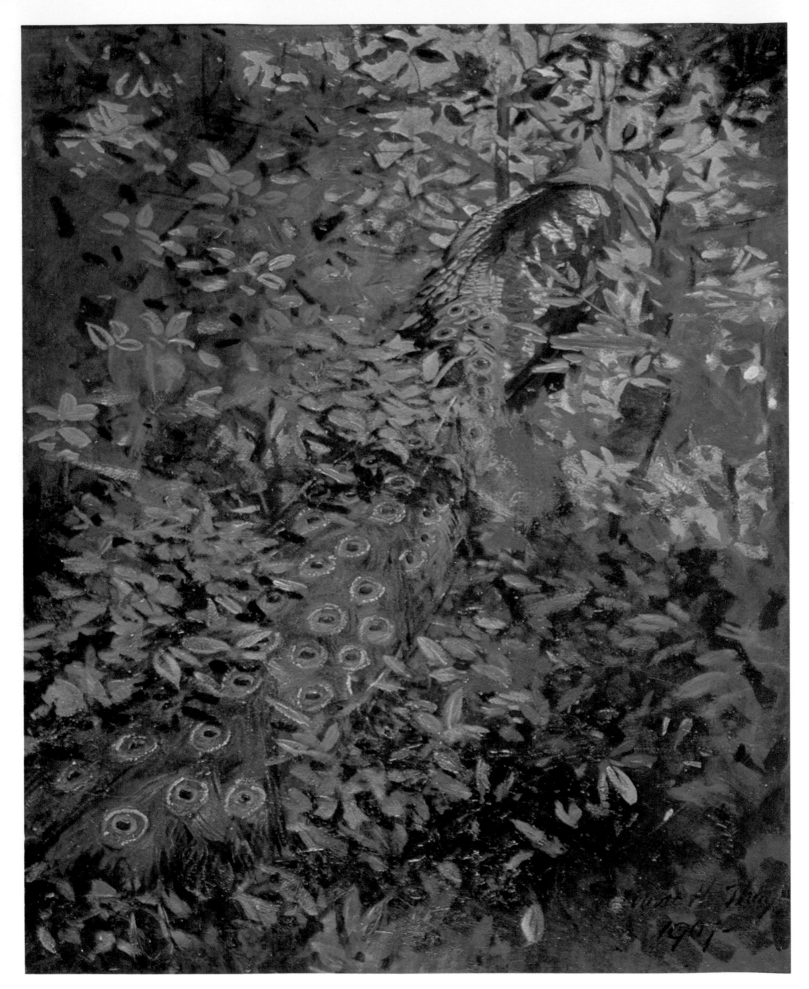

Peacock in the Woods. *1907. Oil on canvas, 45 1/4″ × 36 3/8″. (Abbott Thayer, assisted by Richard S. Meryman.)*

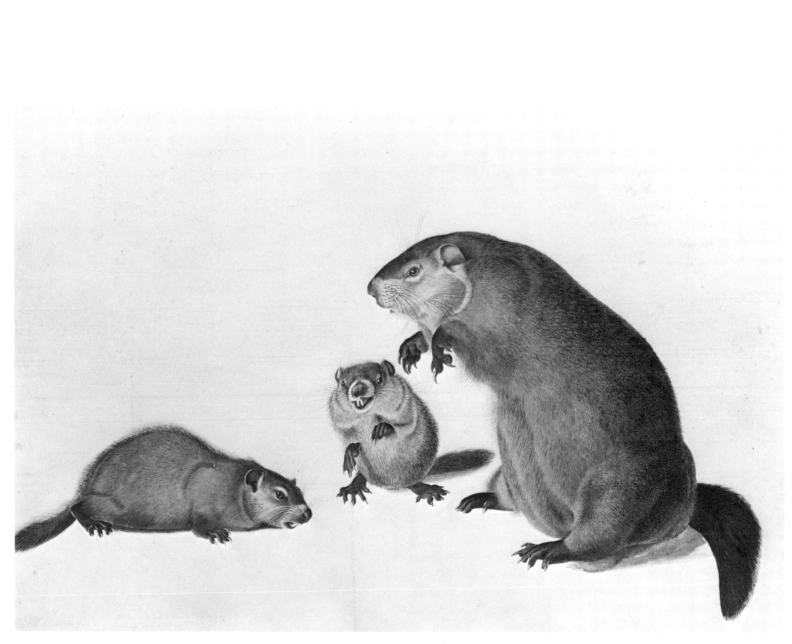

The Wood-Chuck. *1841. Pencil and watercolor on paper, 23″ × 33 3/4″. (Audubon)*

House Wren. *Ca. 1824. Watercolor on paper, 19 1/8″ × 11 1/2″. (Audubon)*

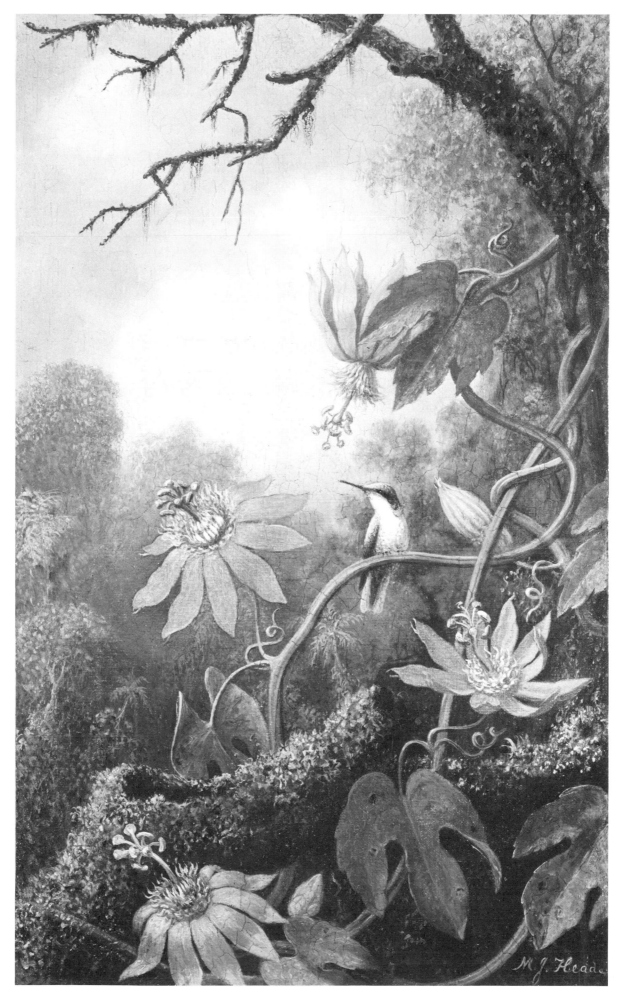

Hummingbird and Passion Flowers. *Ca. 1875–85. Oil on canvas, 20″ × 12″. (Heade)*

Porcelain-White Spider Suffused with Green Light Amid Foliage. *Ca. 1900–1909. Watercolor on paper, 2 15/16″ × 3″. (Gerald and Emma Thayer)*

Actual size

Jagged-Leaf-Edge Caterpillar in Position. *1902. Watercolor on paper, 2 5/8″ × 3 3/4″. (Gerald Thayer)*

Actual size

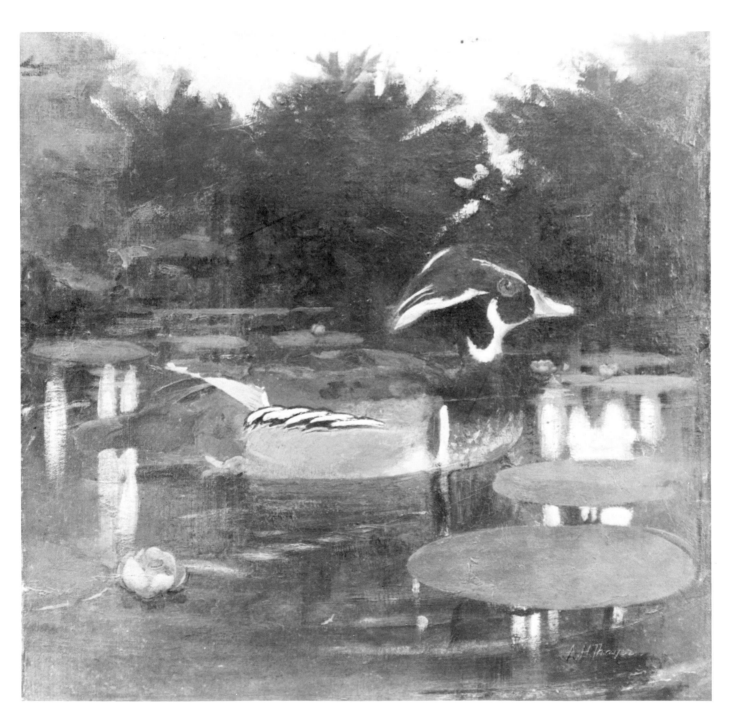

Male Wood Duck in a Forest Pool. *Ca. 1907. Oil on canvas, 20 1/4″ × 20 1/4″. (Abbott Thayer, assisted by Richard S. Meryman)*

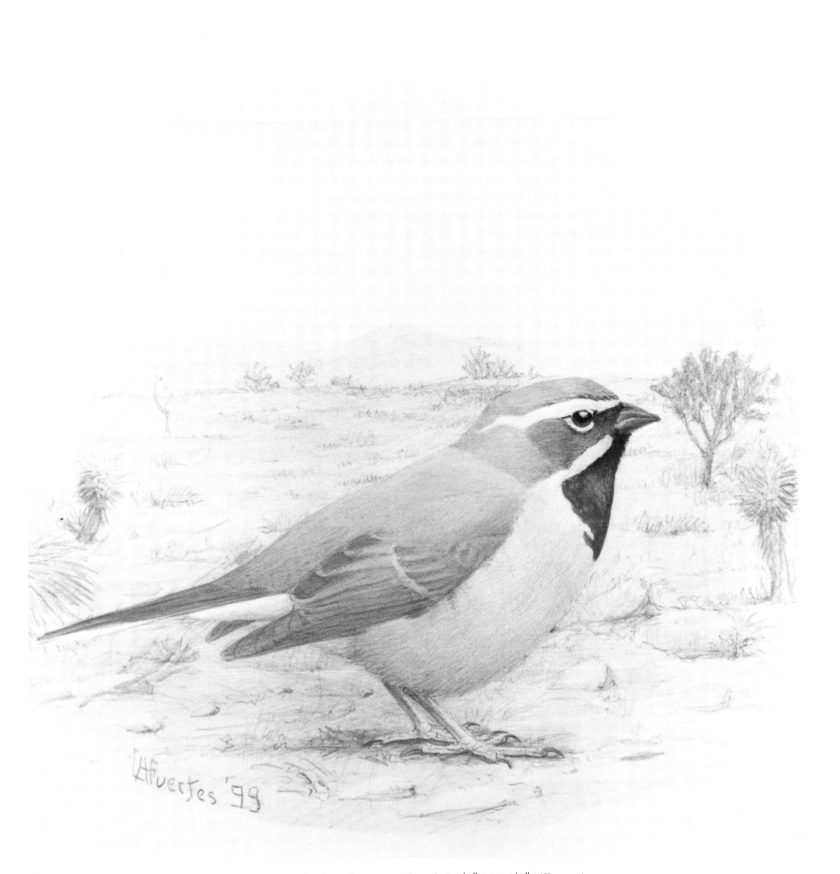

Black-throated Sparrow. *1899. Pencil and ink wash on paperboard, 9 1/8″ × 7 1/4″. (Fuertes)*

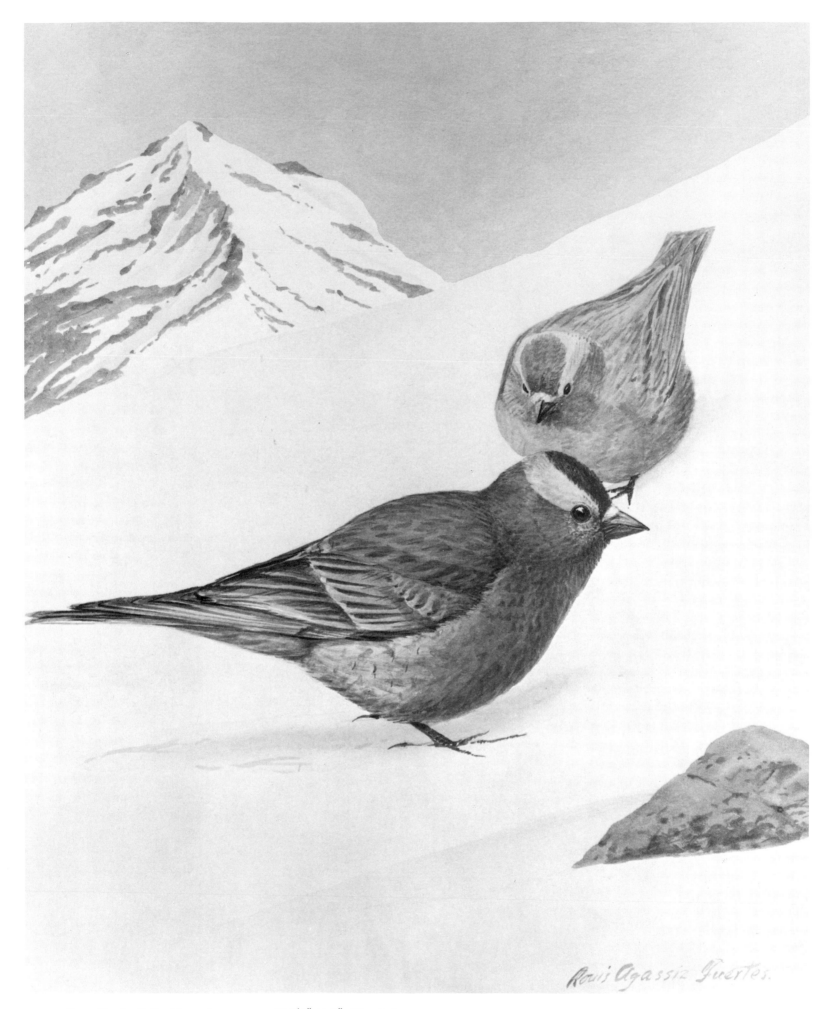

Rosy Finch. *N.D. Ink wash on paper, 10 3/4" × 8". (Fuertes)*

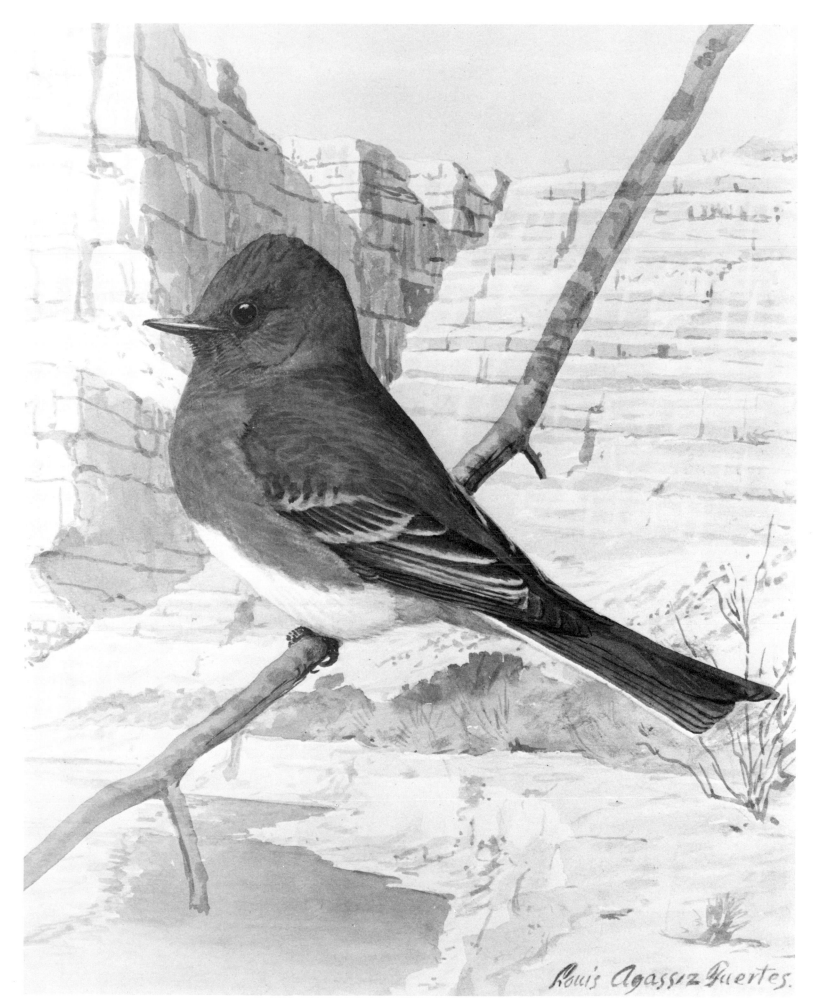

Black Phoebe. *Ca. 1901. Ink wash and pencil on paper, 8 3/8″ × 6 13/16″. (Fuertes)*

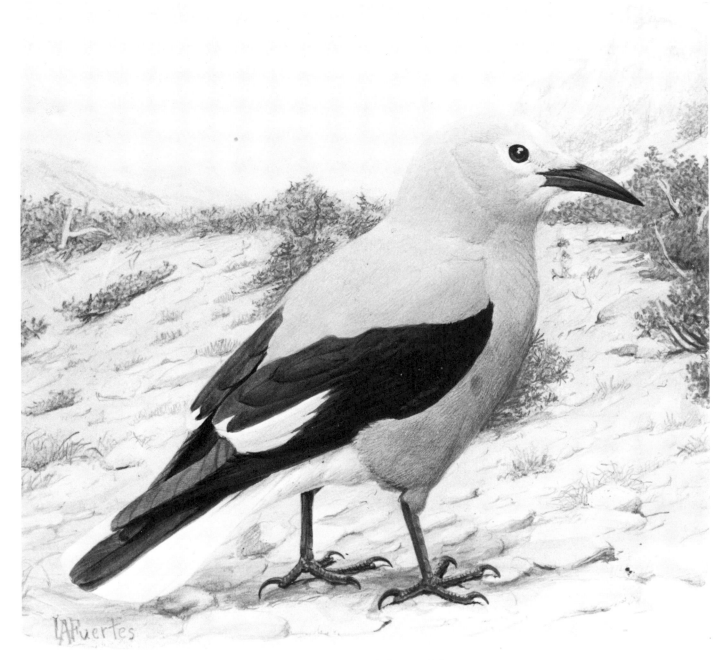

Clark's Crow. *Pub. 1899. Pencil and ink wash on paperboard, 7 1/4″ × 9 1/8″. (Fuertes)*

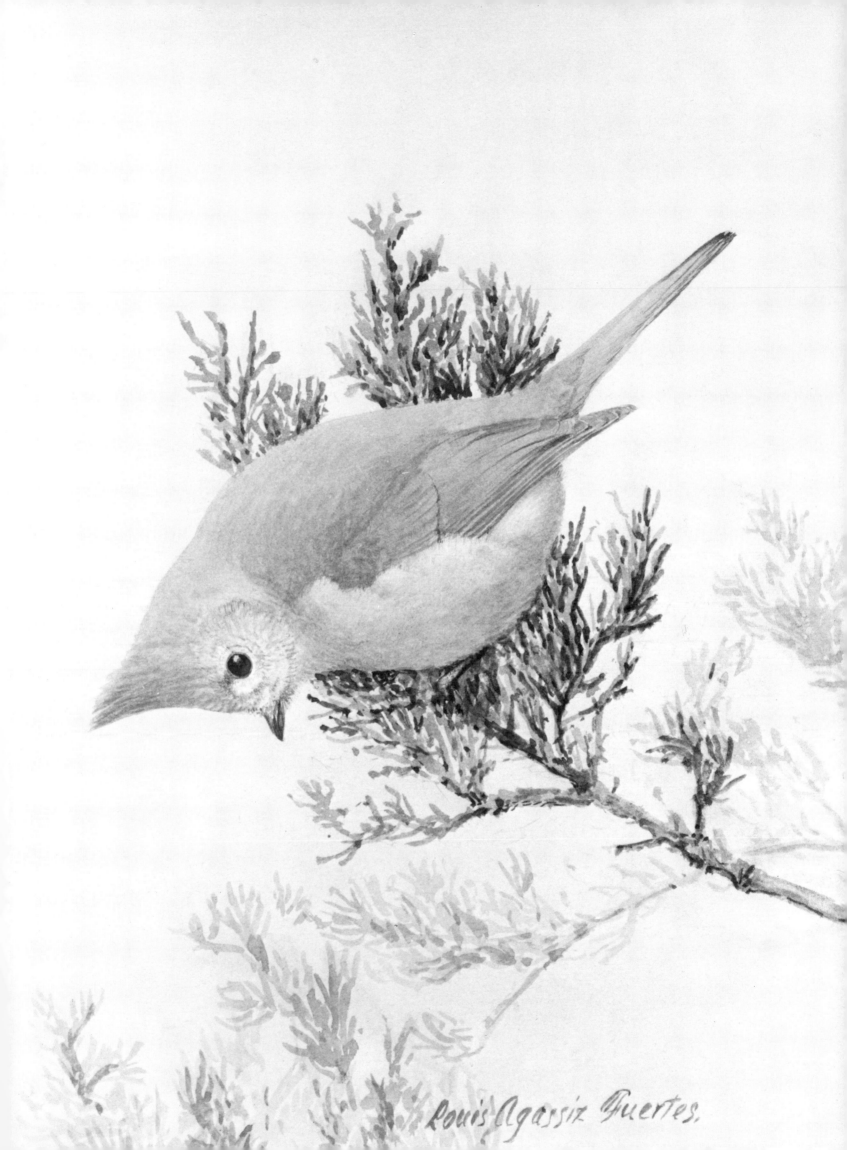

Louis Agassiz Fuertes.

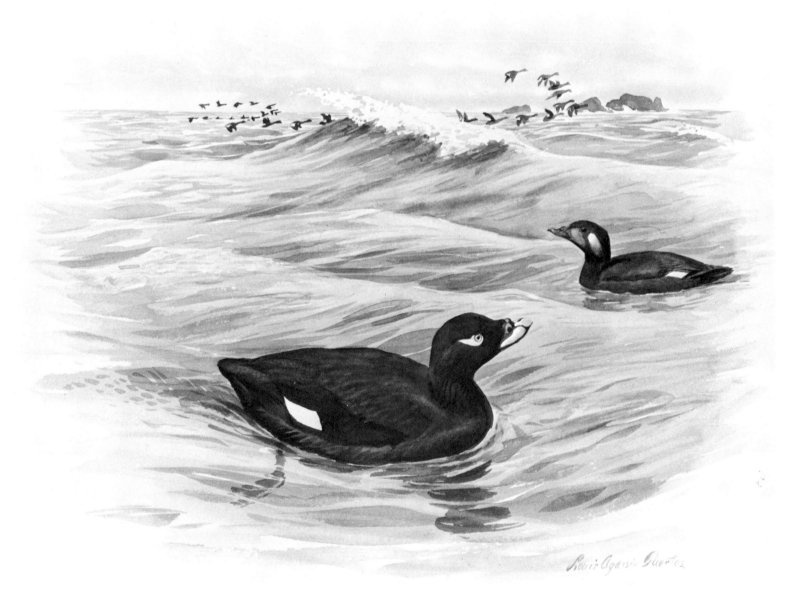

White-winged Scoter. *Pub. 1915. Ink wash on paperboard, 11″ × 13″. (Fuertes)*

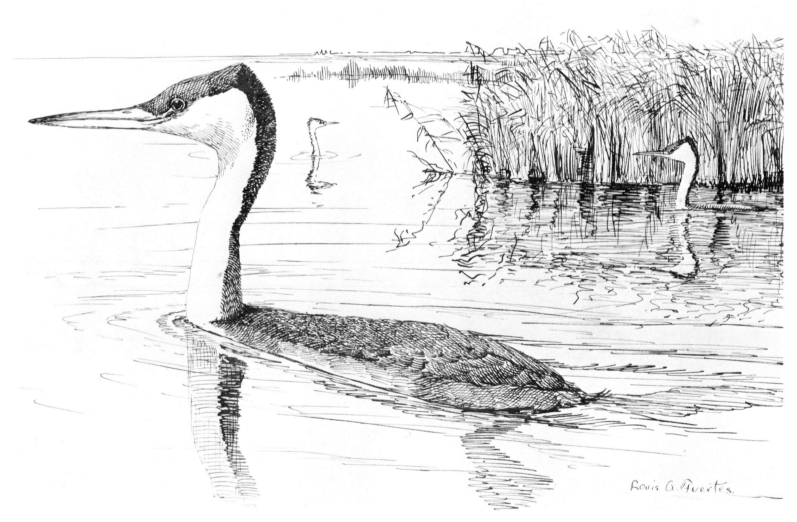

Western Grebe. *Pub. 1924. Ink on paperboard, 6 3/4″ × 9 7/8″. (Fuertes)*

Mark Catesby
1682 · 1749

(Preceding page)
The Great Booby.
*Detail of plate
shown on page 75.*

THE FIRST extensive portrayal of America's flora and fauna was published by Mark Catesby between 1731 and 1743. The two volumes, based on his travels in America, were a remarkable achievement, combining a wealth of information in the text with beautiful illustrations of the species discussed.

Catesby was born in Essex, England, in 1682/3. His parents were of the gentry. John Catesby, his father, was a solicitor and active in the political affairs of the area. His mother, Elizabeth Jekyll, was the daughter of a lawyer and antiquary from Castle Hedingham, Essex. The records of Catesby's youth are sketchy, however there is evidence of frequent contact between the Catesby family and Castle Hedingham where Catesby's uncle, Nicholas Jekyll, maintained a botanical garden and pursued his own antiquarian interests.

The exposure to the intellectual atmosphere of his uncle's home, as well as the opportunity to meet John Ray, England's foremost naturalist of the period, who also lived in Essex, must have encouraged and influenced Catesby's interest in natural history. But these contacts and the studies available in Essex were not sufficient to satisfy his increasing desire to expand his knowledge. In the Preface of his *Natural History of Carolina, Florida and the Bahama Islands,* Catesby wrote of his feelings: "The early Inclination I had to search after Plants, and other Productions in Nature, being much suppressed by my residing too remote from *London,* the Center of all Science, I was deprived of all Opportunities and Examples to excite me to a stronger Pursuit after those Things to which I was naturally bent: yet my Curiosity was such, that not being content with contemplating the Products of our own Country, I soon imbibed a passionate Desire of viewing as well the Animal as Vegetable Productions in their Native Countries;

which were Strangers to England."

In order to fulfill this desire, Catesby arranged to visit his sister, Elizabeth, and her husband, Dr. William Cocke, in Williamsburg, Virginia. He arrived there on April 23, 1712. Due to his brother-in-law's position within the political and social life of the community, Catesby quickly became acquainted with many of the leaders of the Virginia colony, including Governor Alexander Spotswood and William Byrd of Westover. He spent much of his time traveling throughout the colony and collecting seeds and specimens to send to his fellow botanists in England.

Catesby's visits to his sister ended in 1719. During his stay he had acquired a thorough knowledge of the Virginia area and developed a broad base of experience. When he wrote his *Natural History* several years later he was able to draw upon this visit to make comparisons between the southern and more northern areas and to draw conclusions concerning certain of the plants and animals he saw on his later trip to the Carolinas.

The specimens Catesby sent to England during his visit to Williamsburg also brought his name and work to the attention of many of England's leading scientists. Due to his reputation he was one of the first people considered for a sponsored collecting trip to Africa, which was abandoned, and later for the trip to the Carolinas. Plans for Catesby's return to the Colonies moved forward when the necessary patronage was secured. With the financial backing of a group that included Sir Hans Sloane, physician to King George III and President of the Royal Society; Colonel Francis Nicholson, Governor of South Carolina; and William Sherard, a noted botanist, Catesby sailed from England early in February 1722. He was received by Governor Nicholson when he landed in Charles Town on May 3, 1722.

Soon after he arrived in the Carolina colony, he

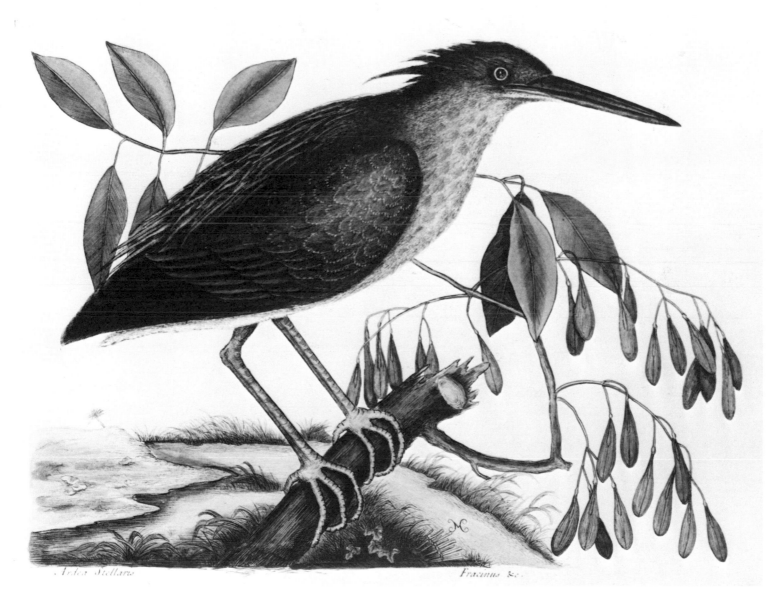

The Small Bittern. *Ca. 1727–31. Hand-colored etching, 13 3/4″ × 10 1/4″.*

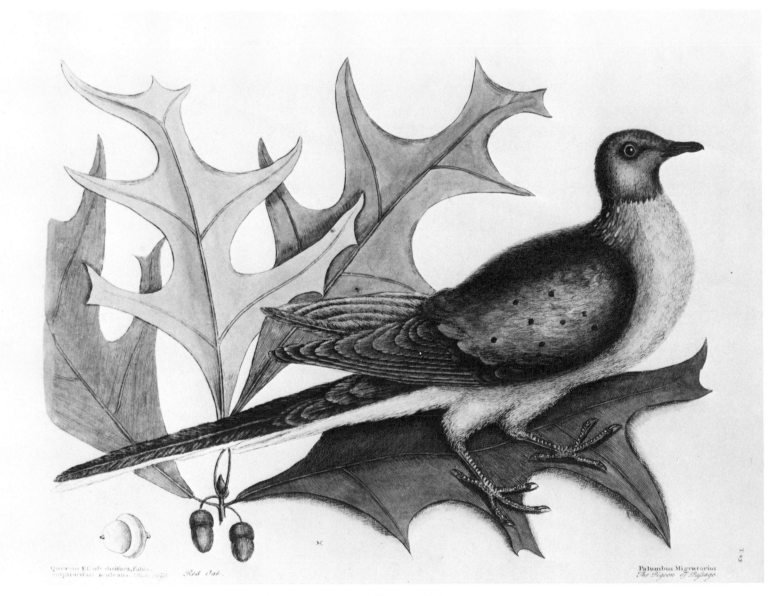

The Pigeon of Passage. *Ca. 1727–31. Hand-colored etching, 14″ × 10 1/4″.*

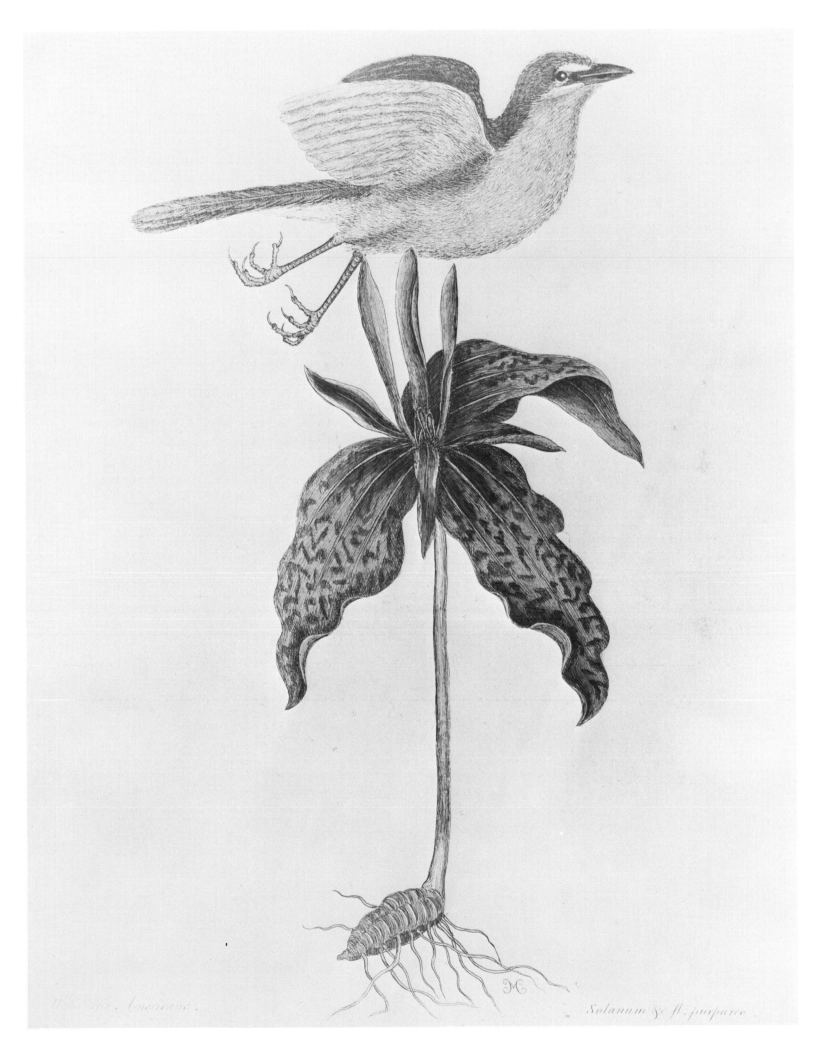

Mocker. Americana.　　　　　Solanum & fl. purpurea

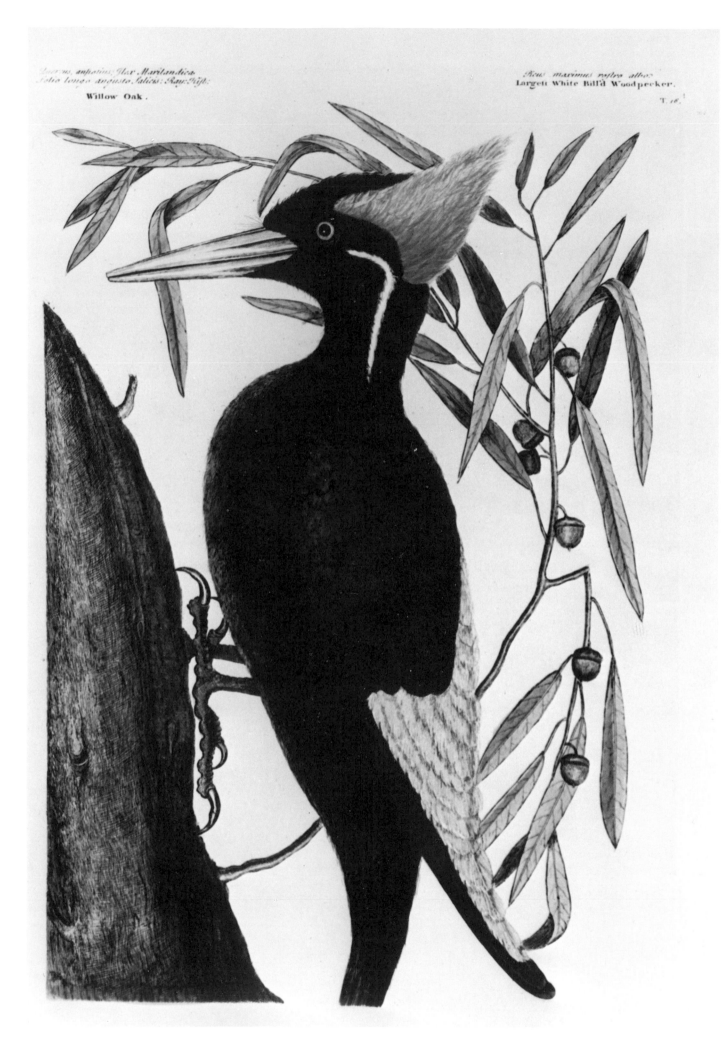

Quercus, ampotius, Ilex Maritandica
Solio longo angusto Salicis: Ray.Fish:

Willow Oak.

Picus maximus rostro albo.
Largest White Bill'd Woodpecker.

T. 16.

Largest White Bill'd Woodpecker. *Ca. 1727–31.*
Hand-colored etching, 14 3/4" × 10 1/4".

began his research trips—collecting specimens, making drawings, taking notes, and discussing his findings. Catesby's job was extremely taxing, because in addition to the work he was doing toward the *Natural History,* his patrons also expected him to provide them with many specimens for their own collections.

Delayed by prolonged illness during the Fall of 1722 and by the destruction of many specimens during a particularly devastating hurricane that September, Catesby continued to work as much as possible. He became somewhat annoyed by the demands of his patrons; he felt his first duty was to produce more than collections of plants, seeds, and animals. He intended to be ". . . the first that has had an Opportunity of presenting to a Queen of Great Britain a Sample of the hitherto unregarded, tho' beneficial and beautiful Productions of Your Majesty's Dominions."

Catesby made watercolor drawings of whatever species he located; these were to accompany the written descriptions in his proposed book. He drew animals and plants after carefully observing them as they lived. He illustrated what he felt could best be explained visually and wrote about those qualities that he could not illustrate. In his Preface, he explained the manner in which he worked: "As I was not bred a Painter I hope some faults in Perspective, and other Niceties, may be more readily excused, for I humbly conceive Plants, and other Things done in a Flat, tho' exact manner, may serve the Purpose of Natural History, better in some Measure than in a more bold and Painter like Way. In designing the Plants, I always did them while fresh and just gather'd: And the Animals, particularly the Birds, I painted them while alive (except a very few) and gave them their Gestures peculiar to every kind of Bird, and where it would admit of, I have adapted the Birds to those Plants on which they fed, or have any Relation to. Fish which do not retain

their Colours when out of their Element, I painted at different times, having a succession of them procur'd while the former lost their Colours: . . . Reptiles will live many Months without Sustenance, so that I had no difficulty in Painting them while living."

Catesby's depictions have, therefore, a marvelous sense of vitality, since he not only closely observed and noted each species' shape and coloring, but also its movements, its habitats, and whatever set it apart from other species. Catesby felt nothing was too insignificant to include in his work. One evening during a visit to the Bahamas he and his host, Governor of the Islands Charles Phinney, examined Phinney's foot, searching for a "chego" to examine under a microscope and record its appearance. The "chego" is Figure 3 in the plate *The Largest crested Heron* on p. 76; there are several insects shown here, one of which, Figure 4, was also removed from Phinney's foot and is actually the size of the dot over its head. Figure 5, *The Cockroach,* Catesby described as ". . . troublesome and destructive Vermin . . . so numerous and voracious, that it is impossible to keep Victuals of any kind from being devoured by them. . . . It is at night they commit their depradations, and bite people in their beds, especially childrens fingers that are greasy."

After three years of traveling in Carolina, Georgia, and Florida, and most of a year in the Bahama Islands, Catesby returned to England in 1726. From that time his life was devoted to his work as an author and as an artist, as well as to continued botanical studies. He would never again work as a field naturalist.

Although he originally planned to have his drawings engraved and to present an overall history of his travels, he went to Joseph Goupy, a Frenchman living in London, and ". . . undertook and was initiated in the way of Etching them my-

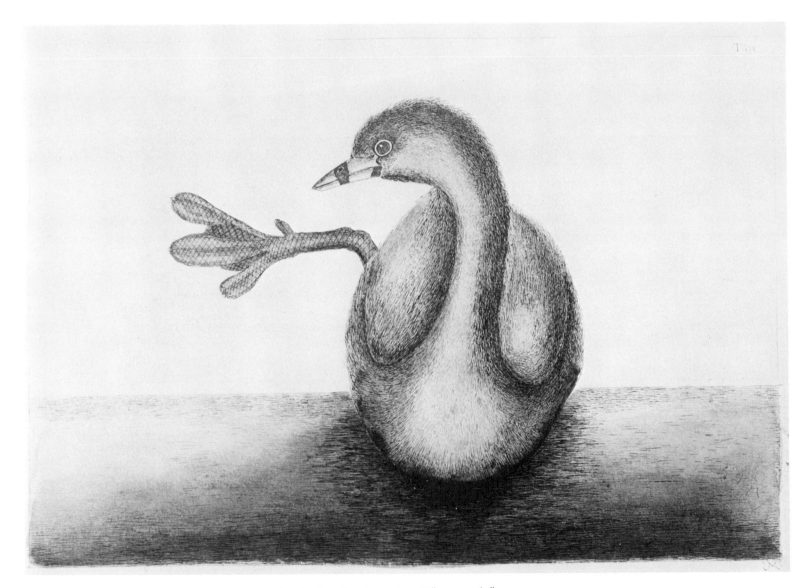

The Pied-Bill Dopchick. *Ca. 1727–31. Hand-colored etching, 10 3/8" × 13 3/8".*

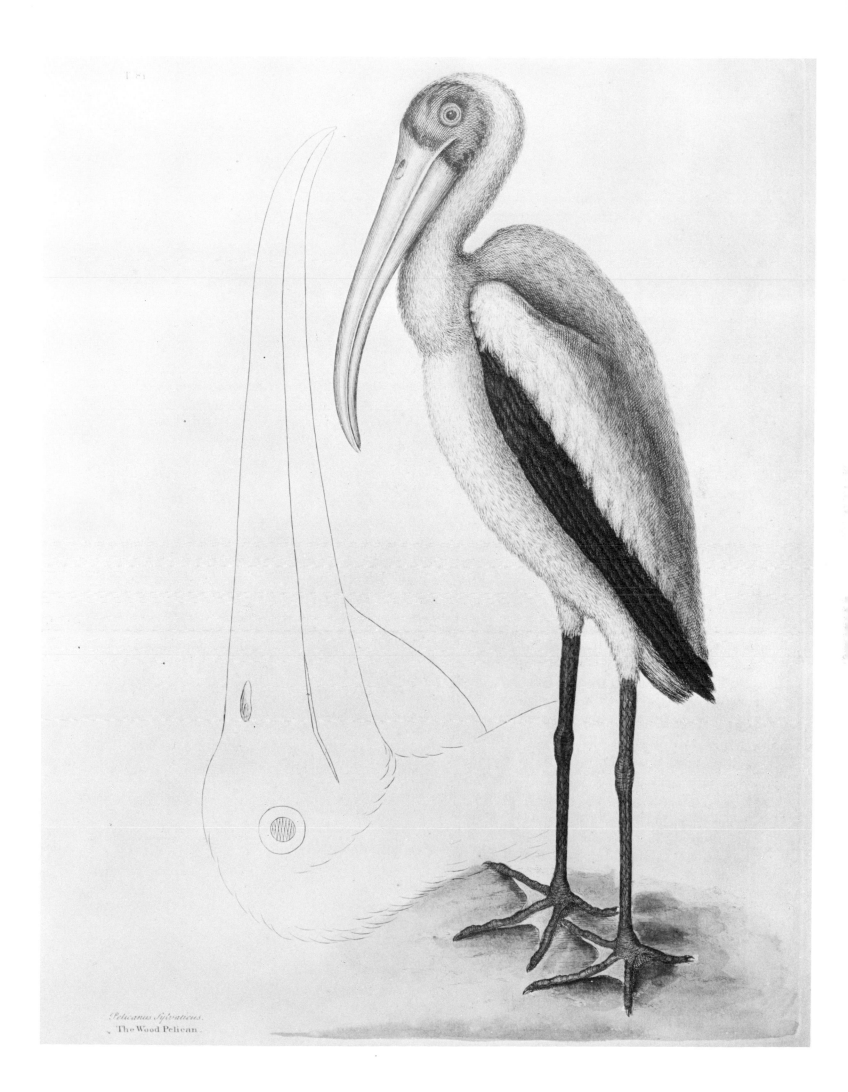

Pelicanus Sylvaticus.
The Wood Pelican.

self, tho' I may not have done in a Graver-like manner, choosing rather to omit their method of cross-Hatching, and to follow the humour of the Feathers, which is more laborious, and I hope has proved more to the purpose." Such was his determination to complete the project that he not only etched all but two of the 220 plates included in the two volumes and the Appendix, but he also hand colored or personally supervised the coloring of all the impressions of the plates published in the first edition. The delicacy of his handling of the coloring is even more evident when plates from the first edition are seen beside plates from the later editions, in which the colors are often opaque, heavy, and garish. As a result of his attention to detail and to coloring, identification of almost every species he depicted has been possible.

Between 1727 and 1746 Catesby worked on the text and the plates for his *Natural History*. He was able to do so only by working in various nurseries and gardens, and through the generosity of Peter Collinson, a Quaker merchant who lent Catesby a considerable sum of money without interest so he could support himself until he began to receive the returns from the sale of the *Natural History*. Collinson also provided Catesby with American specimens from his garden, many of which had been sent to Collinson by John Bartram.

The book, as was the usual practice, was sold in parts, each part containing twenty plates and their accompanying text. This enabled Catesby to derive income from one part to finance the printing of the succeeding part, so that the book, if popular, would be self-financing. The first part was completed by May 1729, at which time Catesby was invited to the Royal Society to display the work. He probably took the opportunity to find additional subscribers to assist in financing the major part of the work to be done.

Between 1729 and November 1732 the first volume of five parts was completed. During this same period, Catesby made a number of visits to meetings of the Royal Society. Following the completion of Volume I, he was proposed as a Fellow of the Royal Society by five men, including his patrons Sir Hans Sloane and Peter Collinson. He was elected on April 26, 1733, and remained an active member of the group thereafter, sharing information he received in letters from friends and exhibiting the parts of the *Natural History* as they were completed.

Catesby also presented several papers before the Society, most of which were incorporated into the account of the Carolinas published with Volume II of his book. One of the most important papers, "Of Birds of Passage," in which Catesby logically set forth his views on migration, was read in 1746/7. Catesby's theory was that birds flew as many degrees south of the equator in winter as they had spent north of the equator in summer. Since this would have placed many birds in the ocean during the winter, it was obviously not accurate, though it was a well thought out and presented paper. It was actually much closer to the truth than the popular misconception that swallows and certain other birds wintered by hibernating in hollow trees, in caves, or in the mud at the bottoms of ponds.

Even with the extra activities, Catesby's work on the second volume advanced. He completed it in 1743, with the final plates including the plant *Catesbaea*. The Appendix, added in 1747, consisted of 20 plates based on specimens sent to him by John Bartram and others in the colonies and was as much an attempt to provide additional income as to update his book.

The most extensive part of Catesby's book was devoted to birds. He actually figured 109 distinct species, in some cases confusing immature and mature specimens of one species as two separate species. Since this same mistake was made by

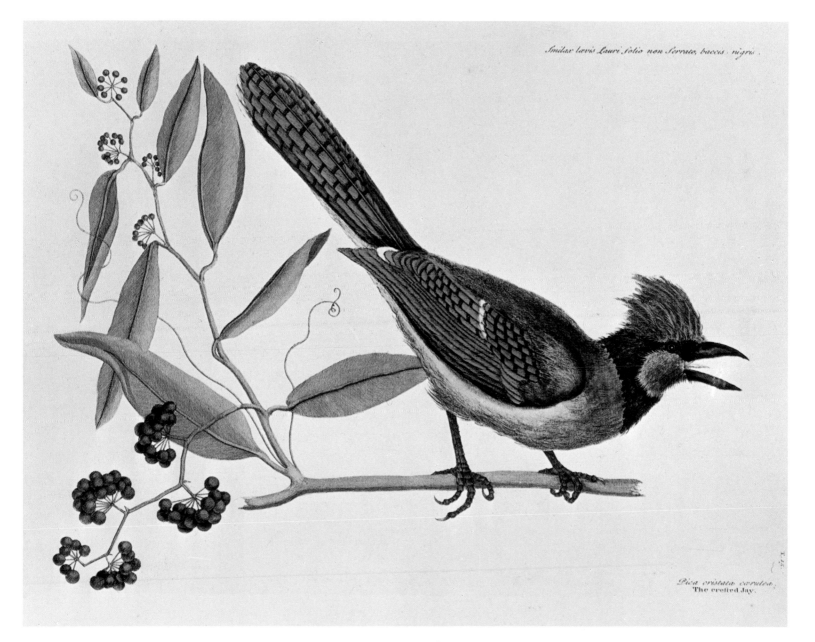

Smilax lævis Lauri folio non ferrato, baccis nigris.

Pica cristata cærulea,
The crested Jay.

The Crested Jay. *Ca. 1727–31. Hand-colored etching, 10″ × 13 3/4″.*

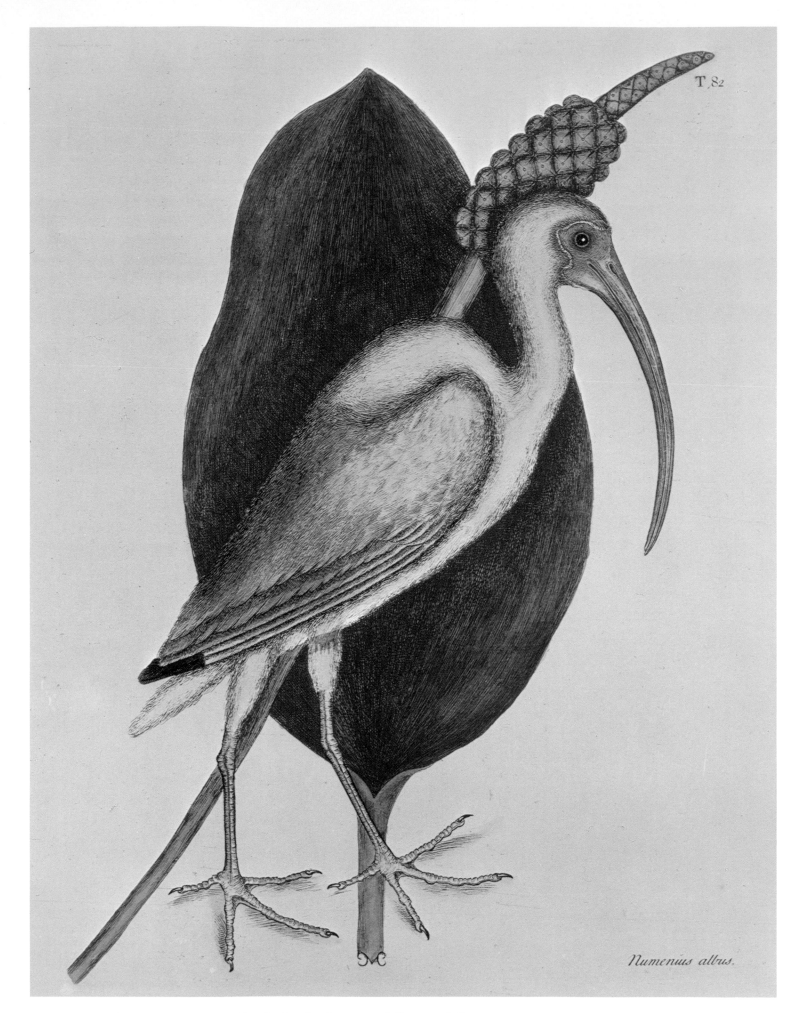

T. 82

Numenius albus.

The White Curlew. *Ca. 1727–31. Hand-colored etching, 13 3/4" × 10 1/4".*

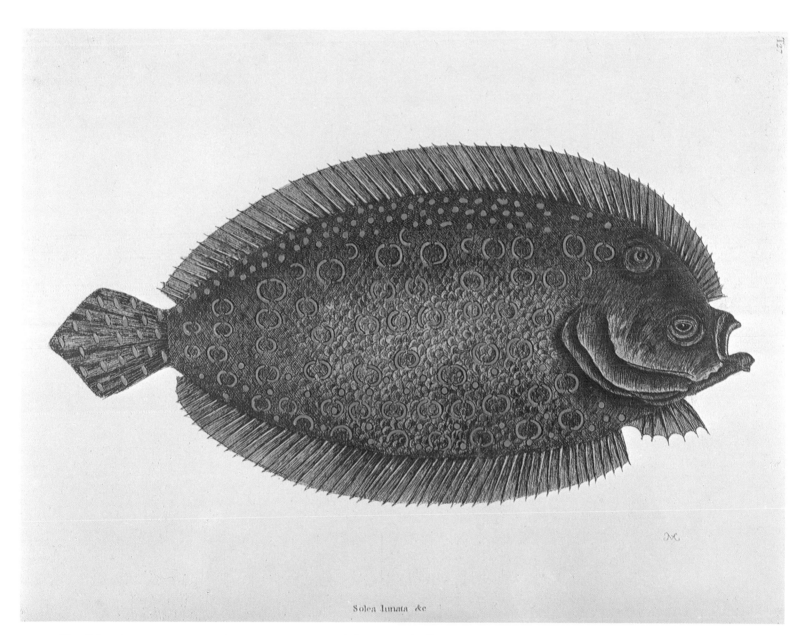

Solea lunata &c

The Sole. *Ca. 1731–43. Hand-colored etching, 10 5/8″ × 14 15/16″.*

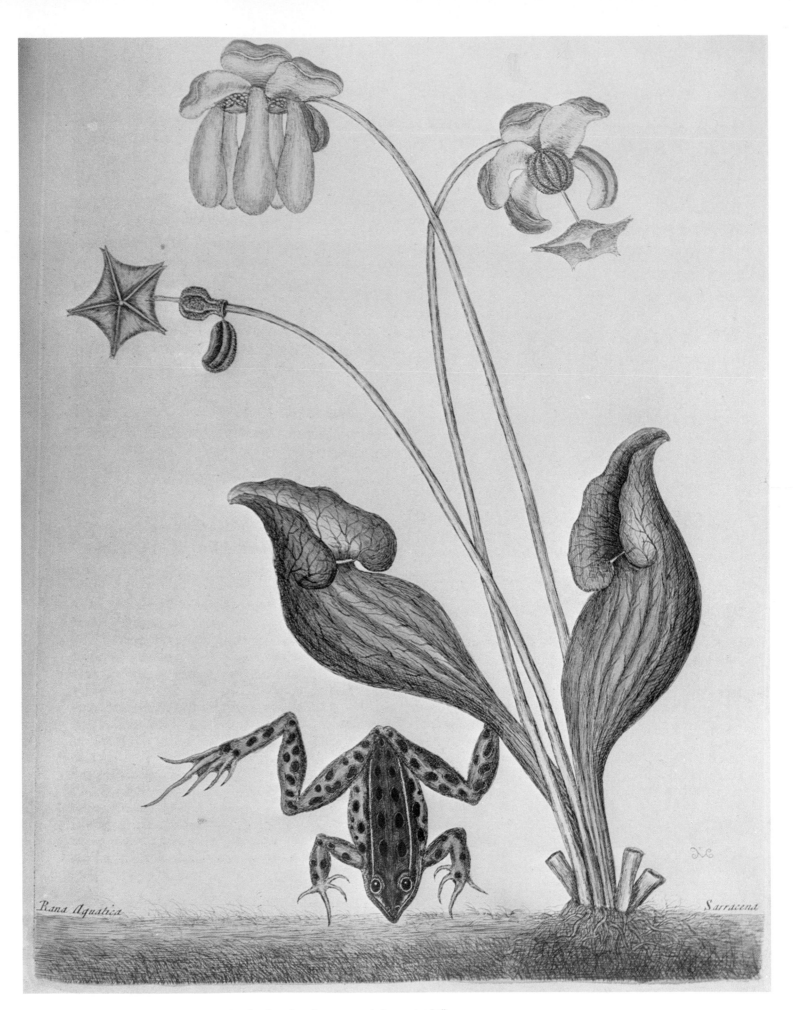

Rana Aquatica

Sarracena

The Water Frog. *Ca. 1731–43. Hand-colored etching, 13 3/4″ × 10 1/8″.*

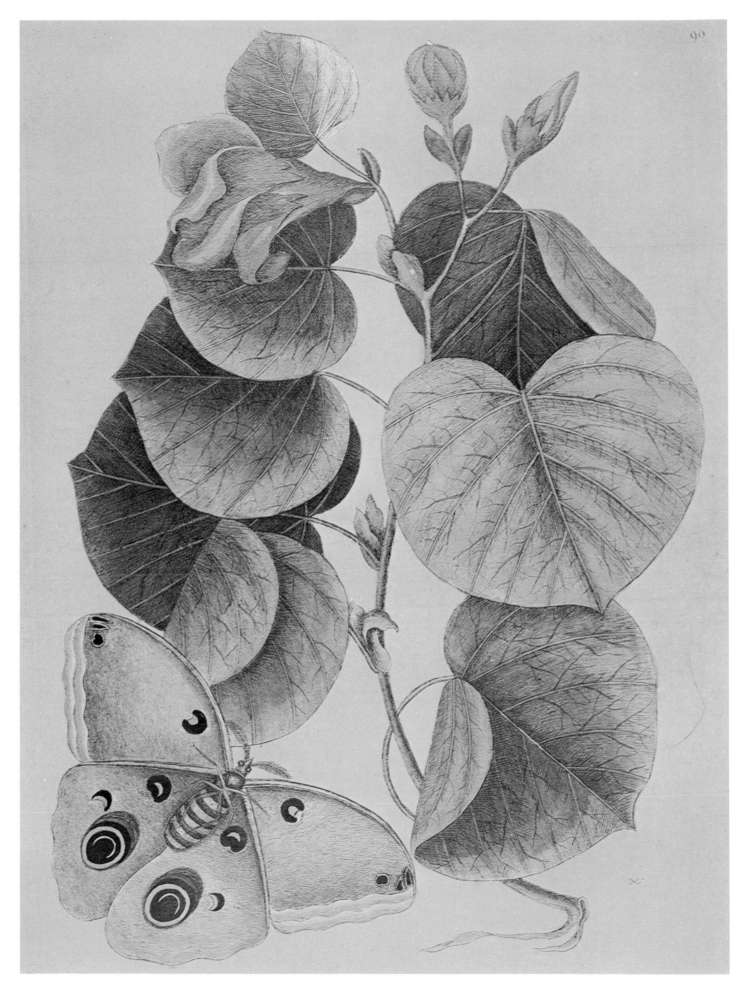

The Maho-Tree, Phalaena Fusca. *Ca. 1731–43. Hand-colored etching, 13 5/8″ × 10 1/4″.*

The Woodcock of America. *Ca. 1731–43. Hand-colored etching, 14" × 10 1/4".*

Yellow and Black Pye. *Ca. 1731–43. Hand-colored etching, 14 1/16" × 10 1/4".*

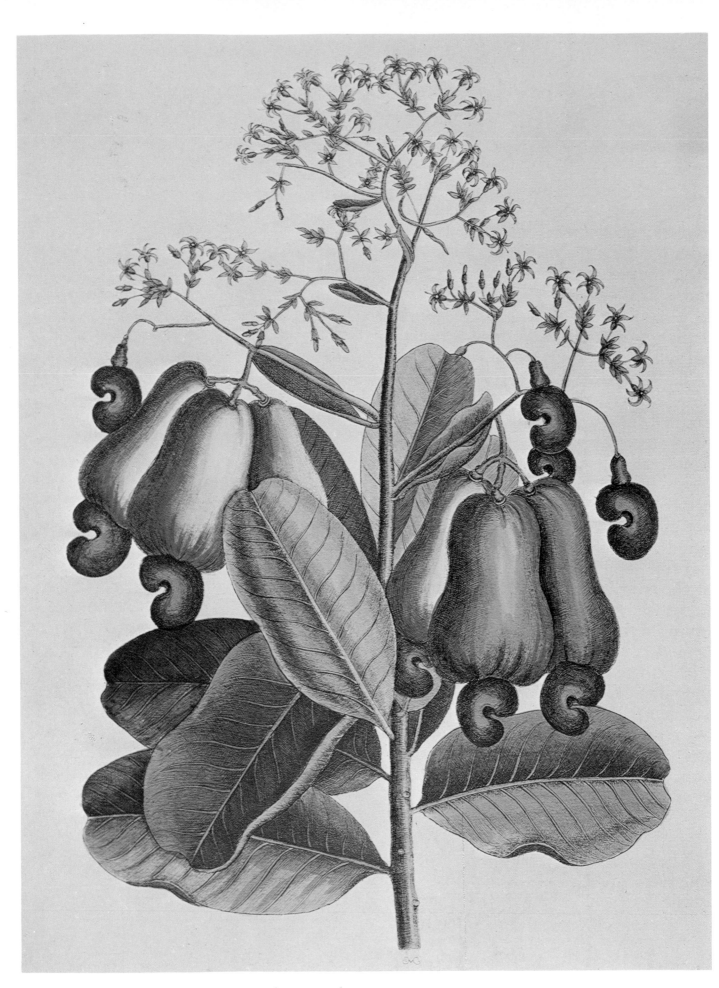

The Cushew Tree. *Ca. 1731–43. Hand-colored etching, 14″ × 10 3/8″.*

Wilson, Audubon, and others in the nineteenth century, it is an understandable shortcoming. The first 100 plates were devoted exclusively to birds and several more appear in the Appendix. Catesby thought he had figured all but some water birds, though he restricted the plates to figuring the colorful male plumages, and verbally described the more subdued female plumages. The second volume of 100 plates was devoted to fish, crabs, turtles, and other marine animals; snakes, lizards, and frogs; botanical specimens; squirrels; butterflies and moths; and small mammals. He tried not to include animals that he felt were of the same species as those in Europe. The Appendix included a variety of additional species including his one-eyed *American Bison* (p. 19) and the striking plate *The Woodcock of America* (p. 70).

The text of the two volumes is filled not only with detailed descriptions of the appearance and habits of the birds, plants, and animals, but with explanations of their uses and stories about them. He describes how nesting flamingos were easily slaughtered due to their lack of alarm at gunshots, how flocks of *The Pigeon of Passage* (p. 58) were shot down by people perched on their rooftops in New York and Philadelphia, and how the Indians made use of the bills from the *Largest White Bill'd Woodpecker* (p. 60). He recounts the singing ability of the "mock-bird" and the curative effects of the pellitory, or "toothache," tree. In discussing the rattlesnake, he relates the alarm he felt when a servant found one coiled in his bed shortly after he had left his bedroom. In addition to all the material included with each plate, Catesby wrote an extensive account of Carolina, describing the air, earth, and water of the region—three of the four elements; the Indians and their crafts; the agriculture and crops of the area—corn, rice, potatoes, fruit; and the native pine tree and how it is used to make pitch and tar.

He also discusses the various large mammals, fish, birds, and insects in general, adding a similar, shorter treatment of the Bahama Islands.

After finishing the *Natural History of Carolina, Florida and the Bahama Islands,* Catesby spent the remaining years of his life working on another, smaller publication, *Hortus Britanno-Americanus,* a book discussing American plants and trees which could be grown in England.

In 1747 Catesby married Elizabeth Rowland. His marriage lasted only two years, for he died December 23, 1749, following six months of illness. He left his widow and two children little more than the plates and a few completed copies of his book. The sale of these sustained them only a few years. Elizabeth Catesby died in 1753, leaving almost no estate.

In his later years, Catesby had attained a position of honor within British scientific circles and was accorded much respect by his contemporaries. When Peter Kalm, the Finn who visited America, stopped in London before leaving on his trip, Catesby was one of those to whom he went to discuss information about the Colonies. Kalm was greatly impressed by the work Catesby had accomplished in America.

The value of Mark Catesby's work lies not only in the mass of carefully thought out theories combined with all the legends, folktales, and eyewitness accounts compiled during his time in America and while working on his *Natural History,* but also in his new approach to natural history illustration. Instead of perpetuating the previous stiff, profile manner of presentation, Catesby devised the method of mingling plants and animals in logical groupings, most often with accuracy and with proportional scale between figure and plant. He did his utmost to convey something of the particular habits or movements of each species. Simple though they are, he infused his compositions with a sense of movement and vital-

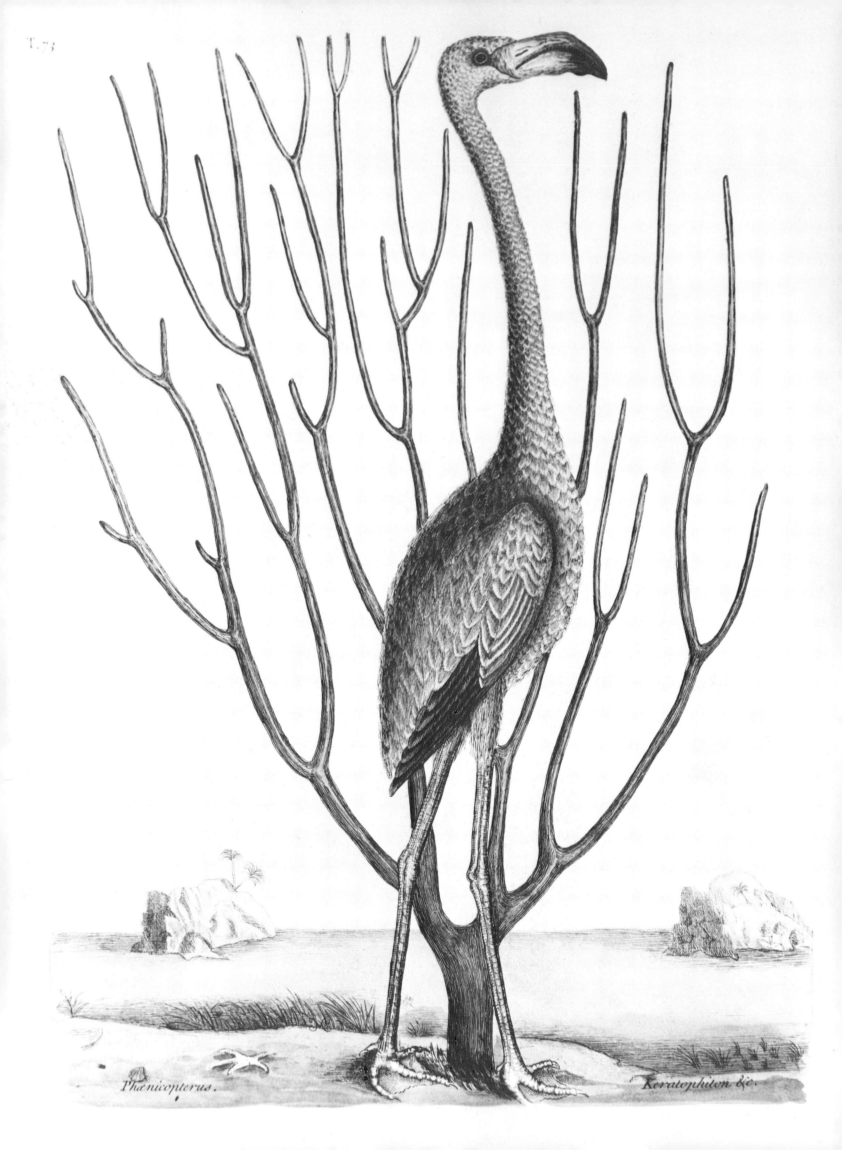

Phænicopterus. Keratophiton &c.

Flamingo. *Ca. 1727–31.*
Hand-colored etching, 14" × 10 1/4".

ity not usual prior to his work. He caught the raucous cry of *The Crested Jay* (p. 65), the sinuous character of *The Coach Whip Snake* (p. 78), the flight of *The Yellow brested Chat* (p. 59) and *The Flying Squirrel* (p. 20), the nest of *The American Swallow* (p. 21), and the paddling motion of *The Pied-Bill Dopchick* (p. 62). The *Natural History of Carolina, Florida and the*

Bahama Islands retains to this day a quality of freshness and a sense of the delight with which Catesby pursued his pioneering work as an artist-naturalist. Catesby's labors for over twenty years produced a work which was to remain for more than fifty years the most complete firsthand account of North American wildlife in existence.

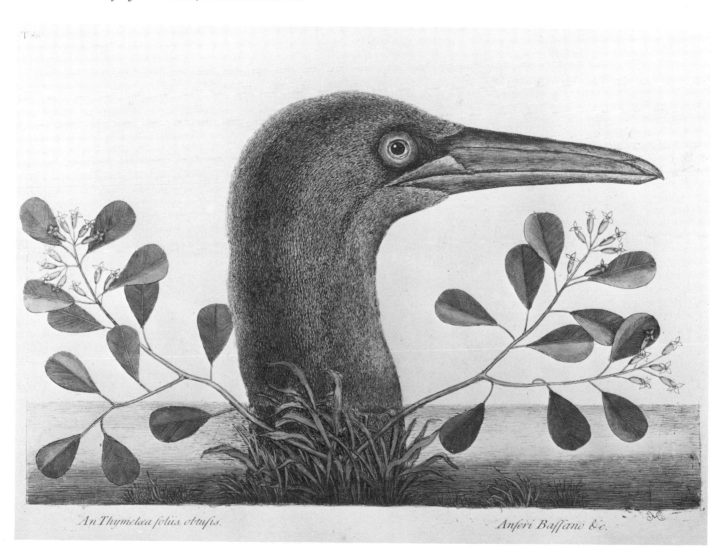

The Great Booby. *Ca. 1727–31. Hand-colored etching, 10 1/4" × 13 7/8".*

Red mottled Rock Crab,
Rough-Shelled Crab.
*Ca. 1731–43. Hand-colored etching,
14 3/16″ × 10 1/8″.*

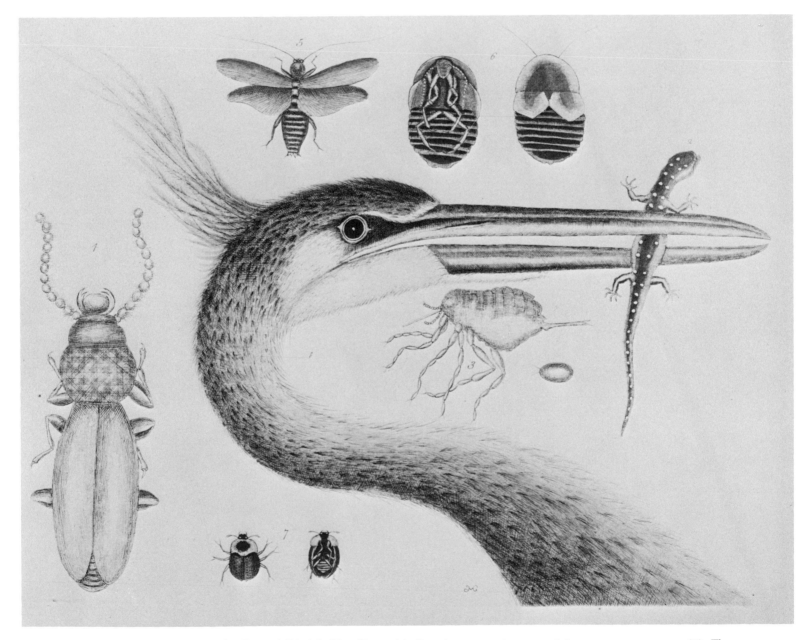

The largest crested heron *(1)*; The Spotted Eft *(2)*; The Chego *(3)*; Scarabaeus capricornus minimus cutem penetrans *(4)*; The Cockroach *(5)*; Blatta maxima fusca pettata *(6)*; Scarabaeus Pettatus *(7)*. *Ca. 1731–43. Hand-colored etching, 10 3/16″ × 13 5/8″.*

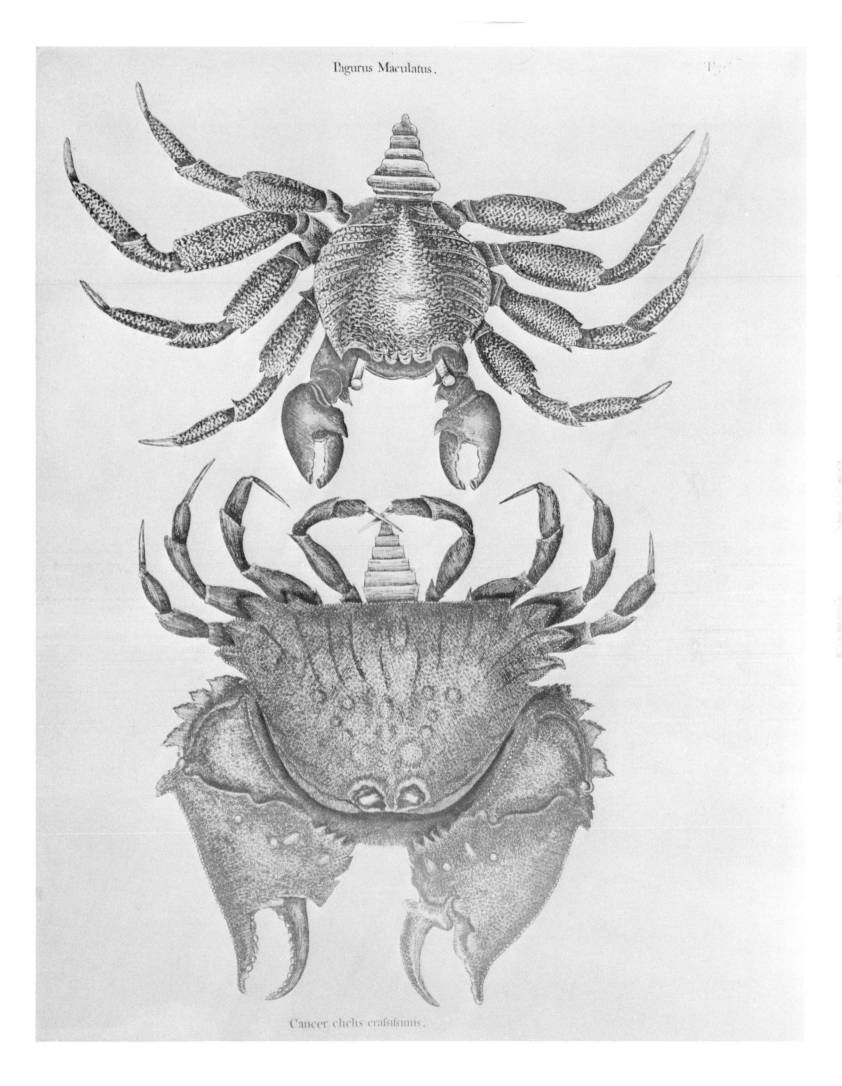

Cancer chelis crafsifsimis.

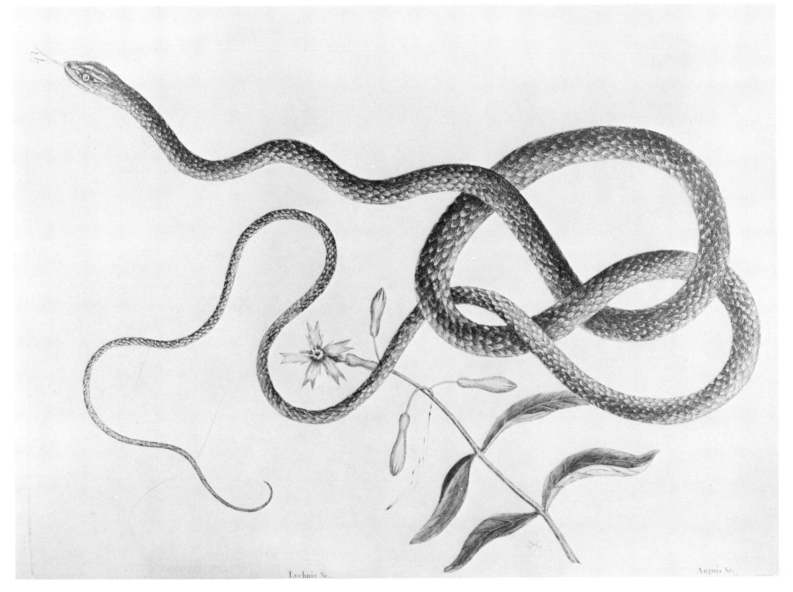

The Coach Whip Snake. *Ca. 1731–43. Hand-colored etching, 10″ × 13 3/4″.*

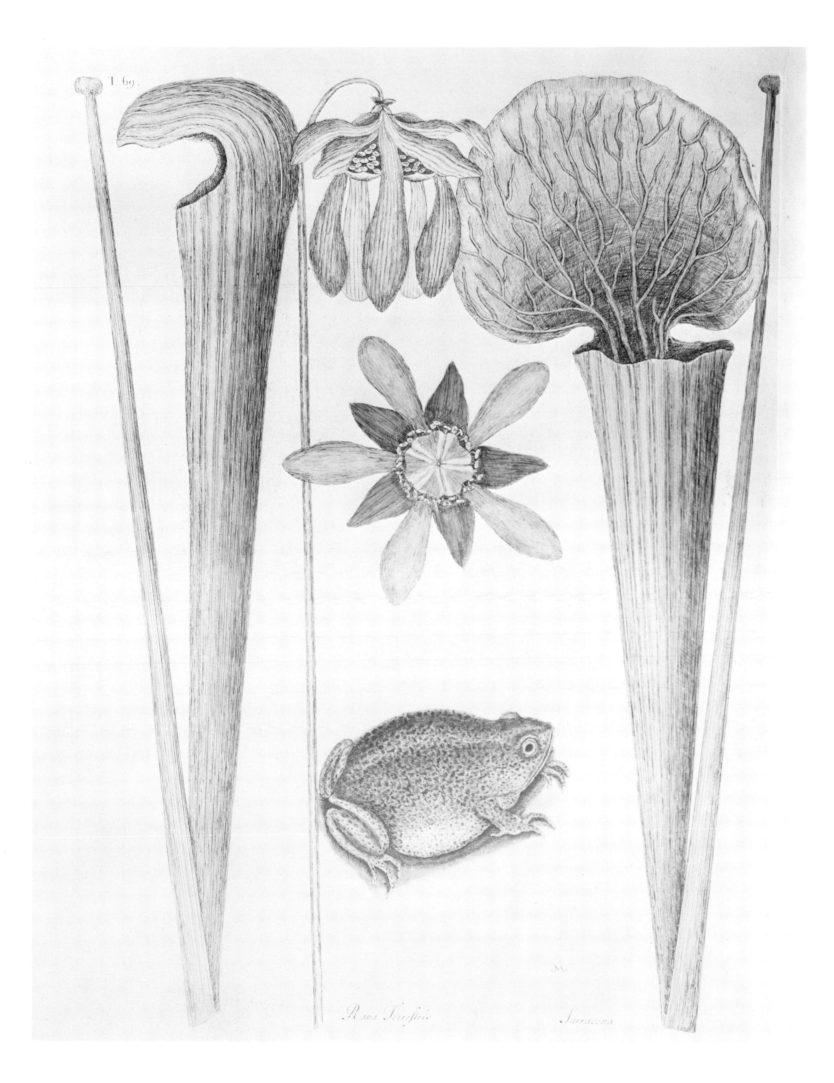

Alexander Wilson
1766 · 1813

(Preceding page)
Barn Owl.
*Detail of plate
shown on page 101.*

ALEXANDER WILSON contributed to the knowledge of American wildlife the first illustrated ornithology printed in America; an enormous undertaking that took him ten years to accomplish. Wilson was born July 6, 1766, in Seedhills, Paisley, Scotland, son of Alexander Wilson and Mary McNab. He was able to attend grammar school and to learn to read and write, but had to leave school in 1779 when his mother died; as with most Paisley men, he was indentured as a weaver. Even though he served his sister Mary's husband William Duncan for three years, and worked as a weaver for four more years after his apprentice period, Wilson hated the enclosed life led by the weavers and was also greatly disturbed by the labor conditions in the weaving industry.

Prompted by his love of nature, his pleasure outside the confines of the weaving shops, and influenced by the writing of his contemporary Robert Burns, Wilson expressed his feeling through poetry. His greatest desire was to achieve a reputation as a poet equal to Burns'. In order to further remove himself from the stifling life of the weaver, Wilson went into business as a peddler of his brother-in-law's woven goods. He often offered his own poems for sale along with the other goods he sold, but was unable to sell many of them in this manner.

In 1792 Wilson's lengthy poem *Watty and Meg, or The Wife Reformed, a Tale* was published anonymously. The success of this poem — especially the fact that some thought it the work of Burns — caused Wilson to expand his poetic efforts. His success was primarily with his more satirical works, and one of these was to influence his life decisively.

Having long been critical of the weaver's working conditions, Wilson wrote a satire concerning a well-known manufacturer, *Shark, or Lang Mills Detected.* Though it was published anonymously,

Wilson was accused of libel by the victim of his satire and was imprisoned during three months of court proceedings. Although Wilson was given the minor sentence of having to burn his poem on the steps of the jail, he was by this time so embittered with life in Scotland that he took a job as a weaver in order to save passage money. Accompanied by his nephew, William Duncan, he sailed from Belfast for America in February 1794.

Wilson arrived at New Castle, Delaware, in mid-July and was so anxious to set foot on American soil that he disembarked there with his nephew and walked to Wilmington that day. He continued toward Philadelphia, looking for work as he went. In a letter to his family shortly after his arrival, he related that there was no work to be found. He was surprised by the small number of weavers providing goods for the city of Philadelphia and that none of them needed journeyman help. He also spoke with awe of the profusion of new birds, fruits, shrubs, squirrels, and snakes he saw — all of which seemed richer in color or somehow different from the varieties he had known in Scotland.

At last Wilson was able to find work with John Aitkin, a copperplate printer in Philadelphia. He stayed there only a short time before joining Joshua Sullivan to weave, and then leaving this, he began peddling once again. Wilson lived in several Pennsylvania towns, sometimes working as a schoolteacher. He spent several years in Milestown, studying to expand his general knowledge as a teacher and spending his weekends working as a surveyor. He continued during these years to write poetry. He also became very interested in politics in America and was extremely impressed by Thomas Jefferson. When Jefferson was inaugurated on March 4, 1801, Wilson read his "Oration on Liberty" at the town's celebration.

Whenever the opportunity arose, Wilson spent time studying birds and other aspects of natural

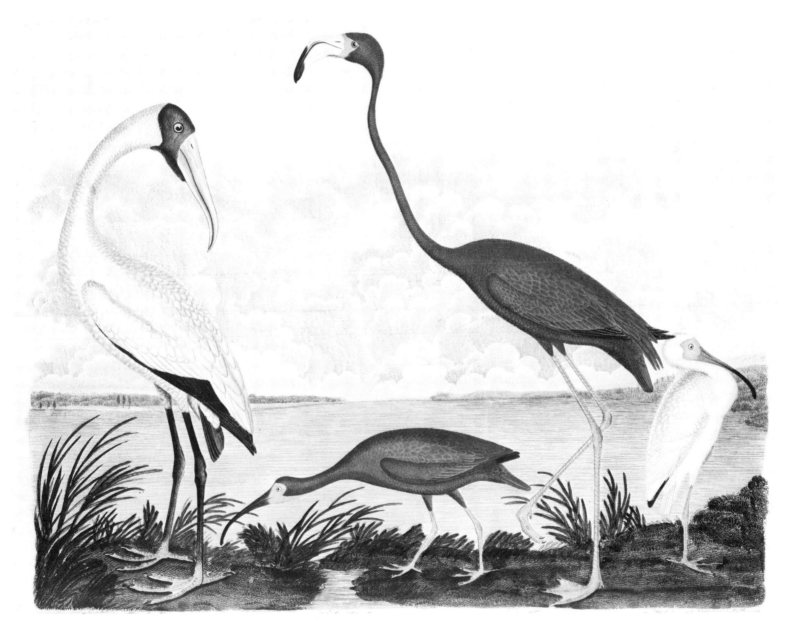

Wood Ibis *(left)*; Scarlet Ibis *(center)*; Flamingo *(right)*; White Ibis *(far right)*. *1814. Hand-colored engraving, 10 1/2″ × 13 3/4″.*

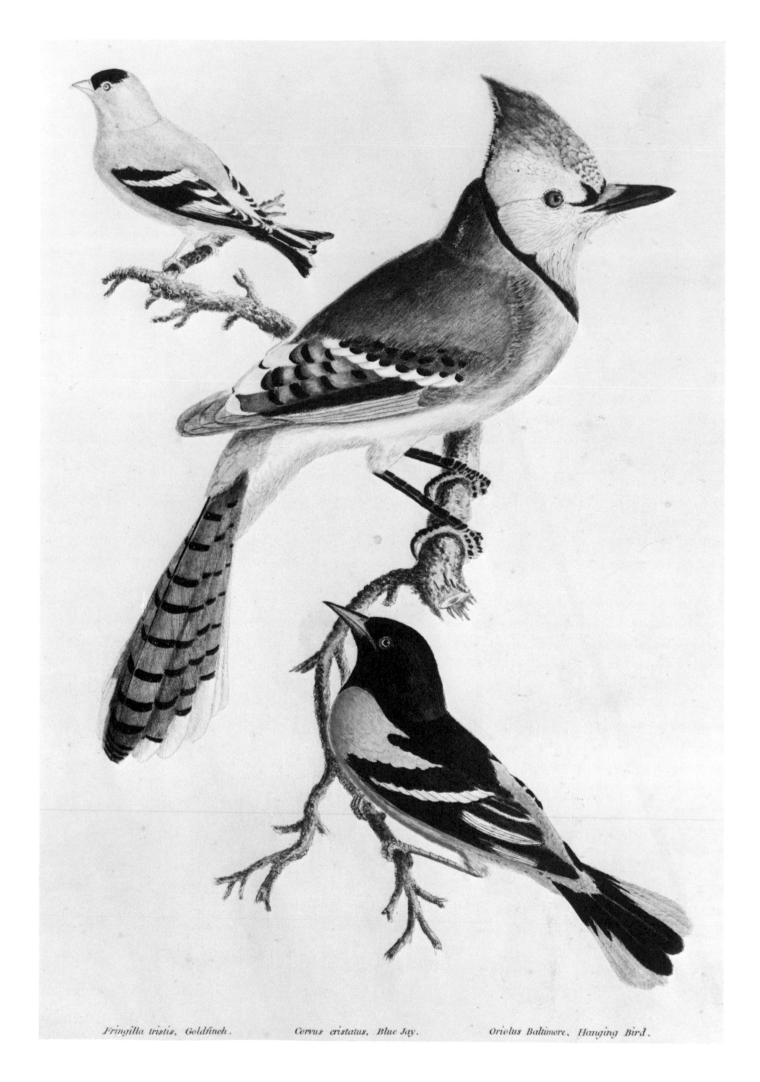

Fringilla tristis, Goldfinch. *Corvus cristatus, Blue Jay.* *Oriolus Baltimore, Hanging Bird.*

Goldfinch *(upper left)*;
Blue Jay *(center)*;
Hanging Bird *(lower right)*.
Ca. 1805. Hand-colored
etching, 13 5/8" × 8 3/4".

history. During a vacation, Wilson took a walking trip to the Finger Lakes region in New York to look at property his nephew was thinking of purchasing near Ithaca. Upon his return from this trip, Wilson settled in Bloomfield, New Jersey, where he was hired as village schoolmaster.

It is believed that he was in love with a married woman in Milestown and he may have left the area due to these circumstances. Whatever the case, he became a very melancholy, bitter man during this period. He wrote his good friend Charles Orr wishing he were back in Scotland—complaining of the pitifully small salary paid the schoolmaster of a village in comparison to the more lucrative position of the minister. Wilson's longing for fame as a poet was again expressed—he felt that his interest in nature expressed through his poetry was his only possibility for lasting renown.

He left Bloomfield the following year to accept another position as schoolteacher at Kingsessing, near Gray's Ferry, Pennsylvania. He became acquainted with his neighbor William Bartram and was thus able to study natural history both through the volumes in Bartram's library and the botanical specimens in Bartram's garden. William Bartram, son of the botanist John Bartram, had Mark Catesby's *Natural History* and the works on American birds by George Edwards in his library, all of which were of particular interest to Wilson.

Wilson spent many hours discussing what appeared in these books with William Bartram, both from the standpoint of text and of accuracy in the illustrations. Since Wilson had already spent much time studying birds throughout the areas in which he had worked and traveled, he was well aware of the fact that the existing works on American birds were in no way complete or wholly accurate. His interest increased, and he daily became more fired by the prospect of creating a work illustrating all of the birds of America with their life histories.

He began immediately to make notes and drawings, to collect birds, and to discuss identification with Bartram. In the spring of 1804 he sent two batches of drawings to Bartram for identification. Wilson was virtually educating himself as he progressed with his work. In October 1804 he began his walking trip to Niagara Falls, spending nearly two months accumulating material for his book, and basing his poem *The Foresters* on his experiences during this and his earlier trip to the Finger Lakes region. Upon his return he also sent two bird drawings and a drawing of Niagara Falls to President Thomas Jefferson who replied with thanks.

Wilson was encouraged by Bartram to apply to Jefferson for an appointment as one of the collectors on the Pike Expedition to the Mississippi, planned for 1806. Unfortunately, Pike's expedition was not sent at the time originally planned and Wilson was not able to be included. Any disappointment Wilson might have felt was tempered by an offer from Samuel Bradford of a job as Assistant Editor for the *Rees' New Cyclopaedia*. Wilson moved to Philadelphia, and in a letter to Bartram shortly after accepting the job in April 1806 he expressed his hope that his new employment would assist his efforts toward his proposed *Ornithology*. He also lamented the closed city life and longed for the pleasures of rural living close to nature.

His new security at Bradford's, although time consuming in its demands, was definitely an encouragement toward his goal. Bradford became interested in his work and agreed to publish it. By 1807 a prospectus for Wilson's *Ornithology* had been printed and was ready for distribution. Originally, Wilson planned to issue ten volumes, six to be devoted to land birds and four to contain water birds. Within these volumes Wilson did not plan to arrange birds by family, but merely to present them as they were prepared, each plate con-

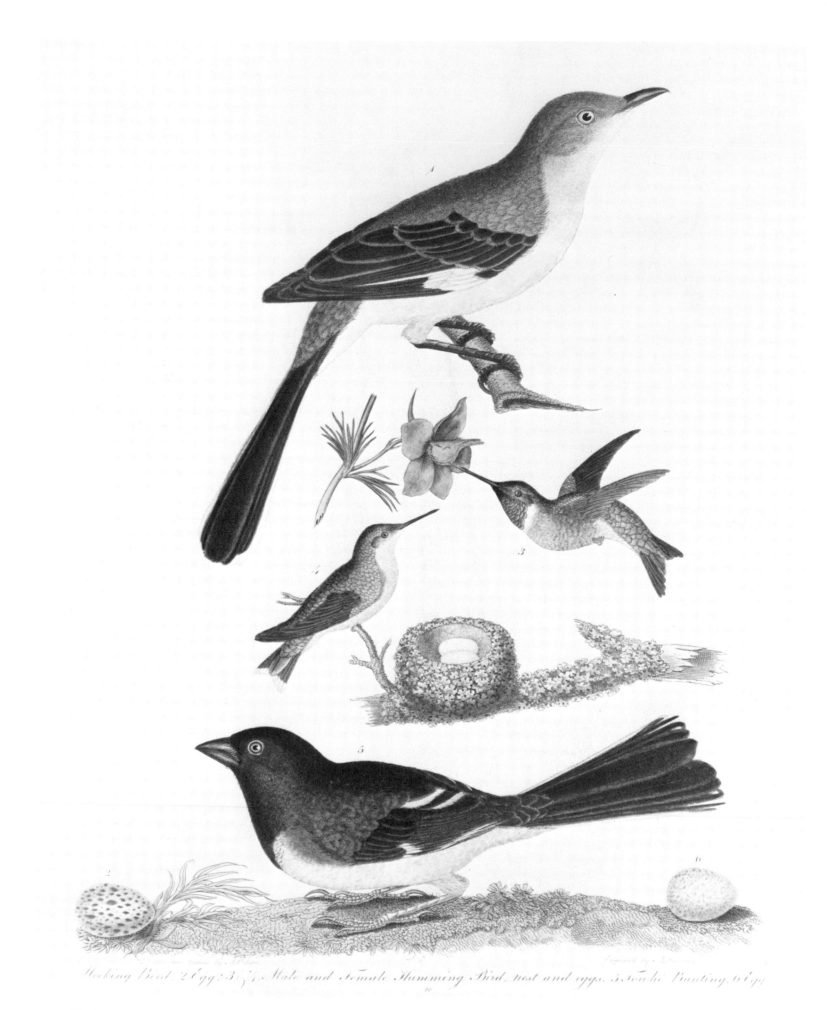

Mocking Bird *(1)*; Egg *(2)*; Male and Female Humming Bird, nest and eggs *(3–4)*; Towhe' Bunting *(5)*; Egg *(6)*. *Ca. 1810.*
Hand-colored etching and engraving, 12 3/4" × 9 13/16".

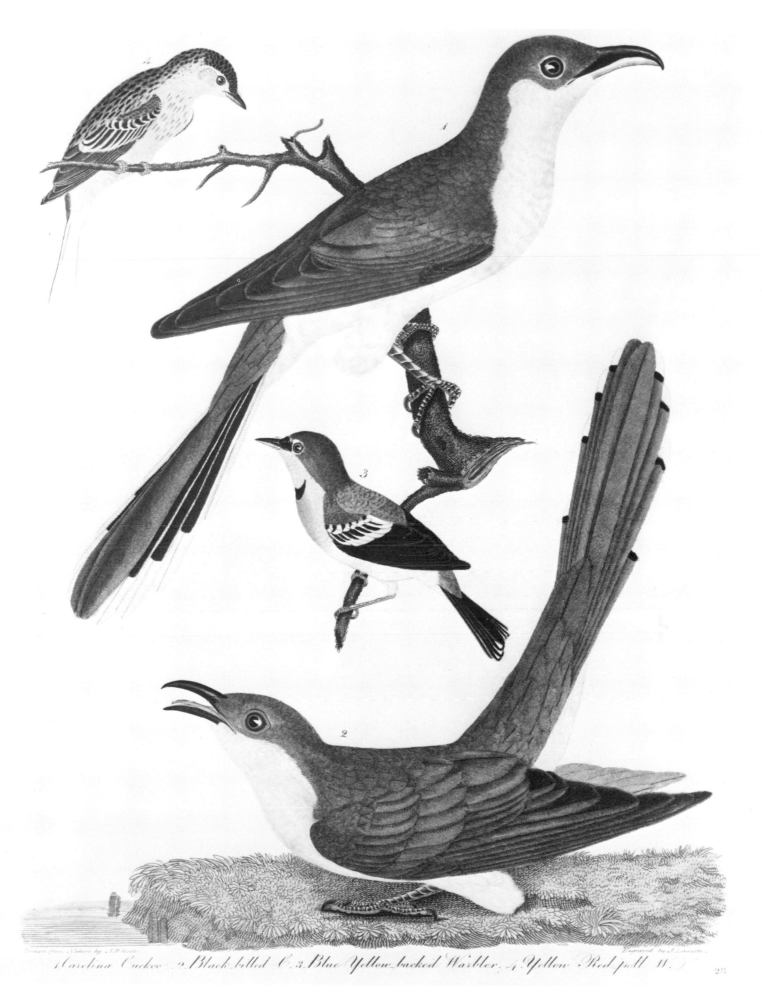

Carolina Cuckoo *(1)*; Black-billed Cuckoo *(2)*; Blue Yellow-backed Warbler *(3)*; Yellow Red-poll Warbler *(4). Ca. 1811.*
Hand-colored etching and engraving, 12 7/8" × 9 7/8".

taining a group of birds with the text on accompanying pages. Wilson did, however, include in the first volume a list of the orders and genera of birds; these he took from John Latham's work *A General Synopsis of Birds*.

The introductory remarks in each volume recount some of Wilson's ambitions, enthusiasms, and desires regarding the publication. His overall intention is set down in Volume I as follows: "Biased, almost from infancy, by a fondness for birds, and litle less than an enthusiast in my researches after them, I feel happy to communicate my observations to others. . . . To furnish instruction blended with amusement, to correct numerous errors by European writers, and to draw attention of fellow citizens from the discordant jarrings of politics to a contemplation of the grandeur, harmony and wonder of Nature."

Wilson was at first convinced that he could learn etching and, like Mark Catesby and George Edwards, produce his own plates. He went to his friend Alexander Lawson for instruction, and so great was his enthusiasm that he completed his first copperplate the day after his initial lesson and had Lawson print it for him. The result *Goldfinch; Blue Jay; Hanging Bird* (p. 84) was of such weak quality that it in no way approximated the strength of imagery Wilson had in mind. He attempted another plate, but the results were also very weak and he was at last convinced that only with the aid of an engraver could he achieve the desired effect in his illustrations. Because of the cost of paying engravers and colorists, it would have been impossible for Wilson to proceed without the backing of Samuel Bradford.

Wilson had developed his drawing ability during his early years at Gray's Ferry when his friend Lawson had suggested drawing as a cure for his melancholy. Bartram suggested Wilson draw birds rather than landscapes. Some of his early drawings are hesitant and tentative, amply conveying his lack of confidence in his work. However, he developed an ability to draw over the period in which he worked on the *Ornithology*. The drawings vary considerably in style from the free, bold brushwork of *Black Hawk* (p. 95) and *Ash-Colored Hawk* (p. 99), to the precise pencil and ink outline drawings such as *Little or Saw-whet Owl* (p. 94) and *Lewis' Woodpecker and Clark's Crow* (p. 25), used as models by the engravers, to the fluid handling of watercolor in the finished models for the plates *Whip-poor-will, male, female, and young* (p. 102), and *Black or surf Duck; Buffel-headed Duck, male, female, and young; Canada Goose; Tufted duck; Goldeneye; and Shoveller* (p. 96). Wilson produced many drawings and seems to have composed the plates by cutting the sketches apart and rearranging them until he was satisfied with the composition. The design was then passed to the engraver and the printed impressions were colored from Wilson's finished models as well as from specimens of the birds provided to the colorists or engravers by Wilson.

Almost all the engraving for the book was done by Alexander Lawson (1773–1846), a Philadelphia engraver who specialized in natural history subjects. Work on some of the plates was also done by John G. Warnicke (died 1818), especially some of the water bird plates. Other work was done by Benjamin Tanner, who worked with Warnicke, and by George Murray, who had worked on *Rees' Cyclopaedia* with Wilson. John Vallance did much of the lettering on the plates, and Wilson hired Joseph Brown to do much of the printing of the plates. The letterpress was printed separately by the company of Robert and William Carr. All the phases of the production of the book were under the general supervision of Wilson, who was also responsible for obtaining subscriptions to the book in order to support its publication.

Throughout the volumes there are many references to the book as an American production.

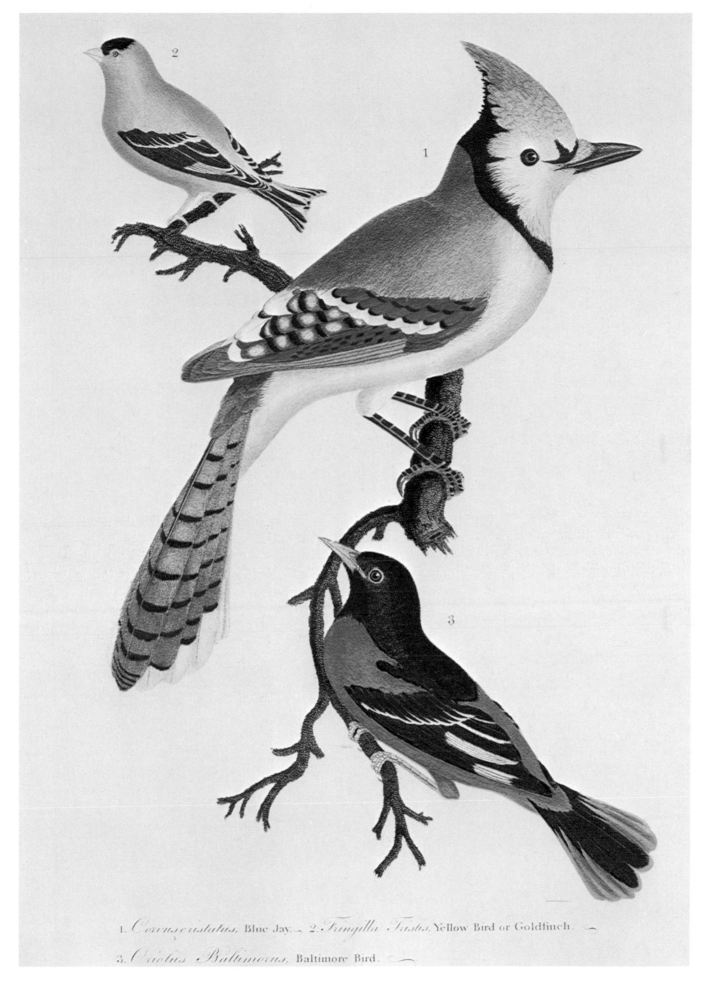

1. *Corvus cristatus*, Blue Jay. 2. *Fringilla Tristis*, Yellow Bird or Goldfinch.
3. *Oriolus Baltimorus*, Baltimore Bird.

Blue Jay *(1)*; Yellow-Bird or Goldfinch *(2)*; Baltimore Bird *(3)*. *Ca. 1808. Hand-colored etching and engraving, 13 13/16" × 8 13/16".*

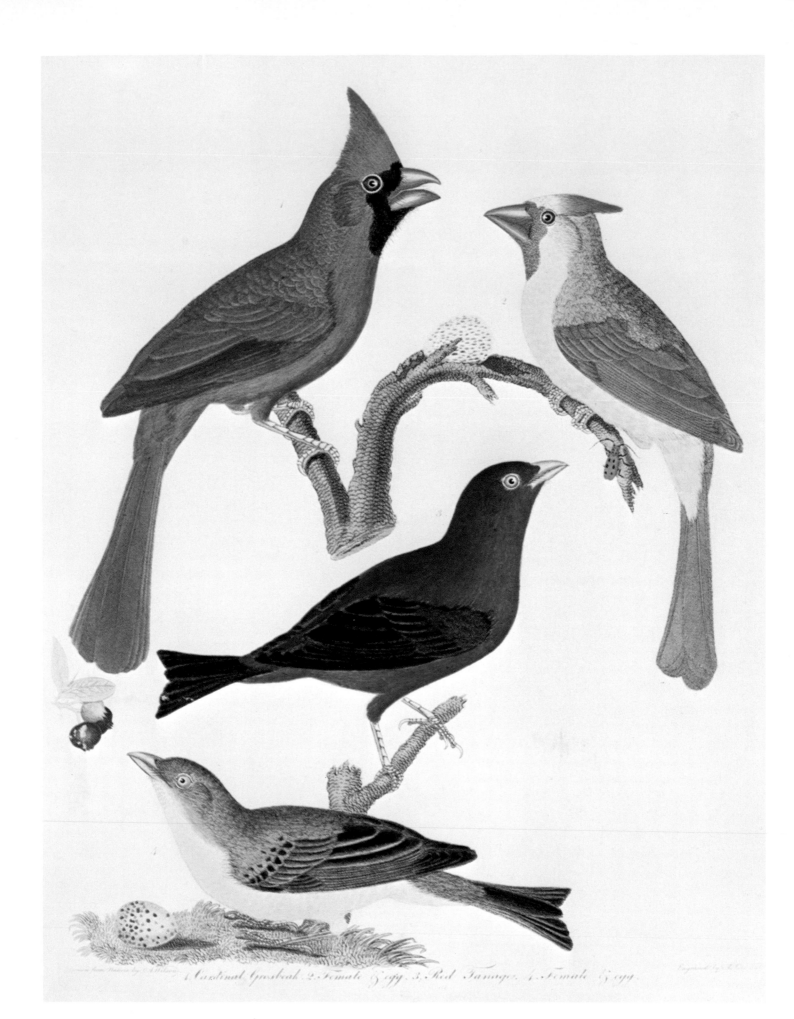

Cardinal Grosbeak *(1)*; Female and Egg *(2)*; Red Tanager *(3)*; Female and Egg *(4)*. *Ca. 1810. Hand-colored etching and engraving, 12 11/16″ × 9 3/4″.*

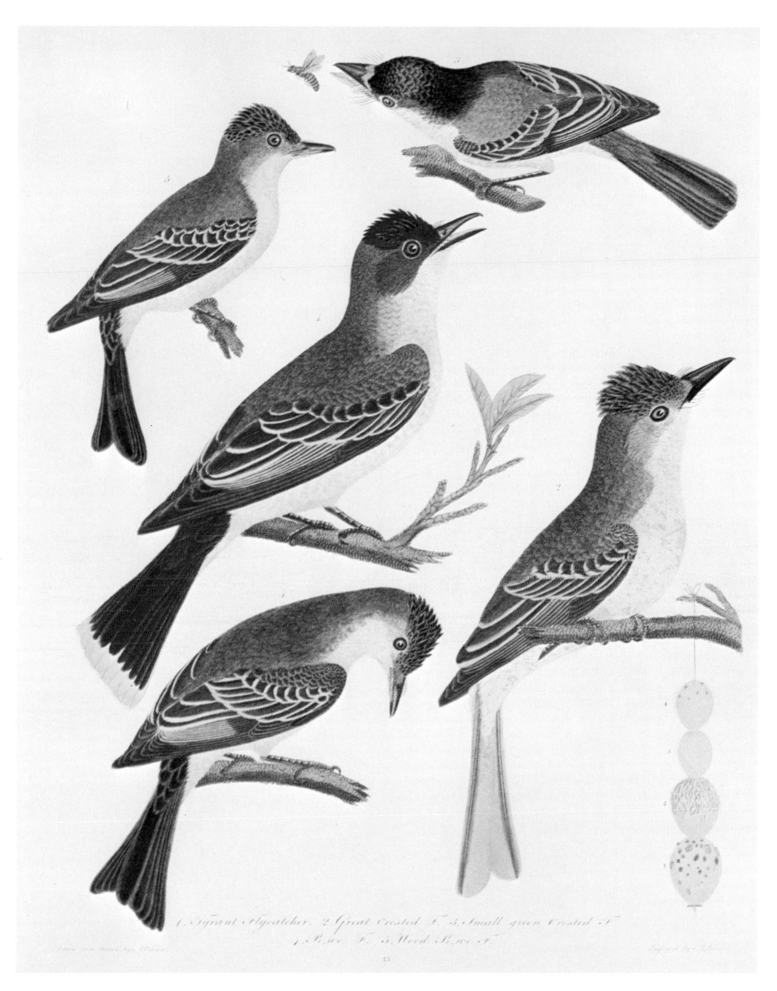

Tyrant Flycatcher *(1)*; Great crested Flycatcher *(2)*; Small green crested Flycatcher *(3)*; Pe-We Flycatcher *(4)*; Wood Pe-We
Flycatcher *(5). Ca. 1810. Hand-colored etching and engraving, 12 7/8" × 9 15/16".*

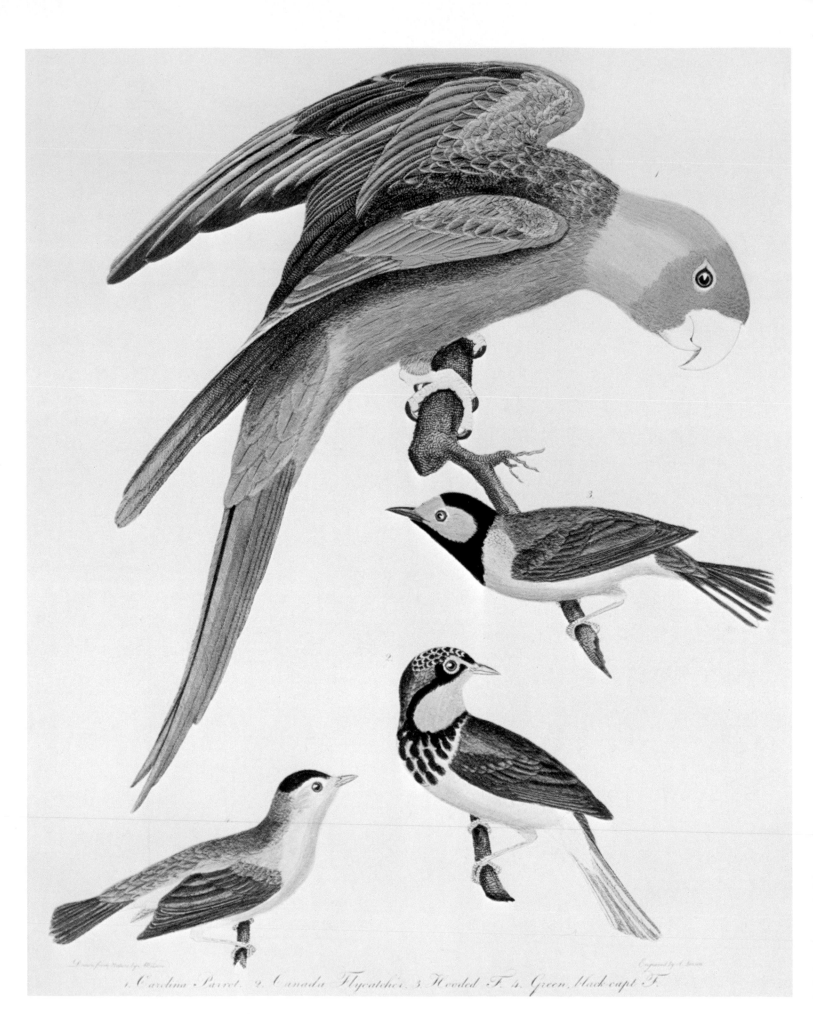

Carolina Parrot *(1)*; Canada Flycatcher *(2)*; Hooded Flycatcher *(3)*; Green, black-capt Flycatcher *(4)*. *Ca. 1811. Hand-colored etching and engraving, 13″ × 10″.*

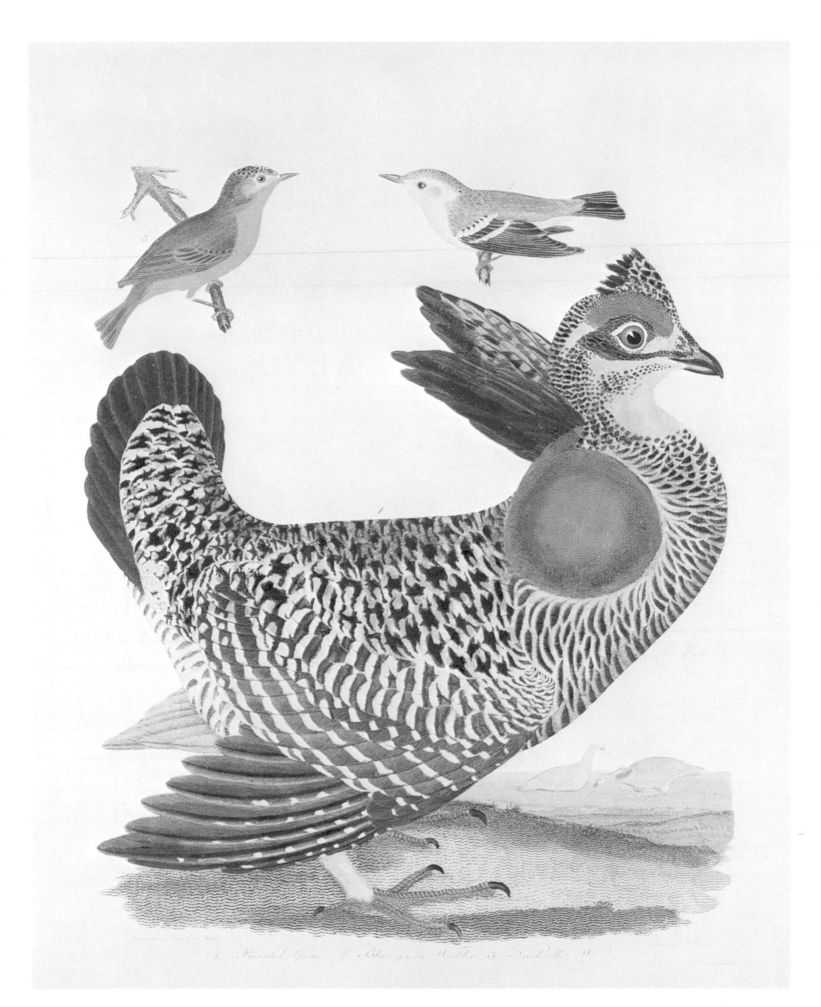

Pinnated Grous *(1)*; Blue-green Warbler *(2)*; Nashville Warbler *(3)*. *Ca. 1811. Hand-colored etching and engraving, 12 5/8″ × 10 1/2″.*

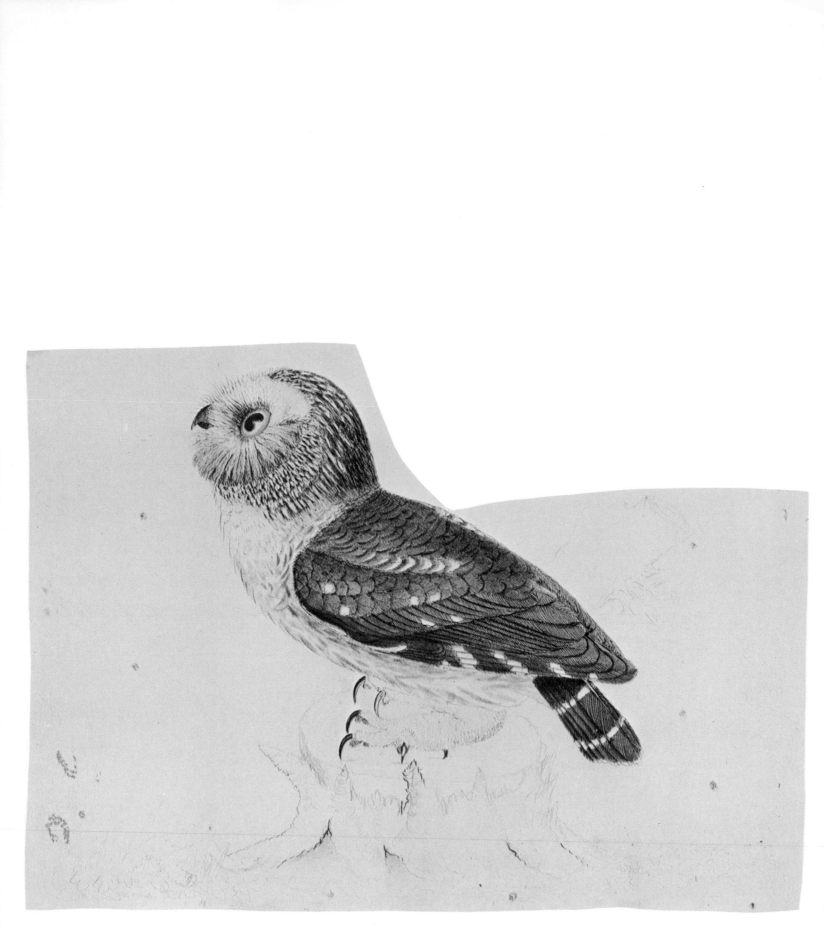

Little or Saw-whet Owl. *Ca. 1811. Pencil, ink, and watercolor on paper, 7 1/2″ × 10 5/8″ (irregular sheet).*

Black Hawk. Ca. 1812. Pencil, ink, and watercolor on paper, 19″ × *11 1/2″*.

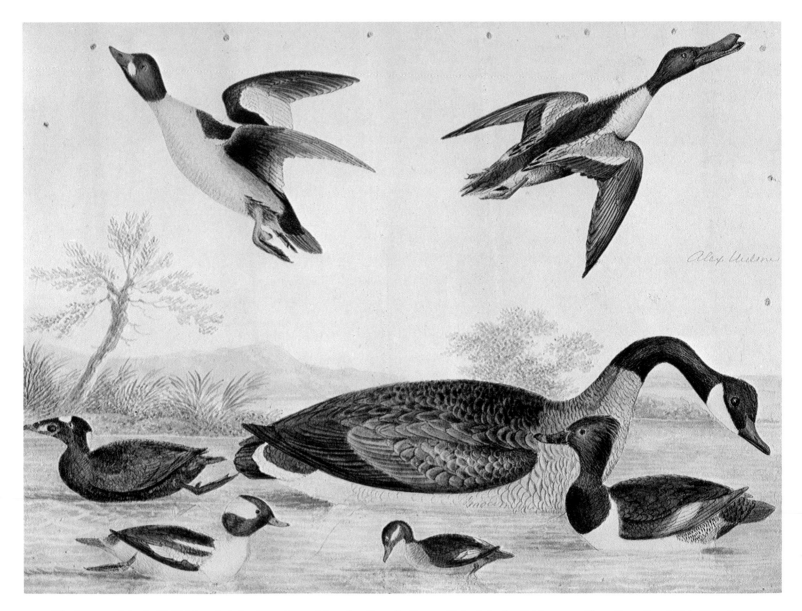

Black or surf duck; Buffel-headed duck, male and female; Canada Goose; Tufted duck; Golden eye; Shoveller. *Ca. 1814. Pencil, ink, and watercolor on paper, 10″ × 13 1/4″.*

Wilson discusses this most extensively in the Preface to his second volume. He thought that it was extremely important for America to develop capabilities and not be reliant on Europe. He felt quite strongly that his work would be of significance to every American because the love of country and its natural wealth was an integral part of American culture—the tie between men not bound together by racial ties or by ancient loyalties to kings. Wilson asked in the Preface for the assistant of all those who were interested in the subject of ornithology to contact him through letters or to send him specimens. "By such combined exertions and reciprocity of information we shall do honour to this branch of science and be enabled to escape in part that transatlantic and humiliating reproach of being obliged to apply to Europe for an account and description of the productions of our own country."

After the publication of Volume I of *American Ornithology: Or the Natural History of the Birds of America* in September 1808, Wilson began his first trip to solicit subscriptions to the book and to continue searching for new birds for future volumes. He traveled through Pennsylvania and to Boston, collecting much praise if not subscribers, as the price was $120 for each set. Wilson continued to travel through the coastal cities as far south as Savannah, Georgia, enjoying the opportunity to reinvestigate Mark Catesby's territory.

In Savannah, Wilson met John Abbot, an entomologist with a strong interest in birds. Abbot had a large collection of drawings of birds he had seen or collected, and an active correspondence developed between Abbot and Wilson during the following years. While in Savannah, Wilson became ill, so he returned to New York by boat. He had collected 250 subscribers during the three months he was on the road.

Wilson made plans for another extended selling-collecting trip during the autumn of 1809,

after he completed work on Volume II. He planned to travel across Pennsylvania on foot to Pittsburgh, down the Ohio by boat to Louisville, Kentucky, and from there by horseback to New Orleans. Wilson left Philadelphia in the latter part of January 1810 and walked to Pittsburgh, arriving February 15. He felt that walking was not only the cheapest method of travel but also enabled him to examine more of the countryside, gather material for his book, and stop whenever he wished to seek subscribers. It is said that he prepared for these trips well in advance by walking further and further from his home until he could cover twenty miles a day without fatigue. Wilson also extolled the health virtues of being out of doors. After signing nineteen new subscribers and hearing that the roads were impassable, he bought a boat, named it *The Ornithologist,* and left Pittsburgh on February 23, 1810, to follow the Ohio past Cincinnati to Louisville. During the voyage he covered 720 miles; this included numerous stops and side trips along the way to visit such sites of interest as Indian villages and the place where mammoths had been found, or to follow a flock of turkeys in the hopes of capturing one of them. He also entertained himself by composing a long poem, *The Pilgrim.*

Arriving in Louisville, Wilson sold his skiff and took a room at a local tavern. On March 19, 1810, he went to a store in Louisville and gave his sales talk to the owner, who almost subscribed to Wilson's book. However, the owner, John James Audubon, was stopped by his partner, Ferdinand Rosier, who suggested that Audubon's own work was of sufficient caliber to also warrant publication. The men showed each other their work, probably hunted together on the twenty-first, and on the twenty-third of March, Wilson left Louisville. Many years later a controversy concerning their meeting was generated by accusations made against Audubon by Wilson's executor. The con-

troversy was encouraged by Audubon's own doubt-ful recollection of precisely what had occurred during that meeting twenty years past, as he wrote in reply to the accusations against him.

If the meeting changed anything for Wilson, it was to increase his determination to complete his work more quickly. He previously had no indica-tion that anyone else had embarked upon a project in any way similar to his own. Moving south by horseback toward New Orleans, Wilson stopped at Nashville to send a large shipment of drawings and notes to Lawson; however, this package — much of it material on new birds — was never received in Philadelphia. Wilson then spent a week at Bowling Green looking for new birds and paid for his lodging by giving drawing lessons to the owner's daughters. Wilson moved on to Natchez about mid-May, where he canceled an in-tended journey to St. Louis due to heavy rains. Having sold twelve more subscriptions, Wilson rode on through Choctaw and Chukkasaw territory toward New Orleans. From here, he returned to Philadelphia by boat in the fall of 1810.

Wilson's lengthy journeys were now over, and he made only short trips to complete his work on water birds. All his activity and exertions were to be expended on writing and drawing from now until his death. During 1811 he published Vol-umes III and IV, followed the next year by Vol-umes V and VI. In April 1813 work on Volume VII was completed. It was at this point that Wil-son decided to shorten the proposed series to nine volumes, and due to rising costs and dissatisfac-tion with their work, he dismissed his colorists and began to complete more of the work on his own. The increased pressures of this exacting job were to add to Wilson's already deteriorating physical condition.

Wilson kept pushing himself to complete more and more work until he finally collapsed from dysentery and died on August 23, 1813. Volume VIII, which included material from his trip to Great Egg Harbor, New Jersey, was nearly com-plete, and some notes and drawings, intended for Volume IX, existed. Wilson had asked that he be buried where birds could sing over his grave, and his executors, George Ord and Sarah Miller, ar-ranged for his burial in the churchyard of Old Swede's Church in Philadelphia.

Ord, a businessman and one of the founders of the Academy of Natural Sciences of Philadelphia in 1812, was also a naturalist who had written several articles of his own. He assumed responsi-bility for the completion of Wilson's book, and though his work on Volume VIII was primarily a matter of editing, much of Volume IX is Ord's writing. Notes for a number of the species de-picted were scant and Ord filled out the text with his own observations. He also added a biography of Wilson to the final volume.

Within a ten year period not devoted solely to his book, Wilson had accomplished a truly as-tounding amount of work. He traveled much more widely than had Catesby—north to New England, south to Savannah, Georgia, and as far west as New Orleans. He had found and named numerous birds never before noted, such as the Mississippi kite (p. 104), and had included in his book many specimens brought to him from the far west by Meriwether Lewis, following the Lewis and Clark expedition. In the 76 plates included in his book, Wilson portrayed more than three-quarters of the species of birds known to have existed in America at that time. His work would be overshadowed by the monumental vision of John James Audubon by mid-century, yet the text of Wilson's book was of major scientific importance. Wilson paved the way for much of what would follow, and the excel-lence of his contributions brought Wilson the dis-tinction of being considered the Father of Ameri-can Ornithology.

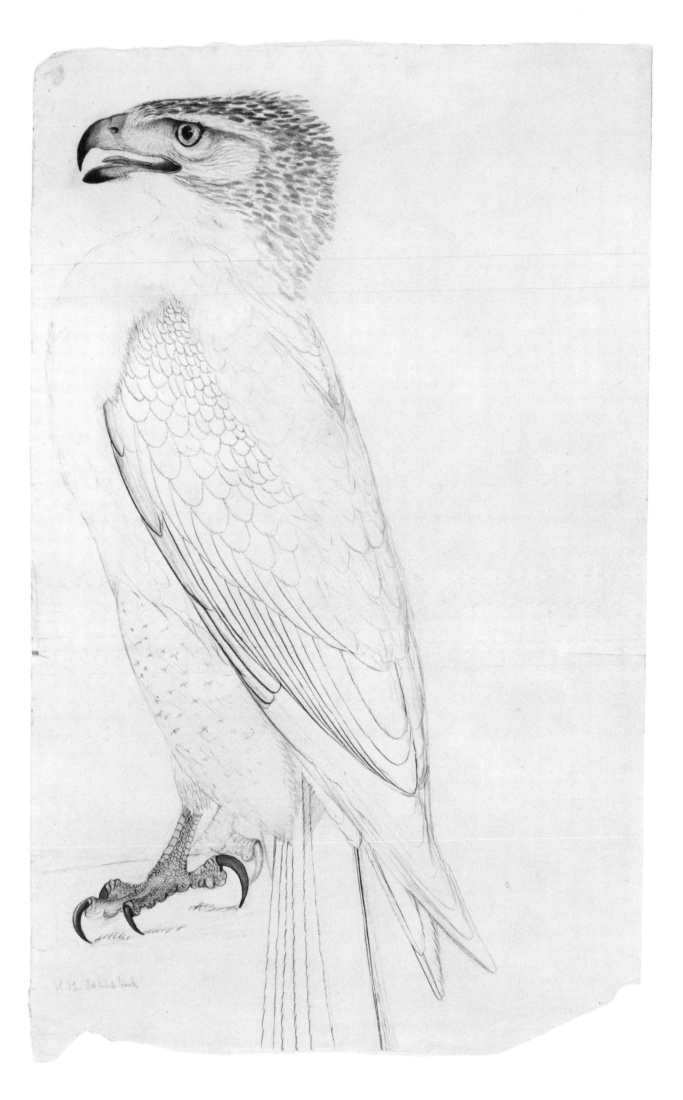

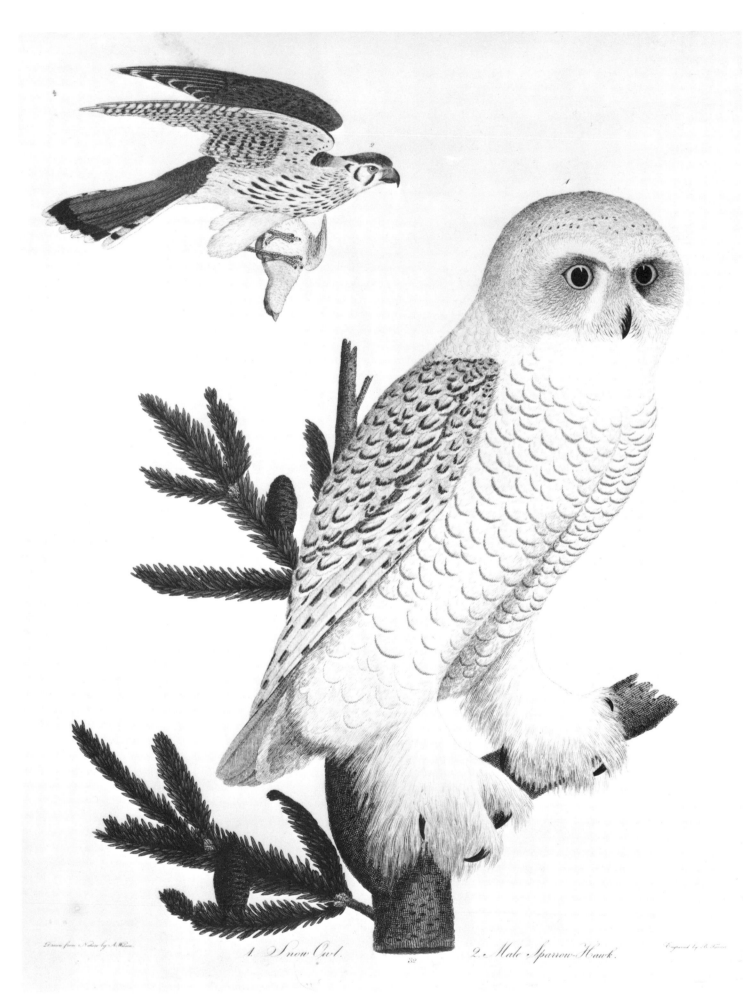

Snow Owl *(1)*; Male Sparrow Hawk *(2)*. *1811. Hand-colored engraving, 13 3/4" × 10 1/2".*

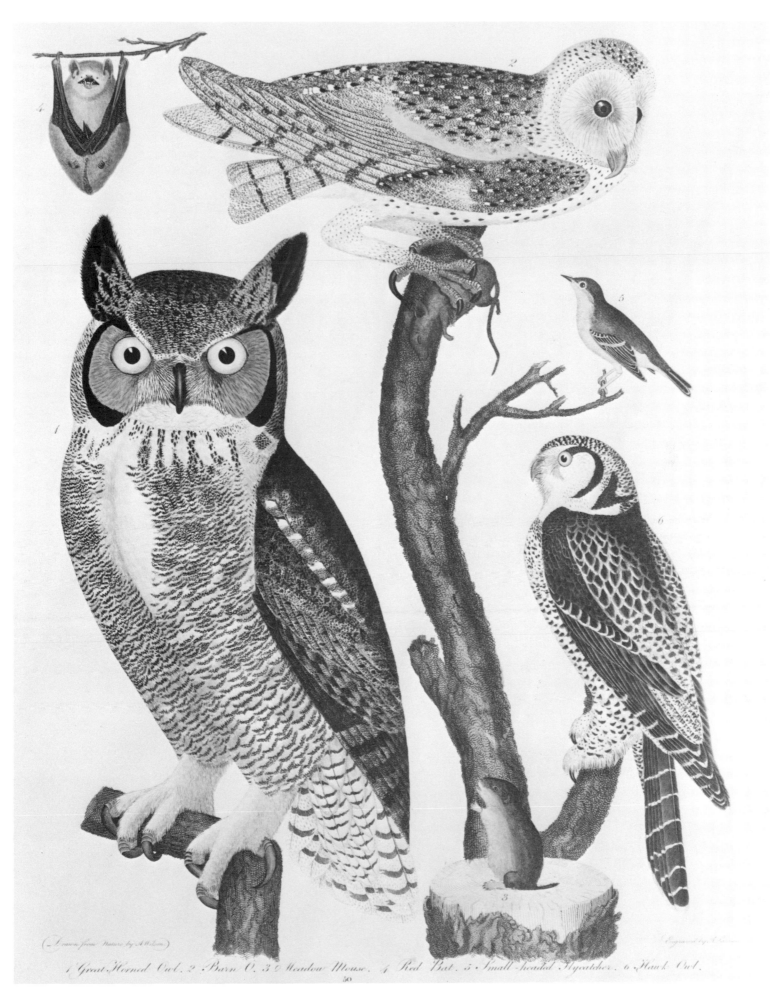

Great Horned Owl *(1)*; Barn Owl *(2)*; Meadow Mouse *(3)*; Red Bat *(4)*; Small-headed Flycatcher *(5)*; Hawk Owl *(6)*. *Ca*. *1812*. *Hand-colored etching and engraving, 13 3/8″ × 10 1/4″.*

by Alex Wilson

Whip-poor-will, male *(top)*,
female *(center)*, and young *(bottom)*.
*Ca. 1812. Pencil, ink, and watercolor
on paper, 13 1/4″ × 10″.*

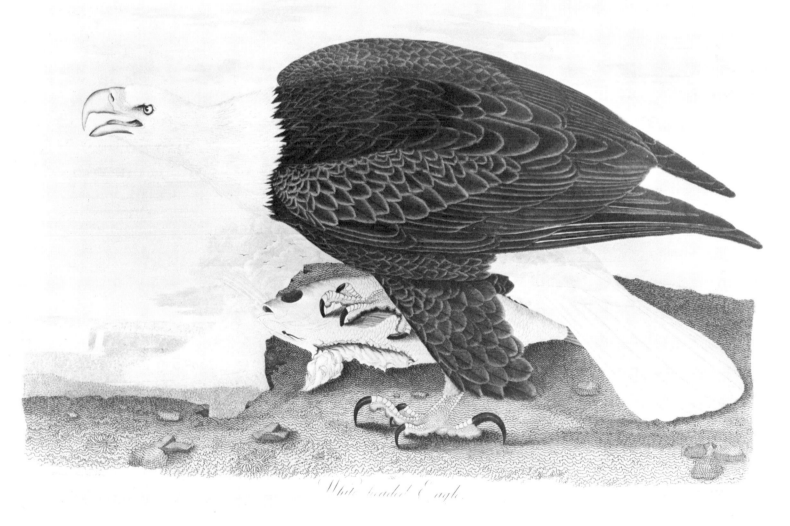

White-headed Eagle. *Ca. 1811. Hand-colored etching and engraving, 10 3/16″ × 13 3/8″.*

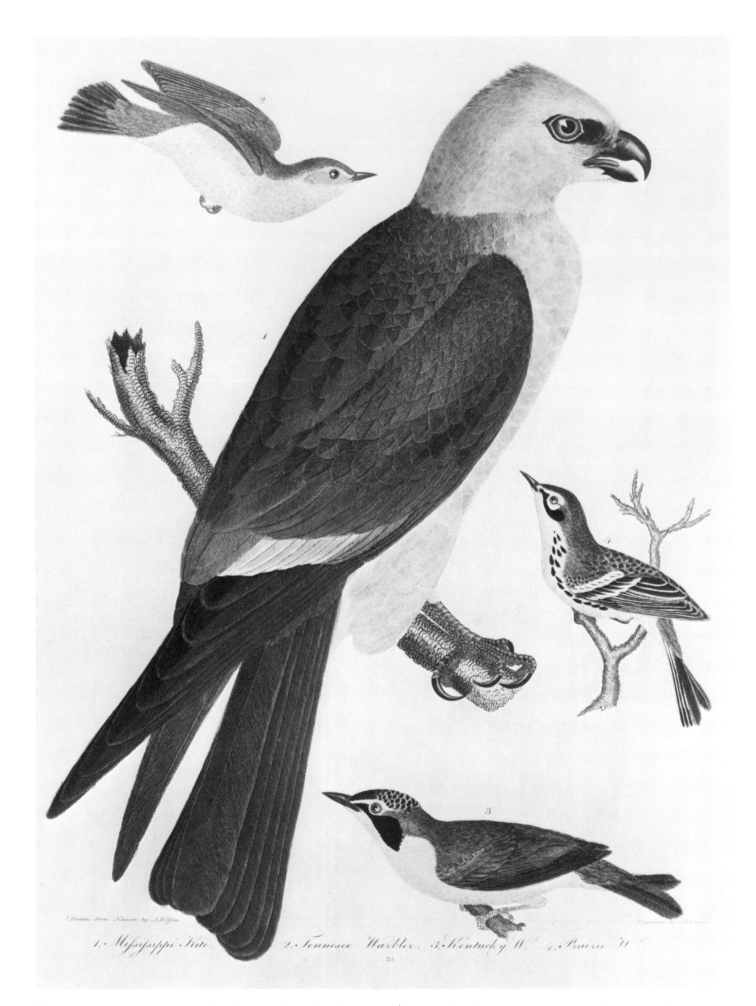

Mississippi Kite *(1)*; Tennessee Warbler *(2)*; Kentucky Warbler *(3)*; Prairie Warbler *(4)*. *Ca. 1811. Hand-colored etching and engraving, 12 7/8″ × 9 7/8″.*

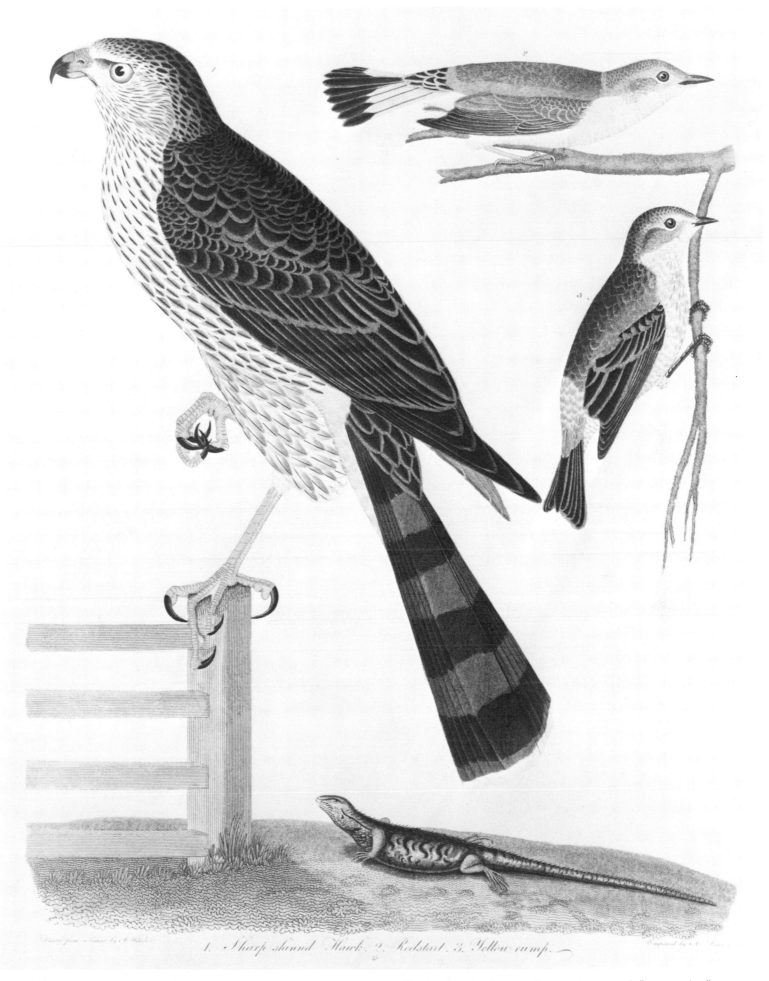

1. *Sharp-shinn'd Hawk.* 2. *Redstart.* 3. *Yellow-rump.*

Sharp-shinn'd Hawk *(1)*; Redstart *(2)*; Yellow-rump *(3)*. *Ca. 1812. Hand-colored etching and engraving, 13 3/8″ × 10 5/16″.*

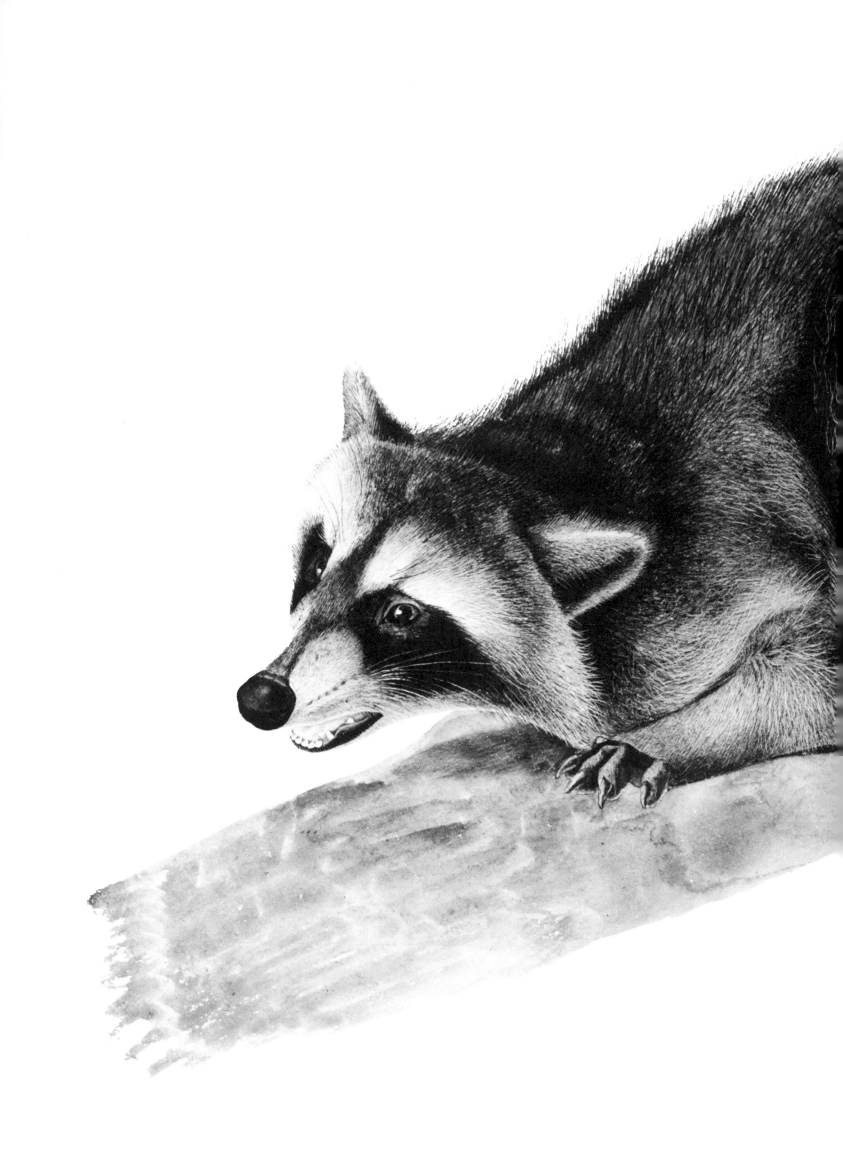

JOHN JAMES AUDUBON, whose dramatic and elegant portrayals of birds and quadrupeds would become classics of American art, was born at Les Cayes, Saint-Domingue, on April 26, 1785, the son of Jean Audubon and Jeanne Rabine. Mlle. Rabine died in November 1785, having been ill since before Audubon's birth. Audubon's father, who had served in the French Navy during the American Revolution, owned a plantation in Saint-Domingue and carried cargo on his own ships between the island and France. His wife, Anne Moynet, who had remained in France during Jean Audubon's years of work in Saint-Domingue, agreed to adopt his son and daughter three years after they arrived in Nantes, having barely escaped the uprising against whites on the island in 1791. Reared in Nantes, Jean-Jacques Fougère Audubon went to Rochefort-sur-Mer Arsenal between 1796 and 1800 for Navy training.

In 1803 Audubon was sent to America to help oversee the property his father had purchased in 1789 at Mill Grove, near Philadelphia. Instead of concentrating on his job, Audubon spent his time hunting, collecting, and drawing animal and bird specimens. He slowly developed his ability to handle watercolors and chalks, and he devised a method of posing freshly killed birds with wires in order to maintain their lifelike appearance.

It was also during this period that Audubon met Lucy Bakewell, the daughter of his neighbor William Bakewell. While Audubon courted Lucy and went hunting, his father continued to press for his attention to the work needed on the mines and property at Mill Grove, and to discourage his ideas of marriage until Audubon accumulated wealth of his own.

When Audubon returned to America after a trip to France in 1805, he brought with him Ferdinand Rozier, his partner for a planned business venture. Both Audubon and Rozier took jobs in the Fall of 1806 to learn business procedures, but Audubon did not apply himself to his work and at the same time lost money on bad investments. He continued to draw birds and to learn more about taxidermy. In late August 1807, Audubon and Rozier left for Louisville, Kentucky, with plans to open a retail store in this busy Ohio River settlement. Audubon, who liked to think of himself as an American woodsman, was very happy with the prospect of life on the frontier. The opportunity for hunting and the proximity of many men with similar interests increased his enthusiasm for the venture. Even though the business suffered due to the passage of the Embargo Act of 1807, Audubon returned to Pennsylvania to marry Lucy Bakewell on April 5, 1808.

While Rozier continued to worry about the business, Audubon rambled the woods hunting and drawing as much as canvassing the area. He completed many works such as the *Belted Kingfisher* (p. 135). The business continued to fail, and a move to Red Banks (now Henderson), Kentucky, in the summer of 1809 was followed that December by a move to Ste. Genevieve near St. Louis. Lucy and their son Victor Gifford, who was born June 12, 1809, remained near Red Banks with Dr. and Mrs. Adam Rankin. Lucy supported Victor and herself by tutoring the Rankin children. Even after Audubon dissolved his partnership with Rozier in April 1811 and returned to Red Banks, Lucy remained with the Rankins until Audubon could open a new store. Unfortunately, Audubon turned over much of the business duties to his clerks and spent most of his time hunting, drawing, or with Lucy and his son. His *Carolina Parrot* (p. 92) which dates from this period was a forerunner of the more complicated design he produced in 1825 and used as a model for the plate in his book. The financial situation became progressively worse, and when Lucy's brother Thomas visited them and suggested a joint venture.

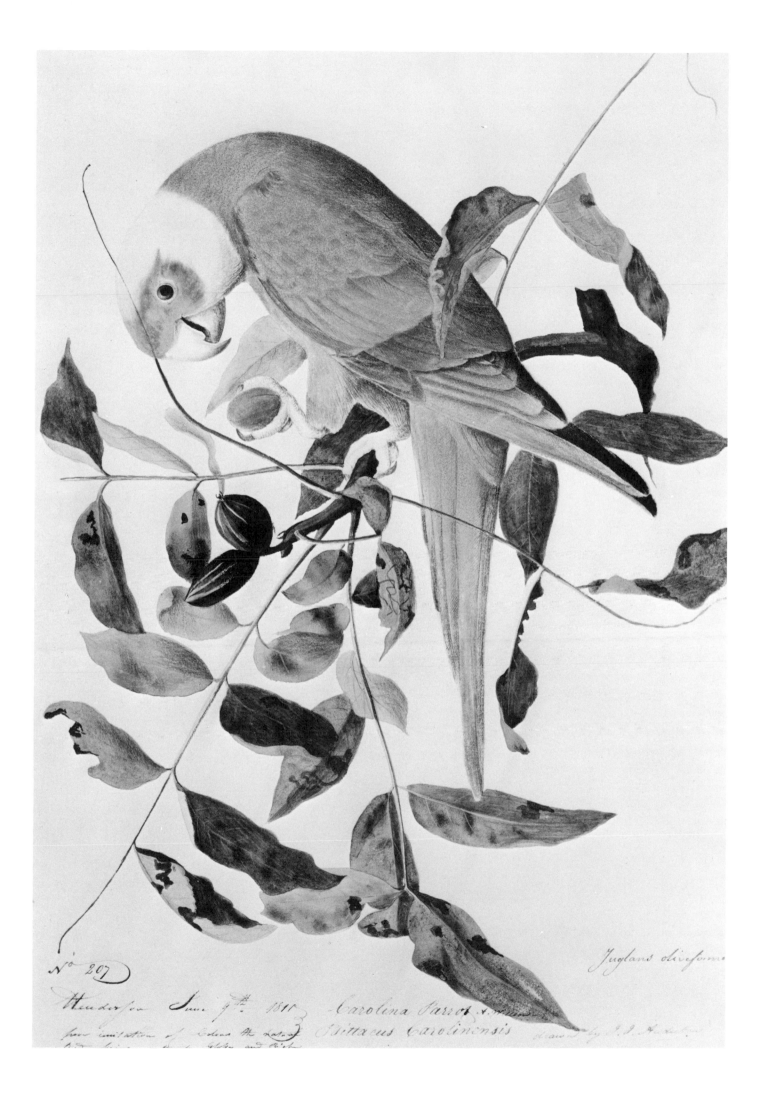

Juglans olivæformis

Nº 207

Henderson June 9th 1811 Carolina Parrot...
fine imitation of ... Psittacus Carolinensis drawn by J. J. ...

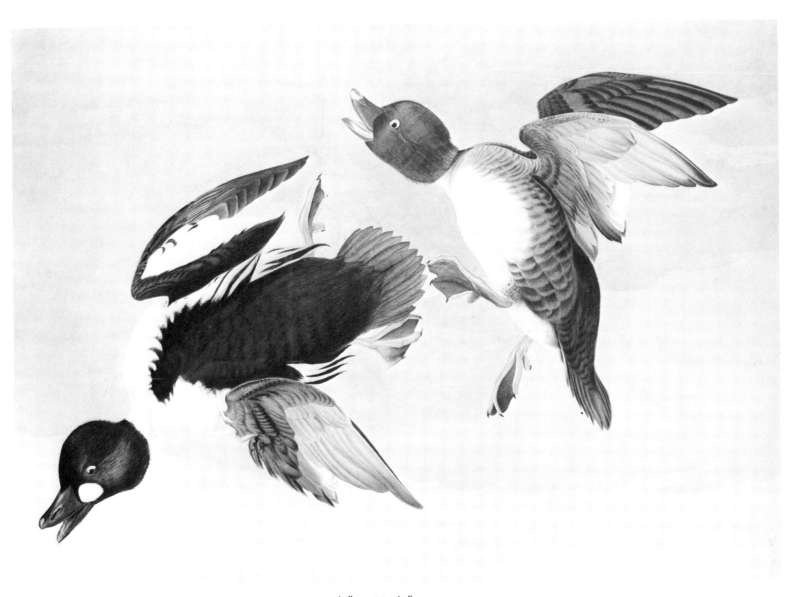

Common Goldeneye. *1834. Watercolor on paper, 21 1/4" × 29 5/8".*

Nᵒ 10.
Plate 49.
(119)

Yellow Throated Vireo. ———— Male
Vireo flavifrons. —
Plant vulgo Swamp Snow-ball.
Hydrangea quercifolia

Drawn from Nature by John J. Audubon
James' Bayou Plantation, Louisiana. July 11th 1825.

Audubon took Lucy and Victor to Fatland Ford, Pennsylvania, to stay with Lucy's father. Audubon obtained a loan and left to join Thomas Bakewell in New Orleans, however he stopped in Kentucky and returned to Pennsylvania. Back in Fatland Ford, he continued to add to his collection of bird drawings. And in January 1812 he took the opportunity to renew his acquaintance with Alexander Wilson, who took Audubon to see Rembrandt Peale's studio in Philadelphia. Also during this year, Audubon became a naturalized U.S. citizen.

The dangerous situation resulting from the War of 1812 caused Audubon to return to Red Banks with his family. He was doubly discouraged to find his entire store of drawings left at Red Banks virtually destroyed by rats and to learn that the New Orleans business had failed. Some happiness was derived from the birth of a second son, John Woodhouse, on November 30, 1812. But Audubon's situation totally disintegrated in 1819 when his financial problems, increasing over the years due to bad investments and commercial difficulties, precipitated the collapse of the milling business he had opened in 1813. Jailed for debt, he was forced to file bankruptcy. He left his wife, sons, and ailing infant daughter, Rose, and moved to Louisville, where he made a small income from commissions for chalk portraits and from teaching drawing. A temporary job in 1820 as taxidermist at the Western Museum of Cincinnati College did not even provide him a regular salary, and when Lucy joined Audubon in Cincinnati following the death of their daughter Rose (their first daughter, Lucy, died in 1817), she again took a teaching job.

Audubon had spent a great deal of time during his difficult years trying to replace the drawings destroyed in 1812. After obtaining some income by giving art classes, he left Cincinnati in 1820 with Joseph Mason, one of his pupils, to travel the South. Audubon had at last decided that his only chance for success depended on publishing his bird drawings. He spent most of 1820 working his way toward New Orleans, where he tried for a position as artist on the Red River Survey Expedition. Barely able to support himself by executing portraits, Audubon was rescued by the offer of a position as drawing instructor for Eliza Pirrie at Oakley plantation, northwest of New Orleans. During the latter half of 1821, Audubon reacted to the more relaxed atmosphere, the security of his job, and his freedom to work by producing some of his strongest bird portraiture to date. The *Yellow-throated Vireo* (p. 111) was painted just three months after he completed the *Purple Gallinule* (p. 113). In the year following, he was joined by Lucy, and with both of them teaching they were able to support themselves and Joseph Mason; Audubon continued to work both in New Orleans and in Natchez on increasing the number of drawings in his portfolio. During 1822, with Mason adding most of the botanical specimens to the designs, Audubon completed *Traill's Flycatcher* (p. 130), the *Red-winged Blackbird* (p. 29), the drawing for the plate *Black-bellied Darter* (p. 138), and the dramatic encounter between the *Chuck-will's-widow* and the deadly coral snake (p. 114). Audubon was rapidly improving in his approach to composition and in his ability to manipulate his media to achieve the soft qualities of the feathers as well as the variety of textures found in legs, talons, beaks, and eyes.

After a long series of disappointments, difficulties, and problems, Audubon, with Lucy's encouragement, left for Philadelphia in search of a publisher for his work. He was unfortunate enough to arrive there in 1824, just as George Ord was preparing another edition of Alexander Wilson's *American Ornithology* for publication. It is evident that Ord did not want to encourage a rival to Wilson's work, nor did Wilson's engraver, Alexander Lawson, wish to assist Audubon. Both

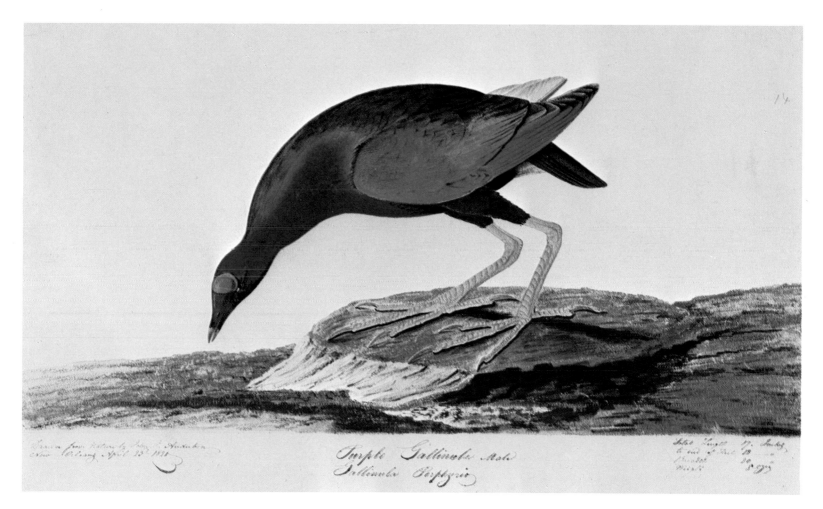

Purple Gallinule. *1821. Pencil, pastel, and watercolor on paper, 12 1/4" × 19 1/4".*

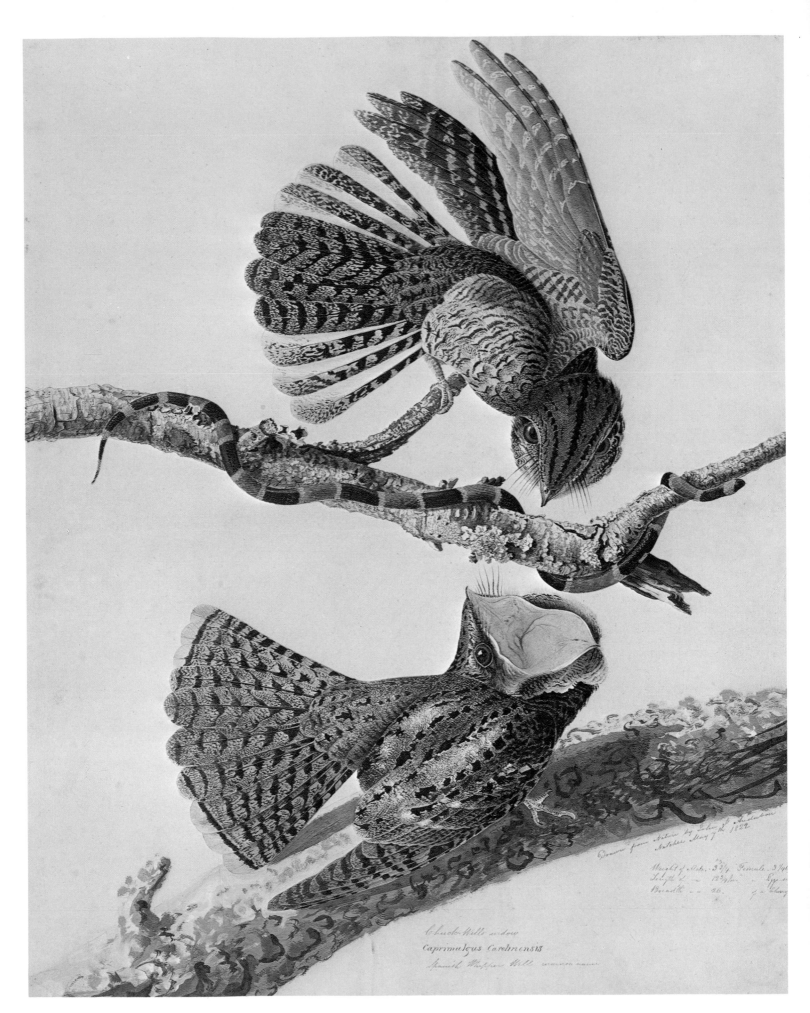

Chuck-will's-widow. *1822. Watercolor on paper, 23 1/2" × 18 5/8".*

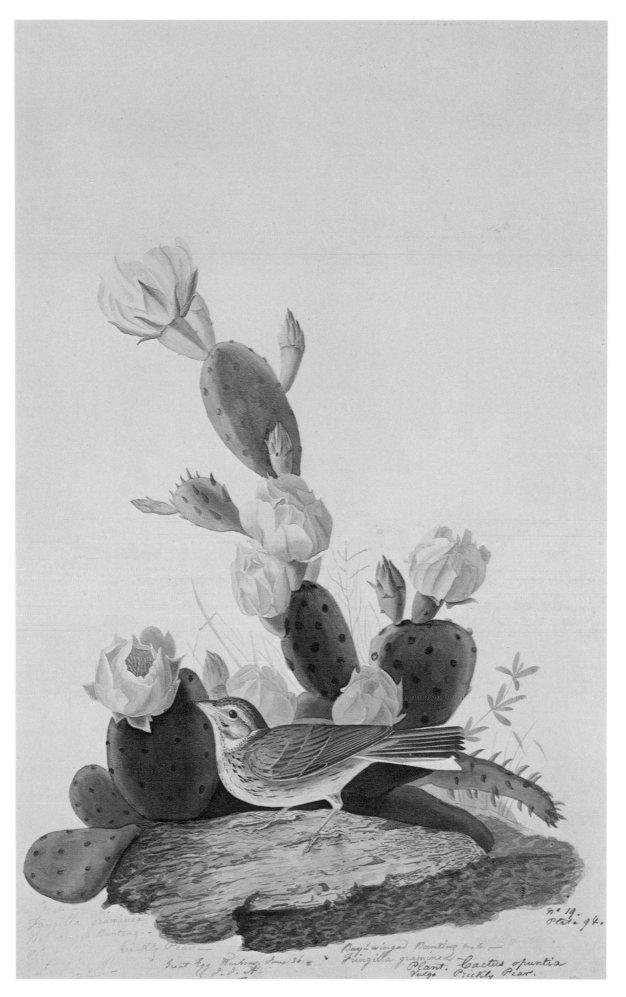

Vesper Sparrow. Ca. 1829. Watercolor on paper, 18 7/8″ × 11 1/2″.

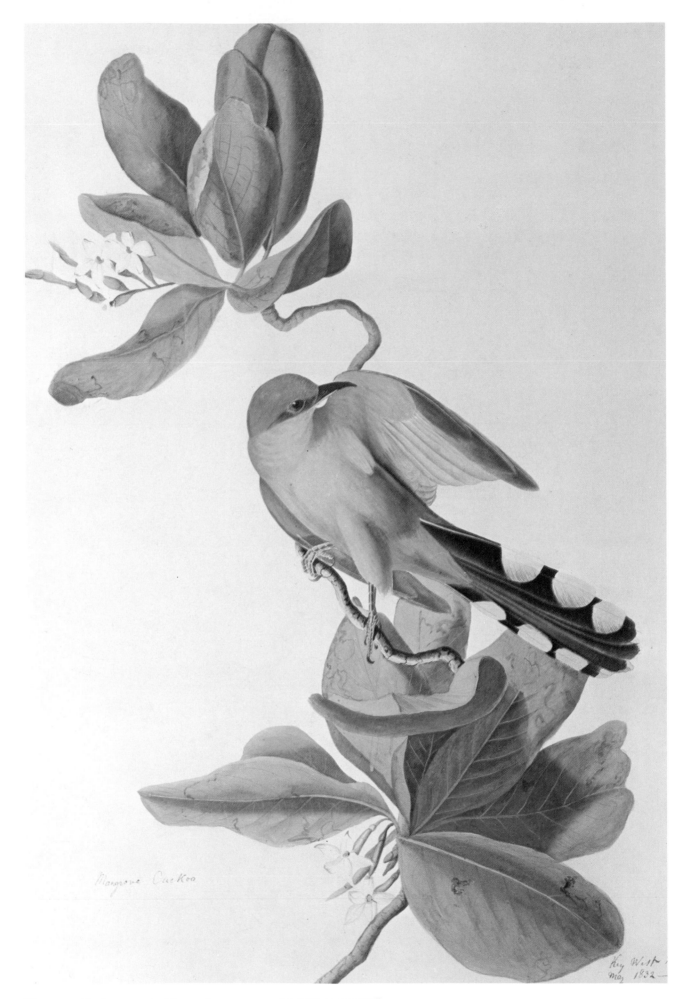

Mangrove Cuckoo. *1832. Watercolor on paper, 21 1/2" × 14 3/8".*

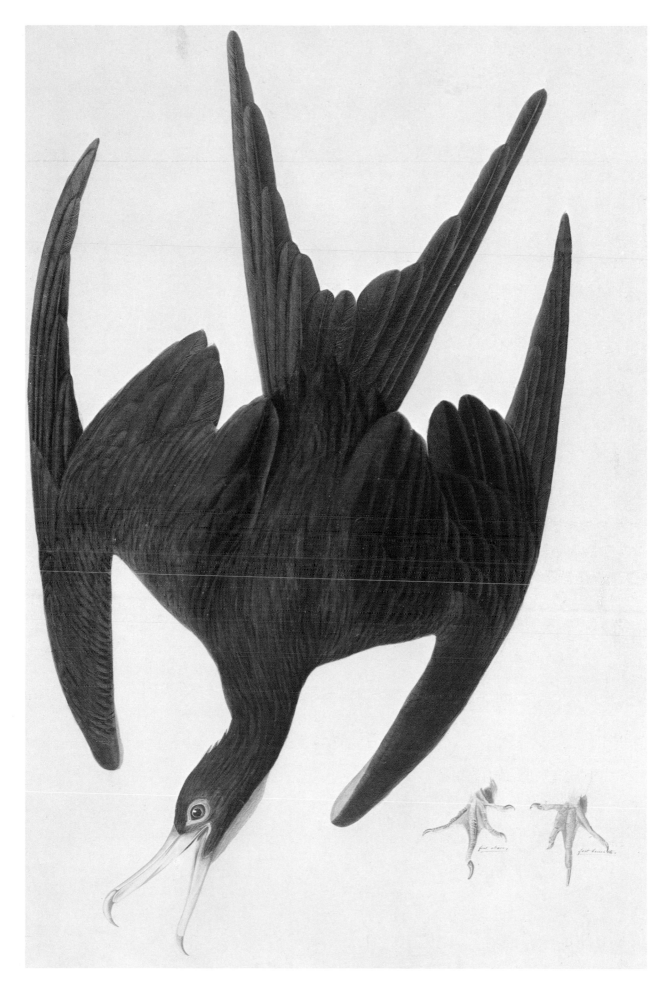

Magnificent Frigatebird. Ca. 1832. Watercolor on paper, 38 1/8″ × 25 1/8″.

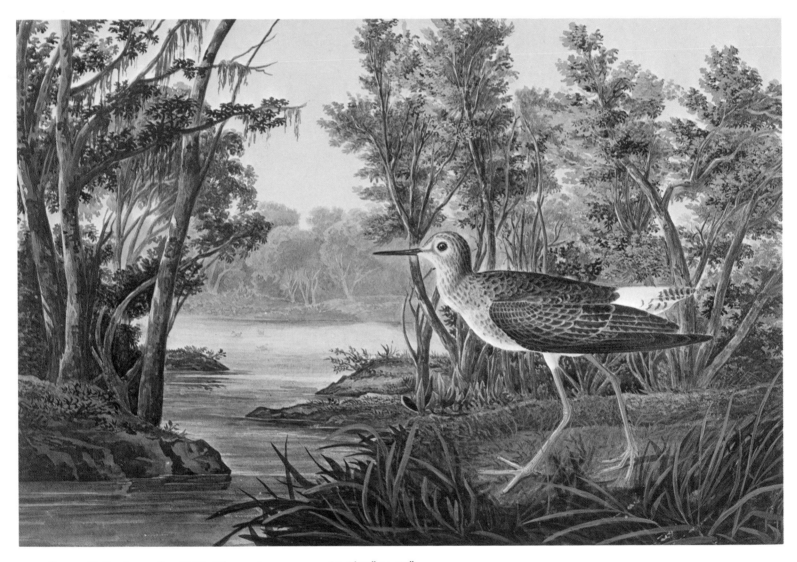

Lesser Yellowlegs. *Ca. 1832. Watercolor on paper, 14 7/16″ × 21″.*

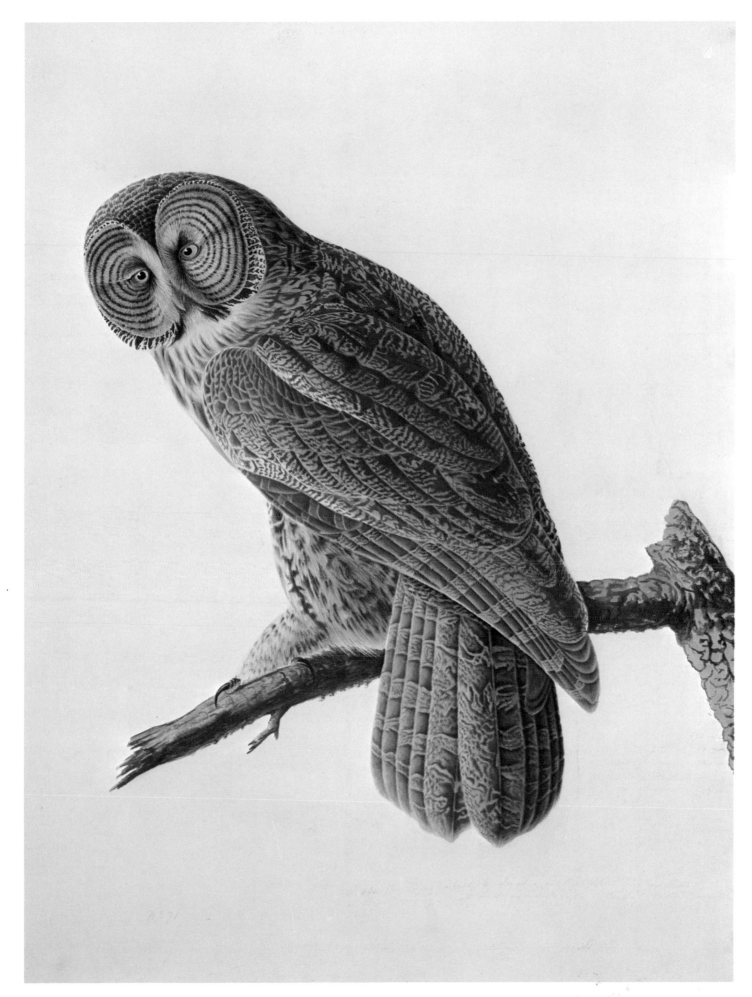

Great Gray Owl. *Ca. 1834–6. Watercolor on paper, 34 1/4″ × 25 1/8″.*

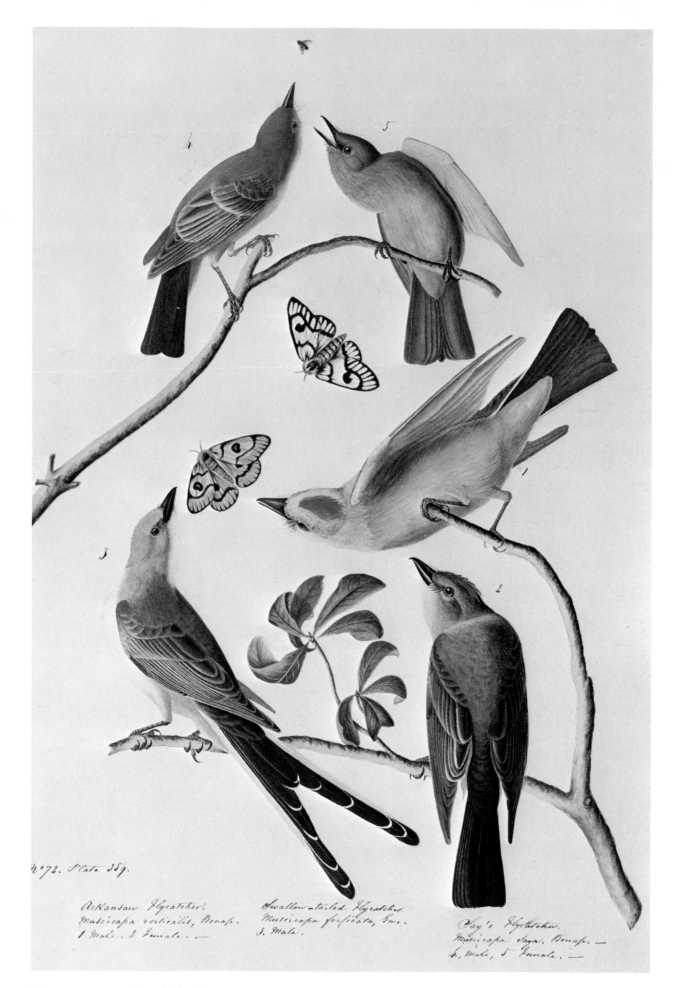

No 72. Plate 359.

Arkansaw Flycatcher.
Muscicapa verticalis, Bonap.
1 Male. 2 Female. —

Swallow-tailed Flycatcher.
Muscicapa forficata, Gm.
3. Male.

Say's Flycatcher.
Muscicapa Saya. Bonap. —
4, Male, 5 Female. —

Western Kingbird *(1 and 2)*; Scissor-tailed Flycatcher *(3)*; Say's Phoebe *(4 and 5)*. *1834. Watercolor on paper, 22 1/16″ × 14 1/2″.*

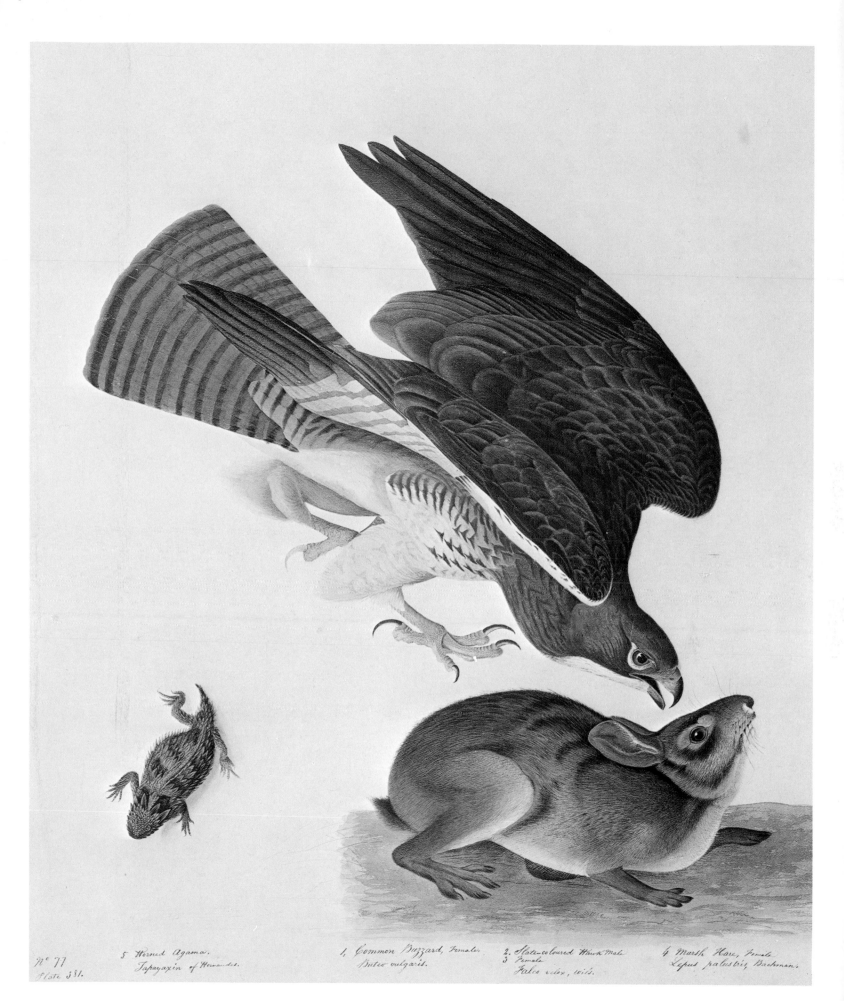

Swainson's Hawk. *1836. Watercolor on paper, 30 1/8″ × 24 3/4″.*

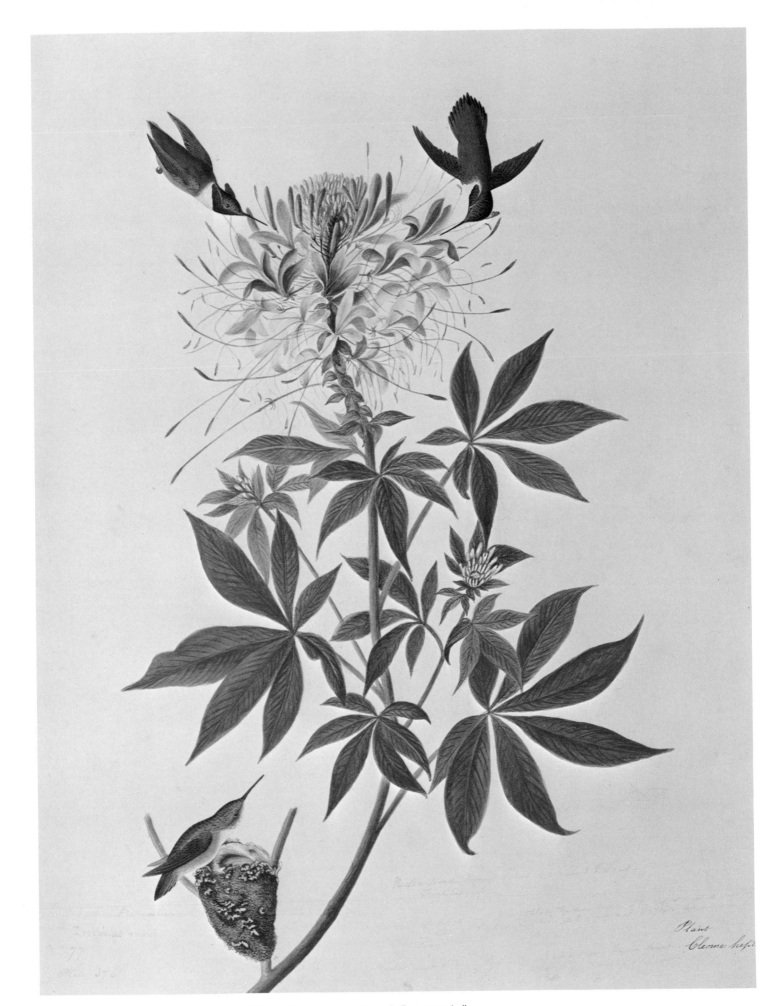

Rufous Hummingbird. *Ca. 1836–7. Watercolor on paper, 21 1/8″ × 15 7/8″.*

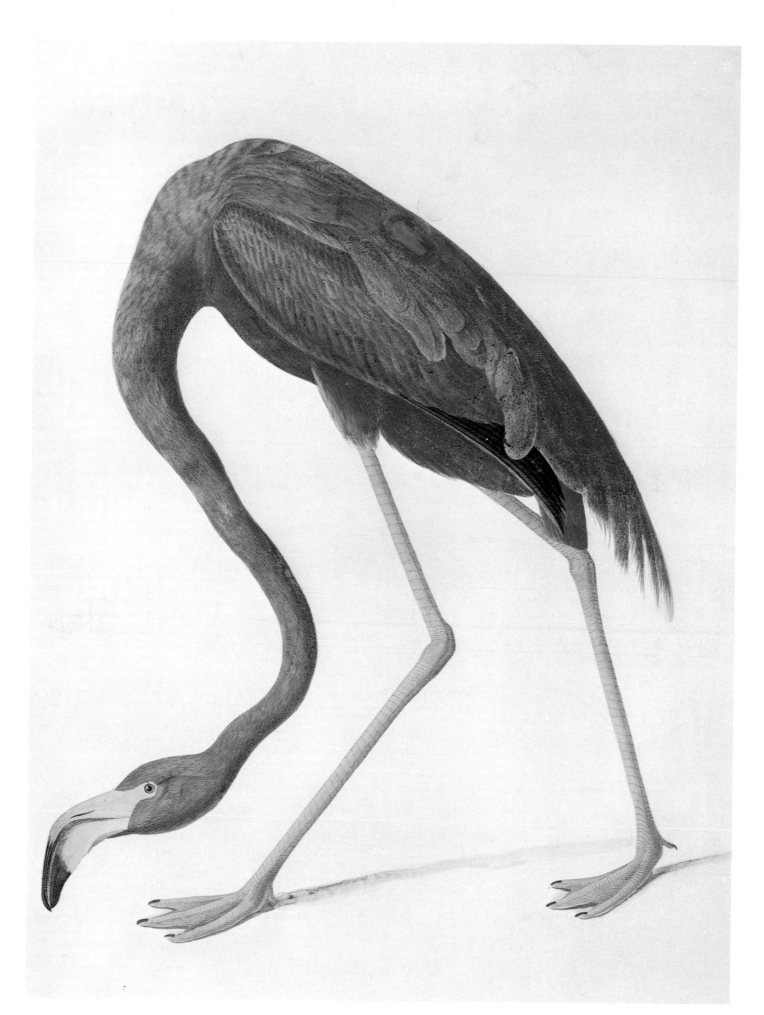

American Flamingo. *Ca. 1838. Watercolor on paper, 33 1/8" × 24 1/8".*

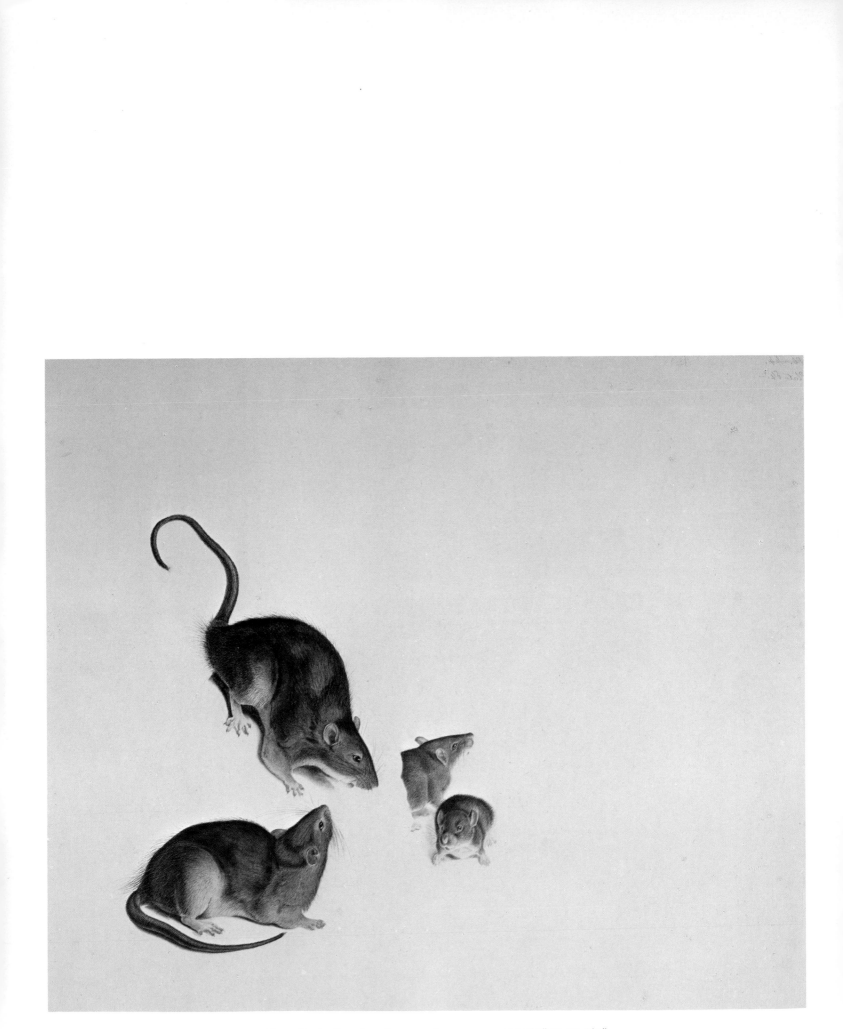

Norway, Brown, or Common House Rat. *1843. Pencil and watercolor on paper, 24 1/2″ × 32 5/8″.*

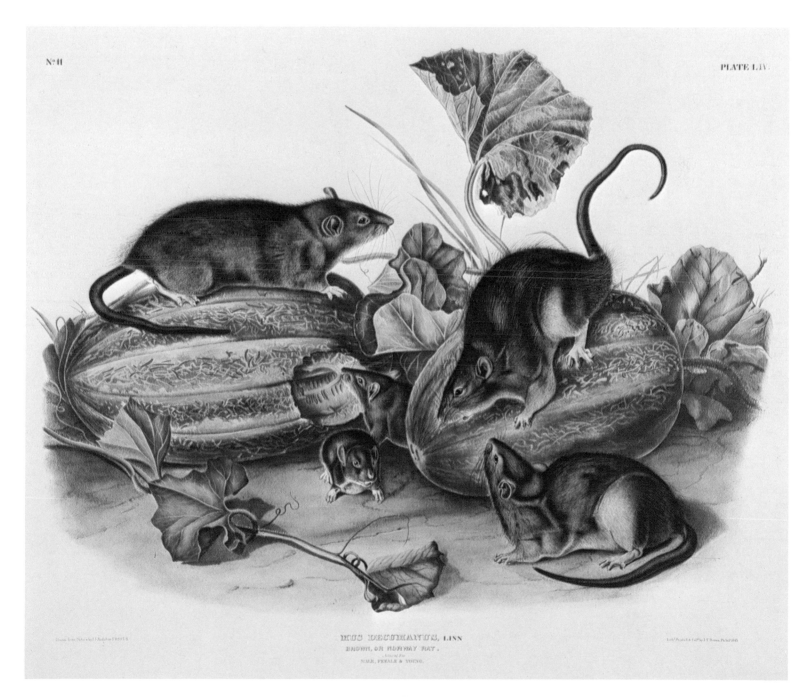

MUS DECUMANUS, LINN
BROWN, OR NORWAY RAT.
MALE, FEMALE & YOUNG.

Brown, or Norway Rat. *1845. Hand-colored lithograph, 21 1/4″ × 27 3/8″.*

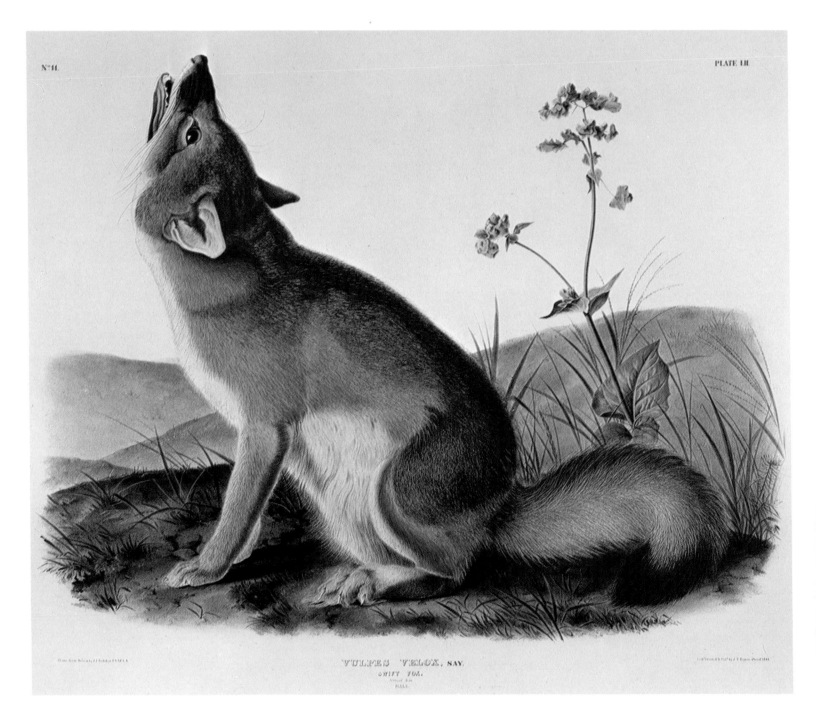

Swift Fox. *1844. Hand-colored lithograph, 21 1/4" × 27 3/8".*

PLATE XC.

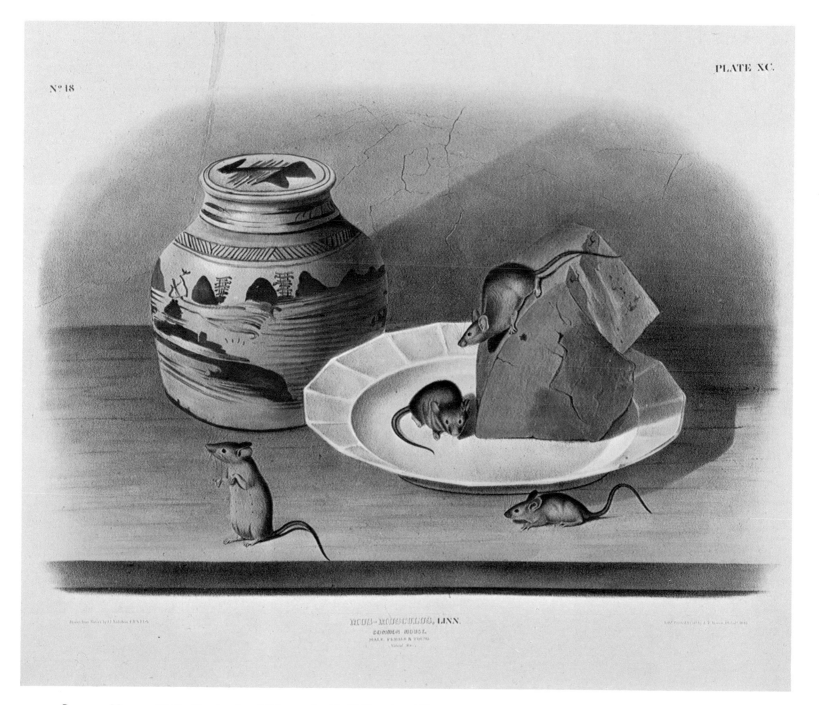

MUS MUSCULUS, LINN.
COMMON MOUSE.
MALE, FEMALE & YOUNG

Common Mouse. *1846. Hand-colored lithograph, 21 1/4″ × 27 3/8″.*

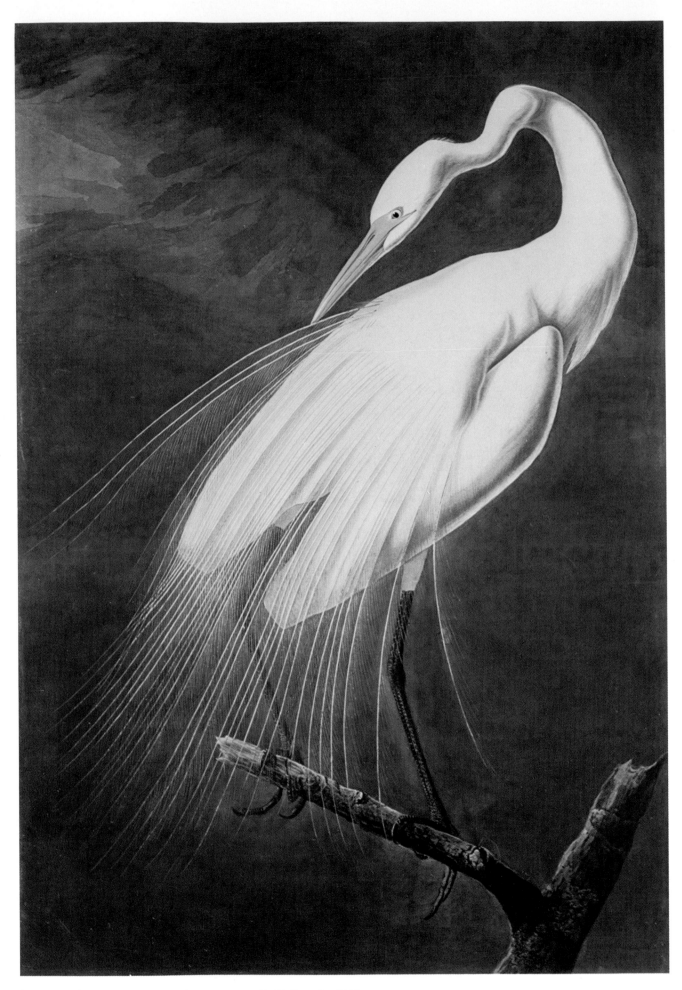

American Egret. *N.D. Watercolor on paper, 37 3/8″ × 35 1/2″.*

these men felt a great loyalty to Wilson and his work, and though their attitude is perhaps understandable, it was another great disappointment for Audubon. Though he had contact with many influential scientists and artists during his stay in Philadelphia, only Gideon Fairman gave him constructive advice. Fairman felt that the type of project Audubon envisaged could best be carried out with printing facilities in London, and he strongly encouraged Audubon to take his work there. He also introduced Audubon to Edward Harris, who was so enthusiastic about Audubon's work that he purchased the collection of bird drawings Audubon had made during his 1805 trip to France.

Audubon was not yet ready to give up on American publishers, but he found little encouragement in New York City even though he was nominated for membership in the Lyceum of Natural History. Audubon went to Albany, New York, but was unable to gather support there; thoroughly discouraged, he made his way south, teaching and doing portraits to support himself. He finally returned to Beech Woods (Louisiana), where he remained for a year teaching, saving toward a trip to England, and adding to his portfolio. He completed the drawing of the *Wild Turkey* (p. 133), the work that would be the model for the first plate in his book, at Beech Woods.

At last, on April 26, 1826, Audubon left Beech Woods to book passage to England on the *Delos*. Armed with 400 drawings and several letters of introduction, Audubon landed in Liverpool, on July 21, 1826, where he was able with the assistance of Dr. Thomas Traill and the Rathbones to arrange for an exhibition of 250 drawings to open July 31 at the Royal Institution of Liverpool. He planned to use the money charged for admission to pay for the publication of his drawings, but a show at Manchester was not as successful as the Liverpool exhibit, so his plans were delayed. He took his portfolio to Edinburgh, and after a few disappointing meetings was at last introduced to William Home Lizars, one of the foremost engravers in the city. Lizars was most impressed by the grand scale and the power of Audubon's drawings and expressed a desire to engrave and publish the work. Audubon agreed to allow Lizars to do a trial engraving, and an exhibit of more than 200 of his birds went on view in Edinburgh in November 1826. At the same time Audubon began to set down his observations on bird lives as a text to accompany his plates. Dr. Traill and others repeatedly encouraged him to produce a text in order to increase the value of his drawings. Audubon, however, insisted on producing lifesize figures of the birds, with the text as a separate publication.

Between November 1826 and June 1827, Lizars worked on the first ten plates, while Audubon worked on his text in Edinburgh and then returned to London. He went to visit Thomas Bewick on his trip to London, as he was familiar with Bewick's woodcut illustrations of British birds and animals. By June Lizars notified Audubon that the colorists were refusing to continue to work at low wages, so in order to raise money Audubon painted several large oils of his favorite themes, particularly the trapped otter.

Audubon finally tired of the delays on the project and asked Lizars to send him a supply of the already completed engravings. He took these to the London engraver Robert Havell, who may have retouched or reengraved some of these early plates and also supervised the colorists for the project through 1828. The remaining work for *The Birds of America* was carried out by Havell's son, Robert Havell, Jr. Working from Audubon's drawings, Havell produced the lifesize hand-colored aquatint engravings. It was necessary to use a double-elephant folio sheet (39½″ x 29½″) in order to translate the monumental character of Audubon's drawings. A reduction in the size of

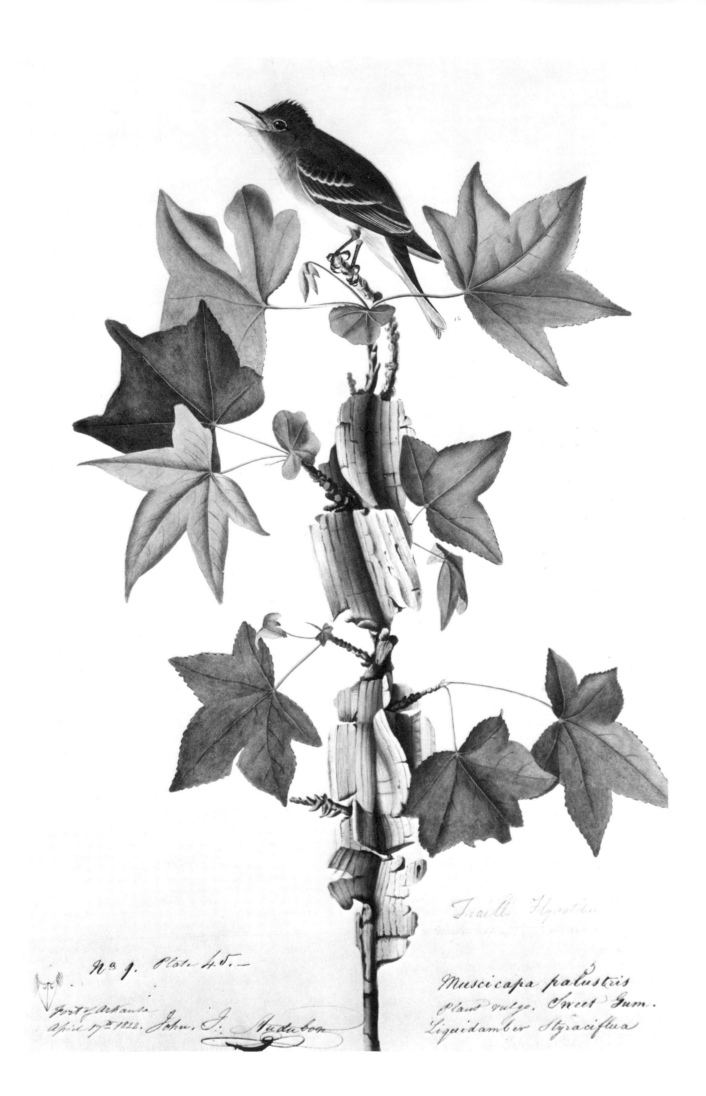

Nº 9. Plate 45.

Fort of Arkansa
April 17ᵗʰ 1822. John J. Audubon

Muscicapa palustris
Plant vulgo. Sweet Gum.
Liquidamber Styraciflua

Traill's Flycatcher. *1822.*
Watercolor on paper, 18 1/2" × 11 3/4".

the 435 plates in the book would have seriously diminished the power of Audubon's work, the strength and vitality of his compositions.

With a projected cost of $1,000 for the complete set of 87 parts (each part including five plates), Audubon encountered much of the same difficulties met with previously by Alexander Wilson. Even the news that King George IV had subscribed was not enough to offset the news of several cancellations and the fact that George Ord and others in Philadelphia had attacked Audubon's early published papers, particularly his work on rattlesnakes. Audubon was also receiving letters from his wife suggesting that he either arrange for them to be together or she would set her course alone. Even though she cared very much for him, the long separations and the necessity of supporting herself and her sons were beginning to weigh on her. Audubon decided that since he had secured more than 140 subscribers by late 1828 he would be able to support his wife if she came to England. So, entrusting his belongings to friends in London and carrying 50 plates with him, he left in April 1829 to go to America. He planned to work during the spring and summer in the New England area, gathering new specimens before meeting Lucy in the autumn. He arrived in New York on May 5 and was given a cool reception. The criticism regarding his papers and the fact that he often discarded the bird skins from which he worked raised doubts among many of the scientists in both New York and Philadelphia about the value of much of his research.

Audubon began his summer work at Great Egg Harbor, New Jersey. He gathered much information on water birds and added thirteen new drawings to his portfolio, including the *Vesper Sparrow* (p. 115). He also stayed in Camden, New Jersey, and traveled to the Great Pine Woods to collect more specimens. Altogether, Audubon managed to complete 40 new drawings that summer, including the *Common Raven* (p. 141). In this striking composition the bird is perched on a branch of shell-bark hickory, which was added to the drawing by Audubon's new assistant, George Lehman. Lehman had met Audubon in Pittsburgh in 1824, and he worked with Audubon again on the 1831 trip through the South.

Audubon returned to London in 1830 with his wife. During the next year he traveled throughout England, giving exhibits to raise subscriptions, working with Havell on improving the plates, and trying to combat the ill feeling stirred up by some of his fellow naturalists. His election to the Royal Society was nearly blocked by those who did not consider him worthy of membership, and a visit to England by George Ord did not add to his reputation. Audubon asked William Swainson to work with him on the text for *The Birds of America* for a fee. Though Swainson would be adding the scientific information that Audubon lacked, Audubon refused Swainson's request for co-authorship. Swainson therefore withdrew from further participation on the project. Audubon was fortunate, however, to find in Edinburgh a professor, scientist, and writer, William Macgillivray, who was willing to assist him for a nominal fee. Working daily, Audubon was able to have the first of five volumes of the *Ornithological Biography* in print in 1831. The binding of the first full volume of 100 plates of *The Birds of America* was also completed that year.

Audubon planned a trip to the southern states to add to his supply of drawings, and arriving in New York in September 1831 he was pleased to learn that favorable Edinburgh reviews reprinted in the Philadelphia papers had helped to change opinions about his work in that city. Not only had The Academy of Natural Sciences and the American Philosophical Society both subscribed to his book, but he had also been elected to membership in the latter. While Lucy went to visit their sons,

Audubon left with George Lehman to go to Charleston, South Carolina. He had hoped to join a revenue ship to cruise the Florida Keys during nesting season. While waiting for the cutter to arrive in Charleston, Audubon met John Bachman, a Lutheran minister and an amateur scientist. Bachman invited Audubon and Lehman to stay with his family, and it was here that they met Bachman's sister-in-law, Maria Martin, who later assisted Audubon with some of his drawings. Audubon traveled in the Florida region until summer, adding a number of new birds to his portfolio, including the lovely *Mangrove Cuckoo* (p. 116) and the strikingly elegant *Magnificent Frigatebird* (p. 117) while in the Florida Keys. Lehman added some of the most interesting backgrounds to Audubon's drawings during this trip, including the views of Charleston and St. Augustine, as well as the elaborate landscape setting for the *Lesser Yellowlegs* (p. 118).

Audubon followed the southern trip by a summer tour through New England with his family. He sent his son Victor to England to oversee his business affairs, while he took a trip to Labrador and Nova Scotia to add the northern water birds to his book. His son John and several other young men who joined the cruise did most of the gathering while Audubon worked on his drawings. He was able to add 23 new drawings on this short trip during the summer of 1833, including the *Double-crested Cormorant* (p. 139) perched on a rock with islands of nesting cormorants seen in the background.

Audubon returned to London in May 1834, having spent the winter of 1833 with his family in Charleston visiting the Bachmans. The next two years were devoted to intensive work toward the completion of Volumes II and III of both *The Birds of America* and the *Ornithological Biography*. Audubon was determined to obtain for his book specimens of the birds brought back by

Thomas Nuttall and John Townsend from the expedition to the Rocky Mountains and Columbia River area. Returning to America in September 1836, he was able to purchase about 93 specimens from a variety of sources. He took the skins to Charleston in November, where he worked through the winter, completing 76 drawings. The *Swainson's Hawk* (p. 121) was completed then; in two others—the *Rufous Hummingbird* (p. 122) and the *Western Kingbird; Scissor-tailed Flycatcher; Say's Phoebe* (p. 120)—the nest, plants, and insects were added by Maria Martin.

After arranging his son John's marriage to Maria Bachman, he returned to London in July 1837 to face the last whirl of activity trying to complete his books. He found to his dismay that many of the supposed new western species were merely immature forms of known birds. He was also forced to crowd numerous species onto a single plate to save space, as the publication now extended beyond the originally proposed 400 plates. He had planned to include several plates in the book illustrating various types of bird eggs, but this had to be eliminated because he had no examples of the eggs of western species. Certain of the last birds he figured, like the *American Flamingo* in Plate 431 (p. 123), were difficult specimens to obtain. He had only been able to secure this specimen after attempting to do so for six years. In June 1838, however, the final plate was printed, and Audubon went to Edinburgh to work on the completion of the *Ornithological Biography* with Macgillivray. The following year Audubon was at last finished with the book, and he and his family returned to New York in September 1839 to settle.

Before leaving England, Audubon had already formulated plans to reissue *The Birds of America* in a smaller format. Not only would this provide additional income from a lower-priced octavo edition, but it would secure an American copyright to

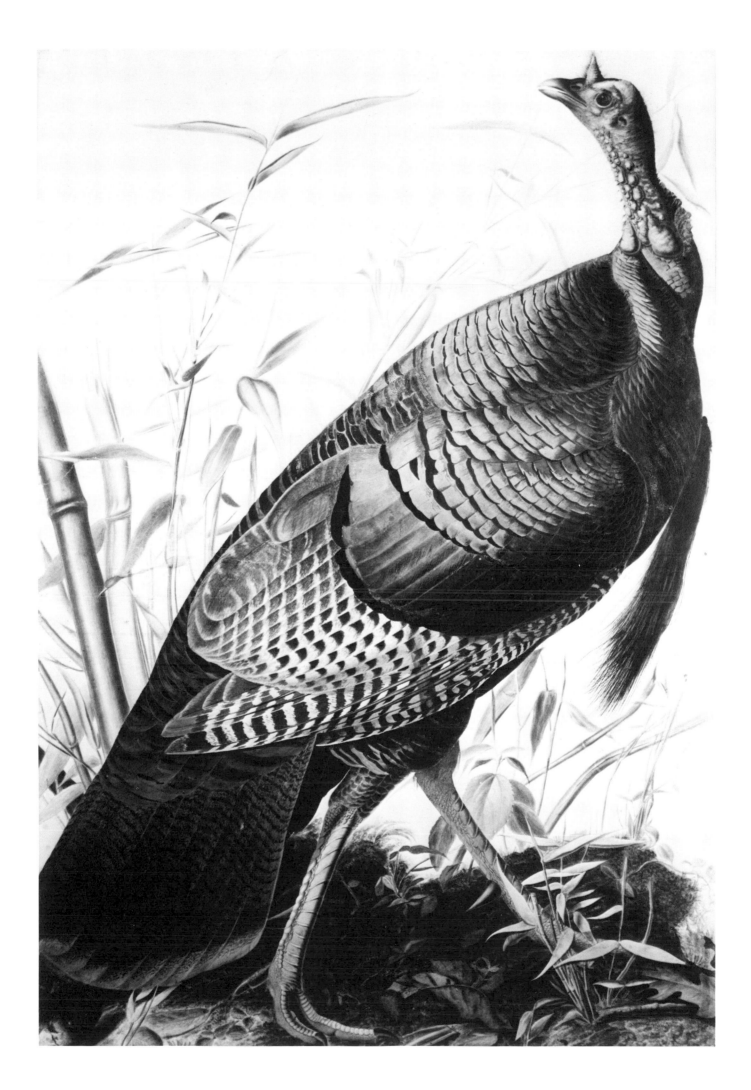

Belted Kingfisher. *1808. Pencil and pastel on paper, 8 3/4" × 16 1/2".*

L. Alcion e amerique septentrionale Buffon.

king Fisher.

Fisher ♂ W. Chute de la Ohio July 15. 1808.

drawn by J. J. Audubon

Canada Goose. Ca. 1834–5.
Watercolor on paper, 29 1/2" × 21 1/2".

protect his work. Audubon's son John Woodhouse worked with the lithographer John T. Bowen on the edition of 500 plates which, accompanied by the text of the *Ornithological Biography,* was sold for only $100. Using a camera lucida, John Woodhouse reduced the double-elephant folio images, and he created the extra 65 plates by separating those species that were originally crowded together in the final plates of *The Birds of America.* In less than a year, Audubon had already secured more than 500 subscriptions for the "Birds in Miniature," thus far surpassing the number of subscribers to *The Birds of America.*

Encouraged by the success of the new edition, Audubon began making drawings for *The Viviparous Quadrupeds of North America.* This project had been suggested several years before by John Bachman, who intended to write the text that would accompany a set of 150 plates illustrating the animals of North America. Like "Birds in Miniature," the book was to be lithographed by John T. Bowen of Philadelphia. Most of the work contributed by Audubon consists of the small animals in the first half of the book, such as the *Young Raccoon* (p. 107) he drew in 1841. Work on the book progressed slowly, as both John W. and Victor Audubon lost their wives, in 1840 and 1841. Audubon also spent much of his time supervising the building of a home on property that he named Minnie's Land; this was located outside New York City, on the Hudson River. After moving into the house in the spring of 1842, Audubon spent the rest of the year traveling and working on drawings for the *Quadrupeds.* In March 1843, he left with his friend Edward Harris for a journey into the West to continue work on

collecting specimens for the plates. He was able to travel only as far as Fort Union below the Yellowstone River because there had been trouble beyond that area with the Blackfoot Indians. His two-month stay at Fort Union produced almost nothing new for the book, although Audubon did record his amazement at the sight of the numerous buffalo in the area.

Upon his return, Audubon, with Victor's help, produced a number of exquisitely detailed drawings. The remarkable feeling for the texture of the fur in such drawings as *The Brown, or Norway Rat* (p. 124) is a product of creating the animal virtually hair by hair, using a tiny brush to make many overlapping strokes. The extensive background shown in the published plate of the same species (p. 125) is the work of Victor Audubon, who provided many of the landscape settings for the animal drawings. By June 1846 Audubon's eyesight was failing so badly that John W. Audubon took over most of the work on the plates and Audubon was only able to accomplish minor tasks relating to the book. The final plates were completed in 1848, three years after the first volume appeared.

Audubon's condition weakened soon after, and all the work toward the completion of the text to accompany the *Quadrupeds* fell to his sons. After two years of increasing weakness, Audubon died at Minnie's Land on January 27, 1851, having created in his lifetime an exquisite collection of wildlife paintings. His work is both a lasting record of the variety of creatures inhabiting North America and an inspiration to the many men who see mirrored in his paintings Audubon's love for the drama and beauty of nature.

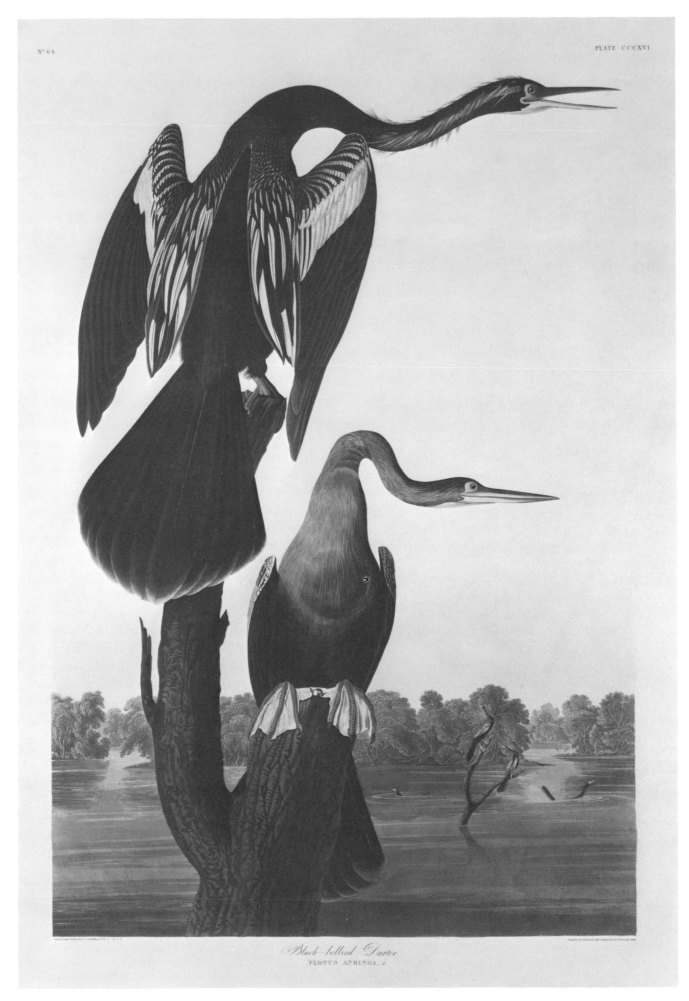

Black-bellied Darter
PLOTUS ANHINGA, L.

Black-bellied Darter. *1836. Hand-colored engraving and aquatint, 38 1/8″ × 25 1/2″.*

Double-crested Cormorant. *Ca. 1833. Watercolor on paper, 29 3/8″ × 21 1/4″.*

Brown Pelican.
PELECANUS FUSCUS.
Male Adult.

Brown Pelican. *1835. Hand-colored engraving and aquatint, 38 1/2" × 25 1/2".*

Common Raven. *1829. Watercolor on paper, 35 7/8" × 25 1/4".*

Martin Johnson Heade
1819 · 1904

FOR MANY years after the publication of Audubon's works on North American birds and animals, there were no attempts to duplicate his extensive coverage of the subject. Instead, the activities were more intensive, concentrating on a particular area or species in order to better understand the individual elements of nature. Martin Johnson Heade was one of these transitional artist-naturalists. He not only enlarged the area of activity into South and Central America, but also concentrated his work on the hummingbirds of the Americas.

Martin Johnson Heade was born in Lumberville, Pennsylvania, on August 11, 1819. The son of a farmer, he became interested in painting as a young man, and his father allowed him to study coach painting with Edward Hicks near Lumberville when he was about eighteen. Heade became acquainted at the same time with his teacher's nephew, Thomas Hicks, who would later be widely known for his portraits. With his father's continued encouragement, Heade also went to Italy to study in Rome for two years, visiting England and France during his European travels.

After his return, Heade spent from 1840–60 traveling throughout the United States. Not many paintings from this period are well known, but portraits and genre scenes predominate in the work from the 1840s. He did exhibit occasionally in Philadelphia and New York, with his work included in shows at the Philadelphia Academy and the National Academy in New York.

Heade again visited Rome in 1848, and he returned to live in St. Louis for a few years. He moved to the Chicago area for a short period before moving to Trenton, New Jersey, in 1854. Two years later when Heade moved to Providence, Rhode Island, he was introduced to the rocky coast and salt marshes of New England; these figured largely in his best known landscape work, begun about this time. Though true to existing na-ture in composition, his work exudes atmosphere. Mist, heavy skys, storms—these are some of the special qualities developed in Heade's landscapes.

During 1859 Heade moved to New York City. In the same building in which he rented a studio, were the studios of Frederic Church and Albert Bierstadt, both extremely popular and important landscape artists. Heade developed a close friendship with Church; this relationship probably led Heade to work toward developing his landscape work instead of continuing with genre and portraiture. After two years he moved to Boston, perhaps to be closer to the areas he was more often painting. Through 1863 Heade evolved his landscape painting style, particularly perfecting his treatment of the coastal and salt marshes from Massachusetts to Florida. The humid, misty, muggy air he portrayed in these works helped to prepare him for the depiction of the atmosphere in Brazilian jungles, exemplified by *South American River* (p. 162).

In a great rush of activity, Heade acquired funds to make a trip to Brazil. He planned to produce a book of chromolithographs ("Gems of Brazil," never published) depicting the varieties of Brazilian hummingbirds. Heade may have been encouraged in this project both by Church, who had painted the South American landscape, and by Reverend James C. Fletcher, an acquaintance from Newburyport, Massachusetts, who was also an expert on Brazil, and a friend of the Brazilian Emperor, Don Pedro II. Heade's work in Brazil was supported by the Emperor who not only subscribed to the venture, but honored Heade's efforts by naming him a Knight of the Order of the Rose.

When Heade arrived in Rio de Janeiro late in 1863, he began to produce a series of small canvases of hummingbirds, such as *Hummingbirds with a Nest* (p. 153) and *Brazilian Hummingbirds*

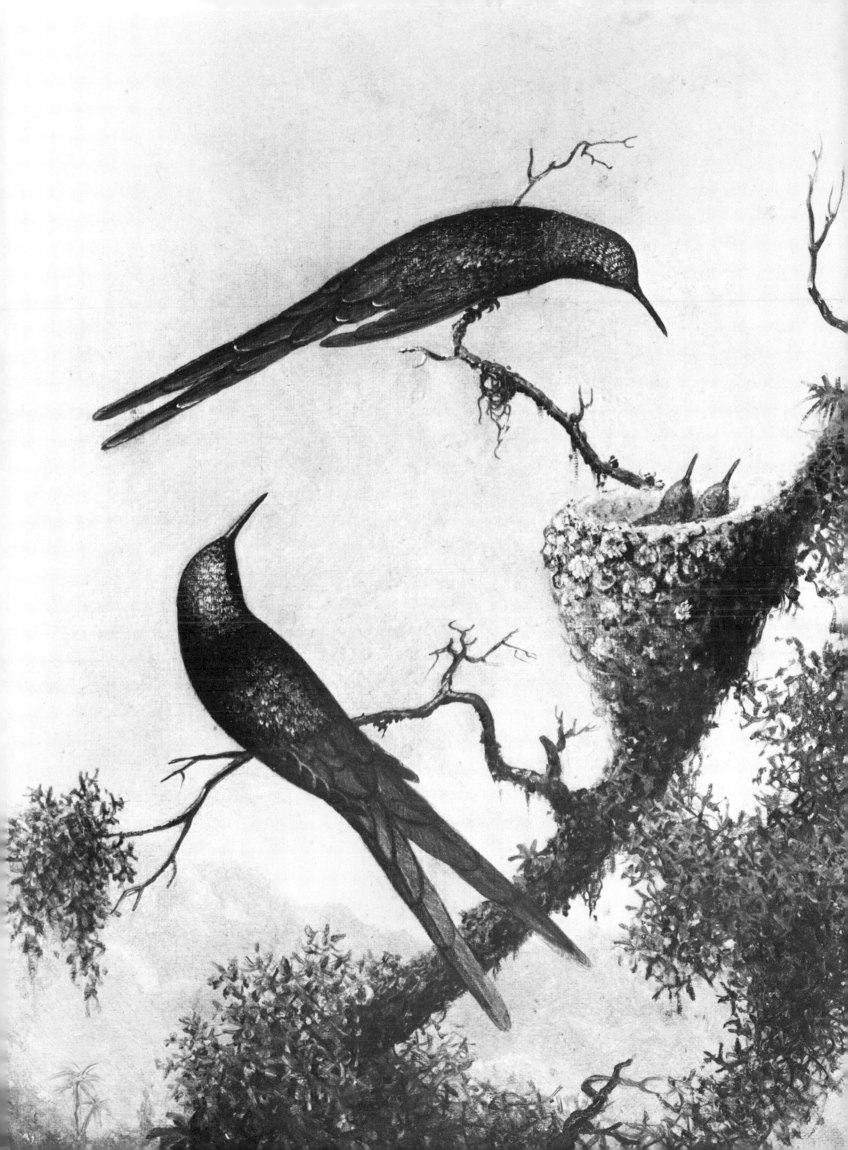

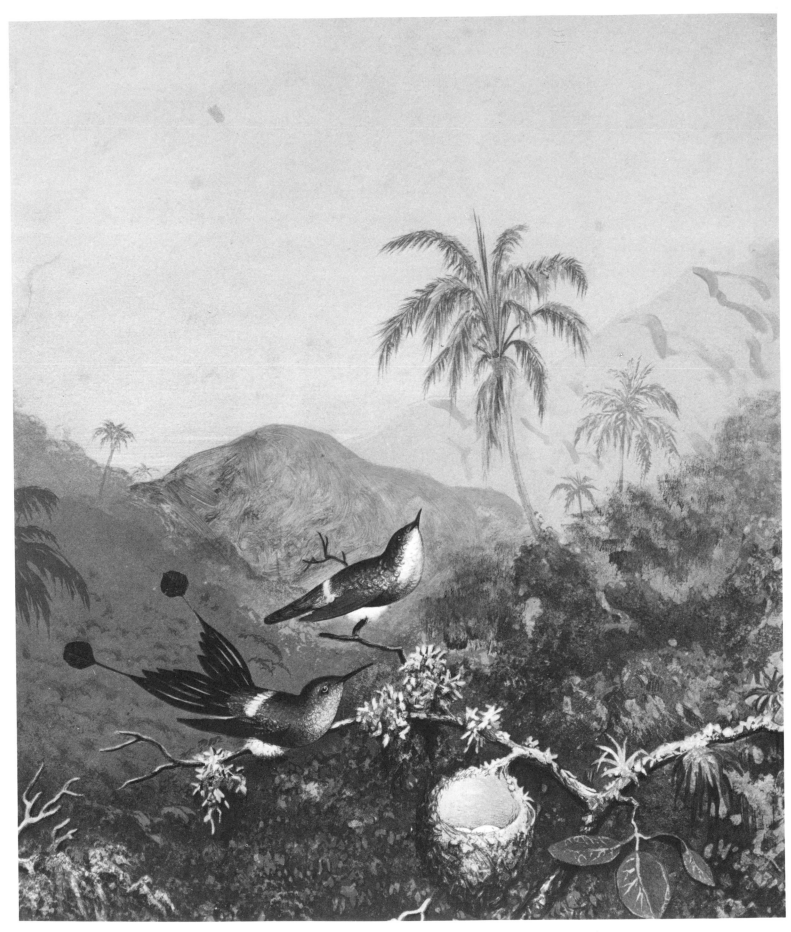

Brazilian Hummingbirds II. *Ca. 1864. Chromolithograph touched with oil, 11 3/4" × 10".*

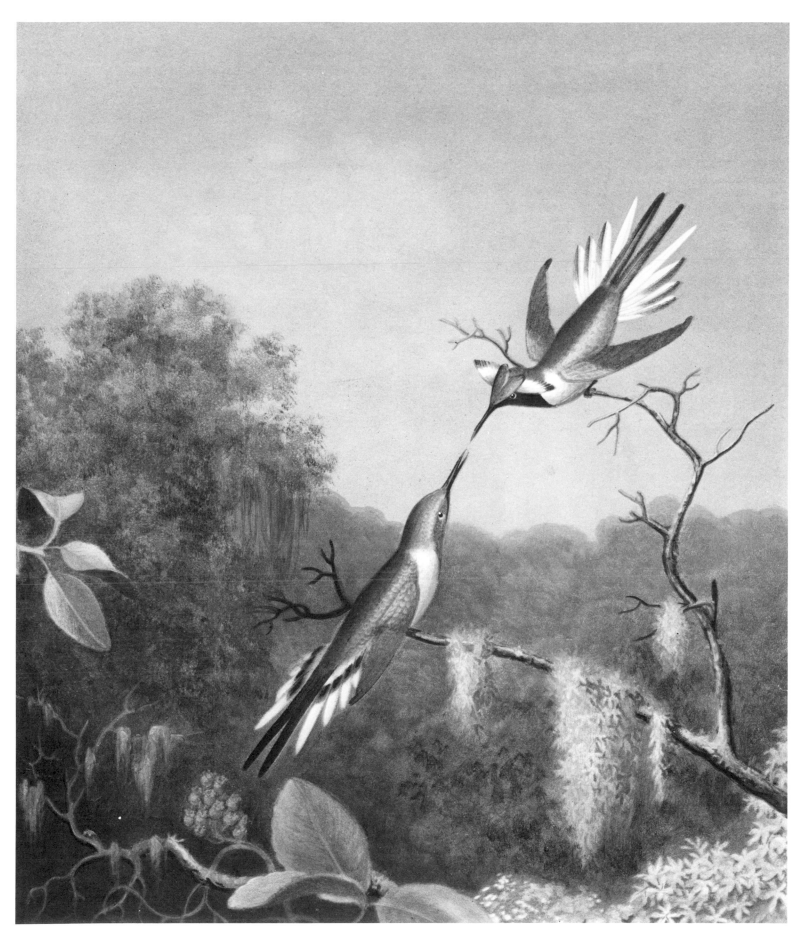

Brazilian Hummingbirds IV. *Ca. 1864. Chromolithograph touched with oil, 11 15/16″ × 10″.*

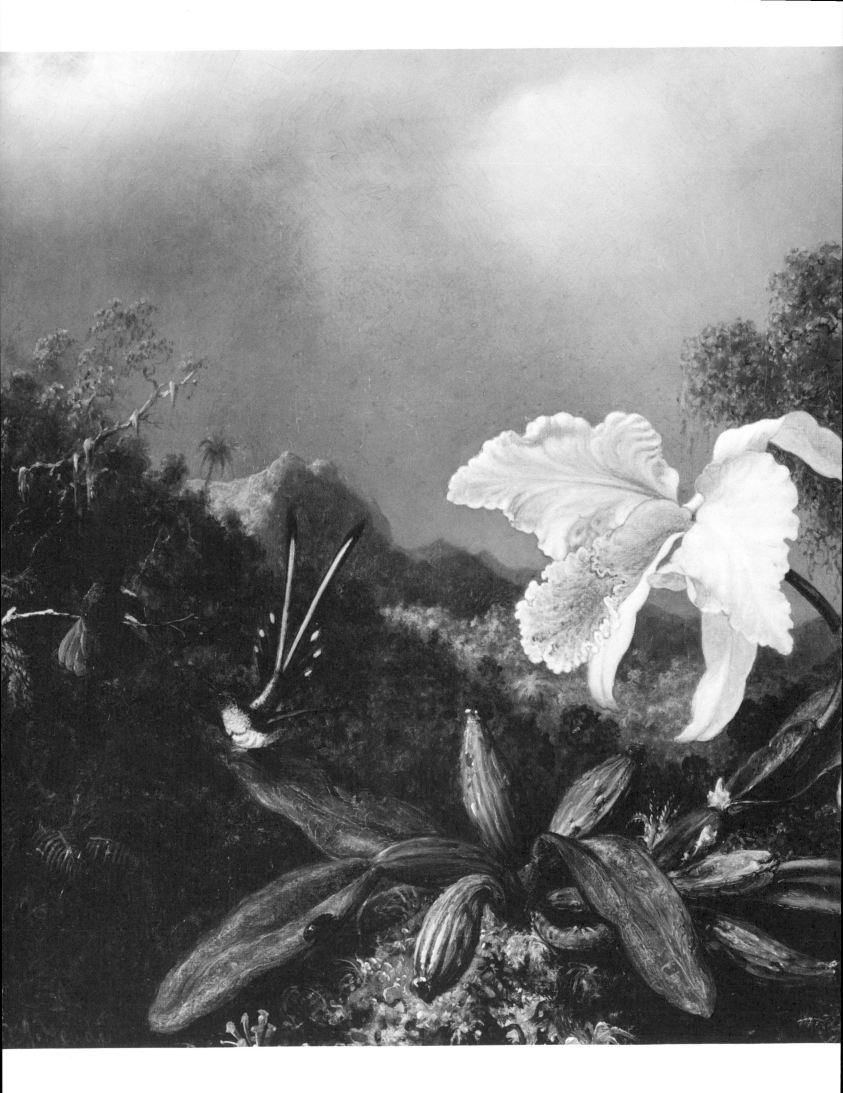

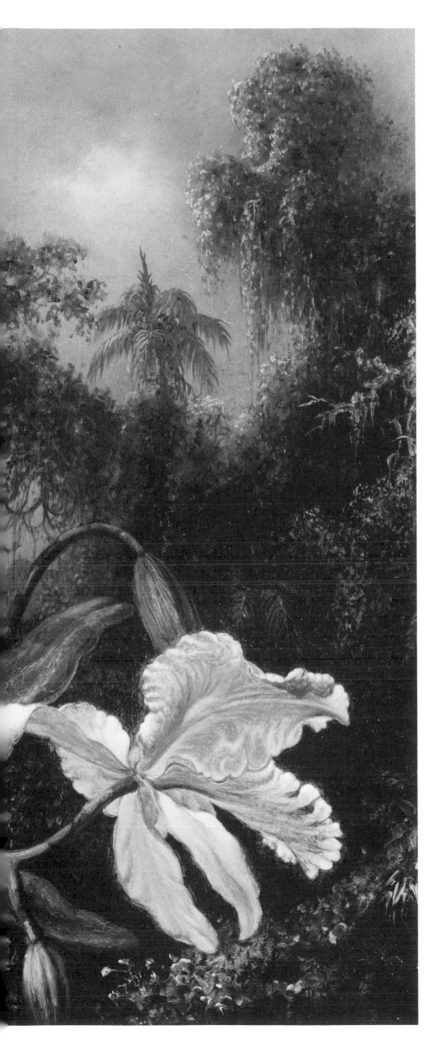

Jungle Orchids and Hummingbirds. *1872.*
Oil on canvas, 18" × 23".

(p. 157). These small canvases, which were to be translated into the twenty prints planned for the book, were intended as bird portraits, and the scale and focus of the paintings reflect this intent.

Heade went to London with his paintings some time in 1864 to work on their reproduction with a chromolithographer. Only a few proofs, *Brazilian Hummingbirds I–IV* (pp. 158, 146, 159, 147), exist from this work. As is evident, the quality of the chromolithographs is not particularly good; the jewel tones of Heade's paintings are not adequately translated into the prints. The bright colors seen in the prints are touches of oil paint probably applied by Heade to working proofs of the chromolithographs.

Since Heade never mentioned this project in later years, one can only surmise the reasons for its abandonment. It has been suggested that he gave up the work after a year because of problems with the reproduction of the paintings. If the existing prints are evidence of the quality achieved by his chromolithographer, then this reason is readily acceptable. The chromolithographs simply do not adequately convey the depth or richness of Heade's work. It has also been suggested that the five-volume work on hummingbirds published by John Gould in 1861 caused Heade to abandon his own project. Heade knew Gould and his work, and the effect of Gould's work would most likely have been to reduce Heade's possible subscriptions. As had been found by Catesby, Wilson, and Audubon before him, obtaining subscriptions was probably the most difficult aspect of natural history publication for the author. Heade may not have wanted to apply the effort to selling his book that would have been required, and with the added problem with the chromolithographs, he abandoned the project altogether, sold the hummingbird paintings to Sir Morton Peto in 1865, and returned to New York.

In mid-1866 Heade went to Nicaragua for about

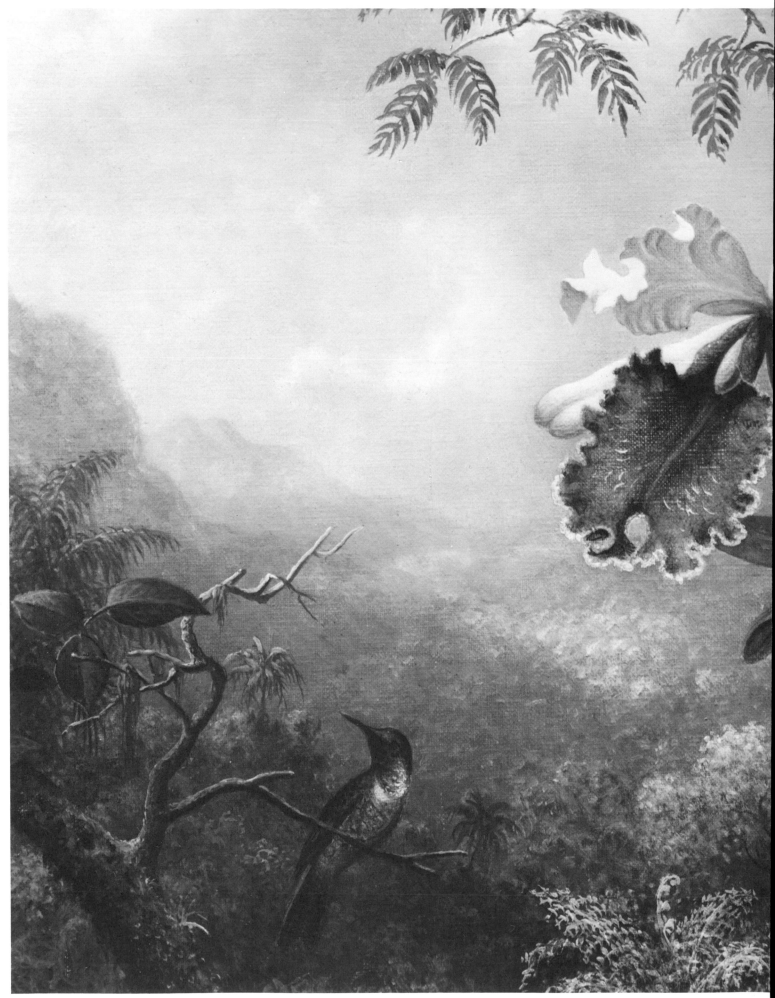

Orchids and Hummingbird. *Ca. 1865. Oil on canvas, 14 1/2" × 22 1/4".*

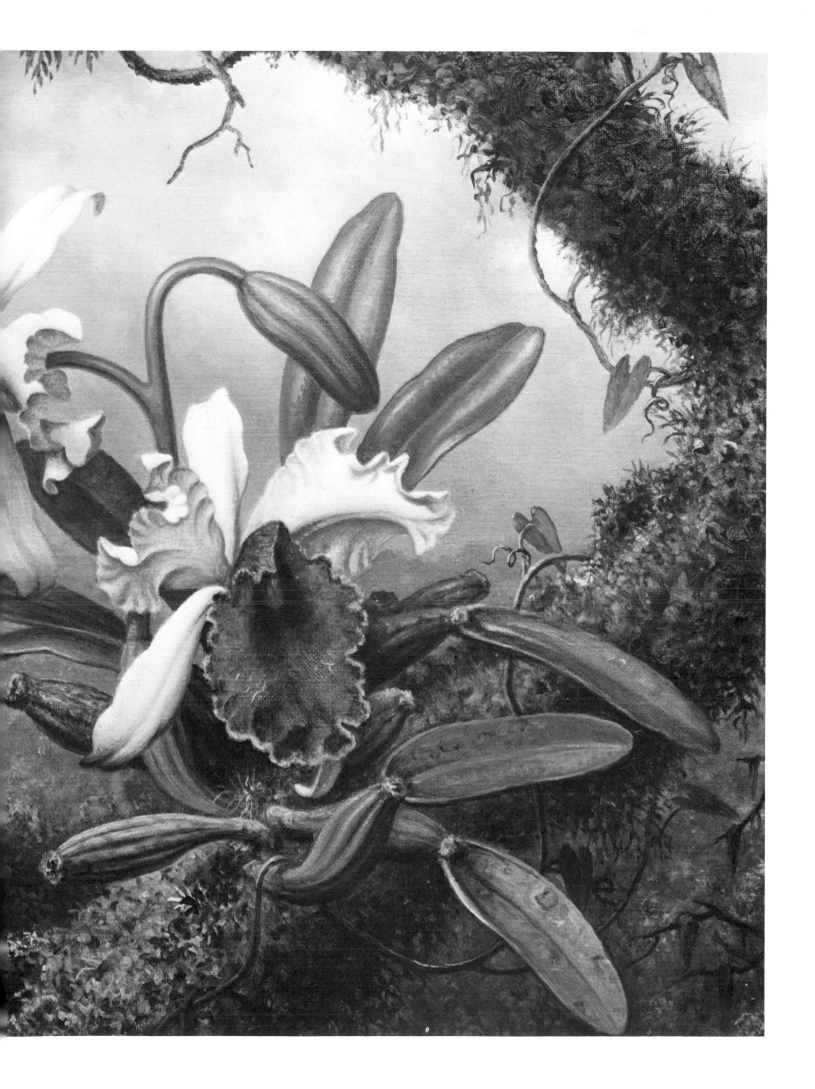

three months to paint landscapes, adding to the small number he had completed while in Brazil. On his return, he continued to concentrate on landscapes, painting some of his best work of both the coast and the marshes. Heade traveled once more to Central America in 1870 to visit Colombia and Panama, also making a stop in Jamaica. Not only did Heade produce several outstanding landscapes on this trip, but it seems to have triggered a renewed interest in hummingbirds. When Heade began to paint them again, however, he utilized the hummingbirds as a focal element within a larger landscape/still life. A background of steamy, misty jungle sets off the carefully detailed studies of orchids and passion flowers now included with his flashing, exotic little birds. Occasionally in these works, one element may dominate the others, but most often they blend to provide a striking balance of birds and flowers placed within a dramatic landscape. Some of the paintings Heade did during this period are *Hummingbird and Passion Flowers* (p. 43), *Orchids and Spray Orchids with Hummingbird* (p. 155), *Orchids, Passion Flowers and Hummingbirds* (p. 154), and *Two Fighting Hummingbirds with Two Orchids* (p. 161).

Heade continued to travel throughout the 1870s and early 1880s from Canada to California, Vermont to Florida, where he found at last a place where he wished to settle. 1883 was the year in which he found both St. Augustine, Florida, and a wife, Elizabeth Smith. Heade remained in Florida, with summer trips to the north, painting the great Florida marshes. He also began developing his interest in floral still life, which resulted in his 1890s series of magnolia blossoms highlighted against rich satins and velvets.

During the 1880s Heade also began to write to *Forest and Stream* (now *Field and Stream*), putting in writing during the next twenty years his thoughts and opinions regarding hunting, hummingbirds, people, places, and his life. It is in these letters, all signed by his pseudonym, Didymus, that the depth and breadth of his interest in hummingbirds and his knowledge of other natural history topics becomes evident. Though he painted the hummingbirds with fidelity, it is in his writings that one becomes aware of his intense attachment to these little birds. Struck, as he says, by an "all-absorbing hummingbird craze" as a youth, he devoted much study to the habits of these and other birds and animals throughout his life. Heade was also an avid hunter, and the areas of marsh and coast where he painted were areas where one could find ample game. Heade's choice of Florida as a place to settle could be partially explained by the appeal of marshland and coast, and the warm climate which enabled him to keep hummingbirds. He managed to tame, feed, and study them, and he reported his findings in his letters to *Forest and Stream*.

Martin Johnson Heade was a transitional figure in the artist-naturalist tradition. Although his superb and beautiful paintings of hummingbirds were never reproduced and presented in a book as he had planned, his studies and observations were made available to a broad range of sportsmen and natural history devotees through the forum of the sports periodical of his day. The "Letters to the Editor" column of *Forest and Stream* was one of the major means of exchanging information of this type. Heade may have been unsuccessful in his attempt to publish a book of his favorite birds, but when he died September 4, 1904, he left an important legacy, both on canvas and in print.

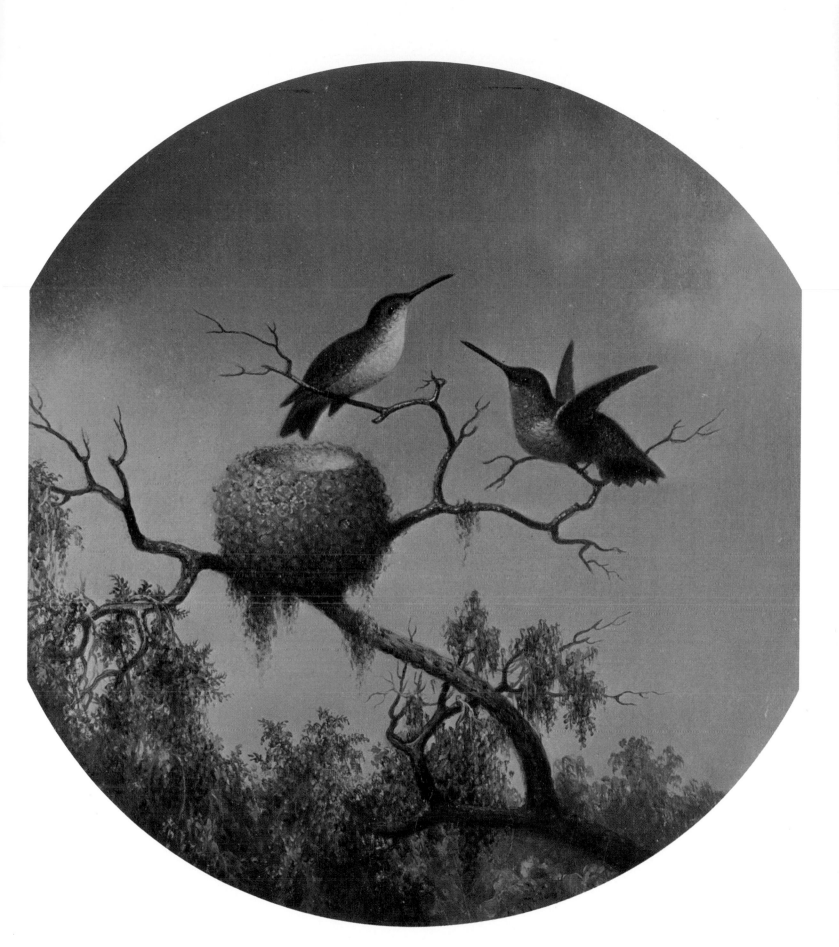

Hummingbirds with Nest. *1863. Oil on canvas, 12" × 10 1/2".*

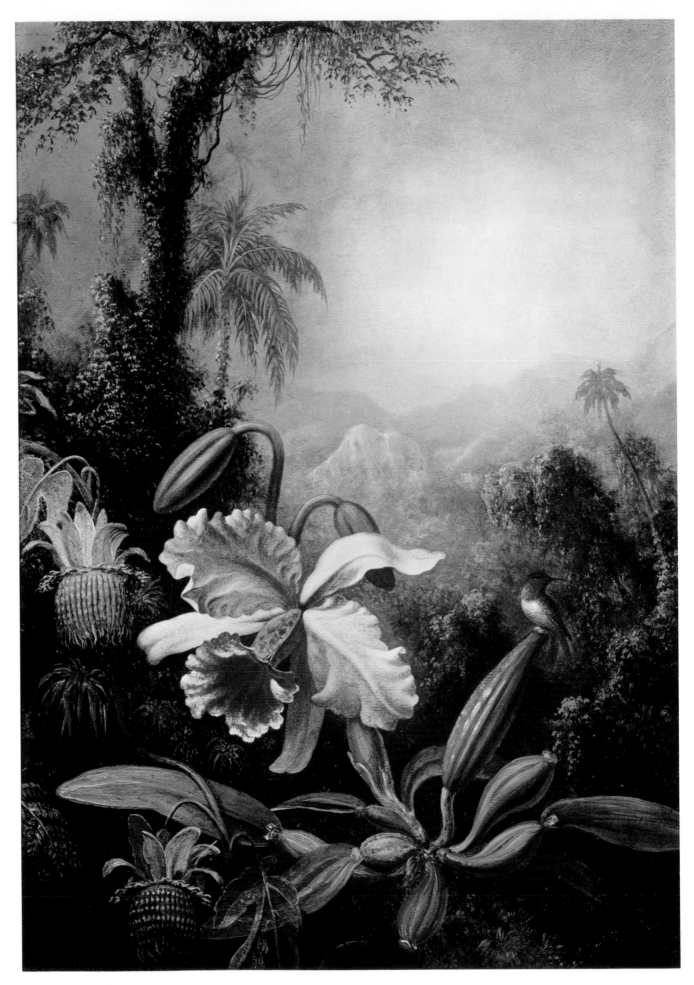

Orchids, Passion Flowers, and Hummingbird. *Ca. 1865. Oil on canvas, 19 1/2″ × 13 1/2″.*

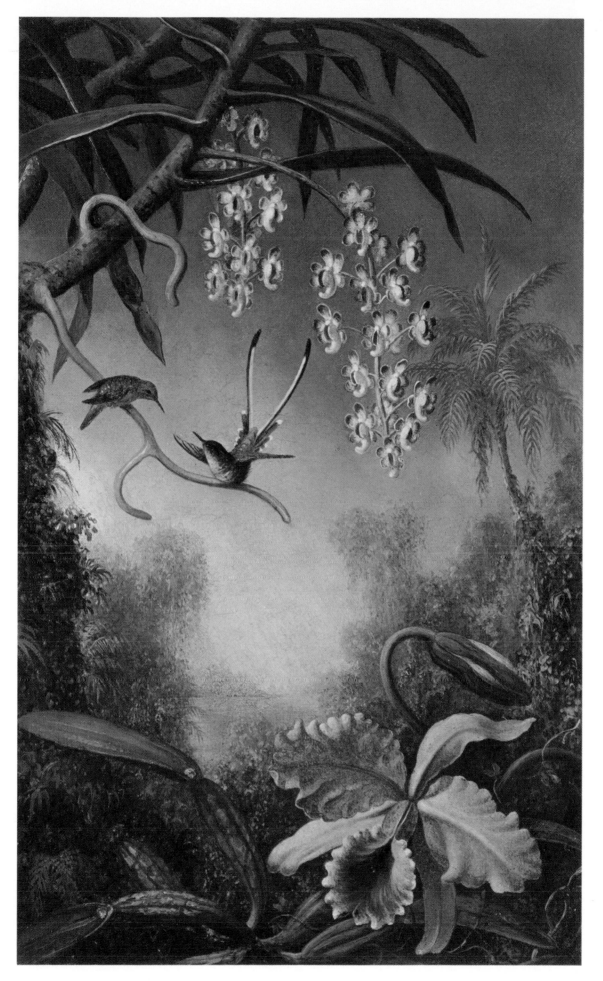

Orchids and Spray Orchids with Hummingbirds. *Ca. 1865. Oil on canvas, 20″ × 12″.*

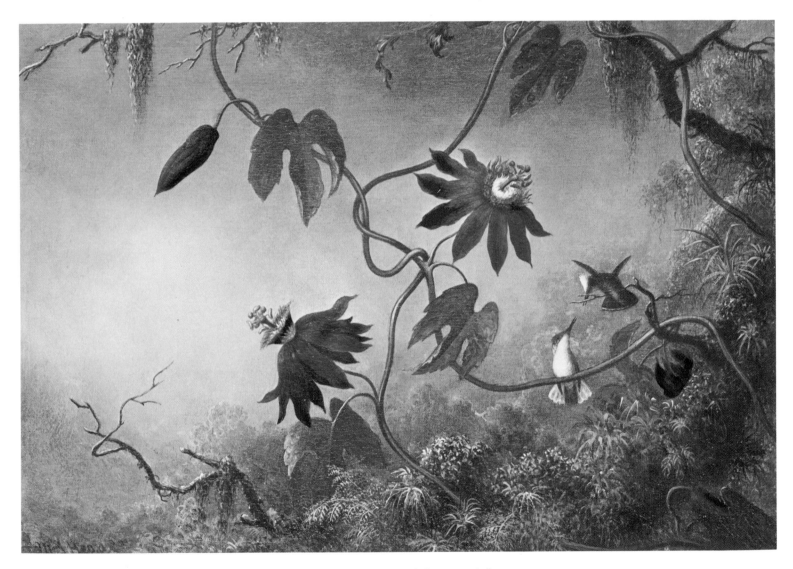

Passion Flowers and Hummingbirds. *Ca. 1865. Oil on canvas, 15 1/4" × 21 1/2".*

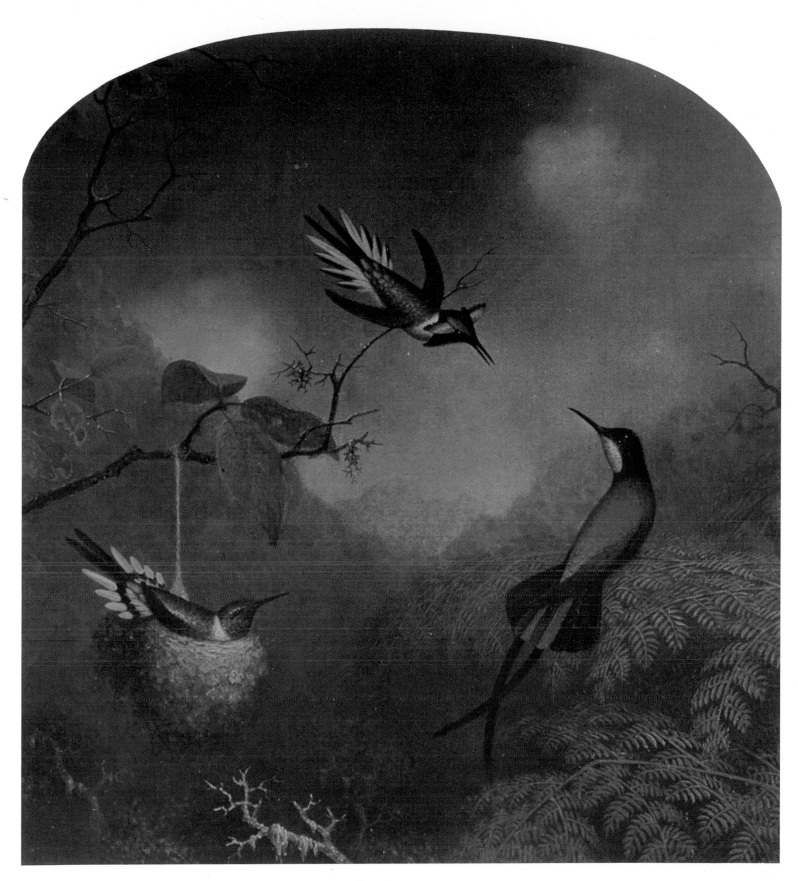

Brazilian Hummingbirds. *1866. Oil on canvas, 14″ × 13″.*

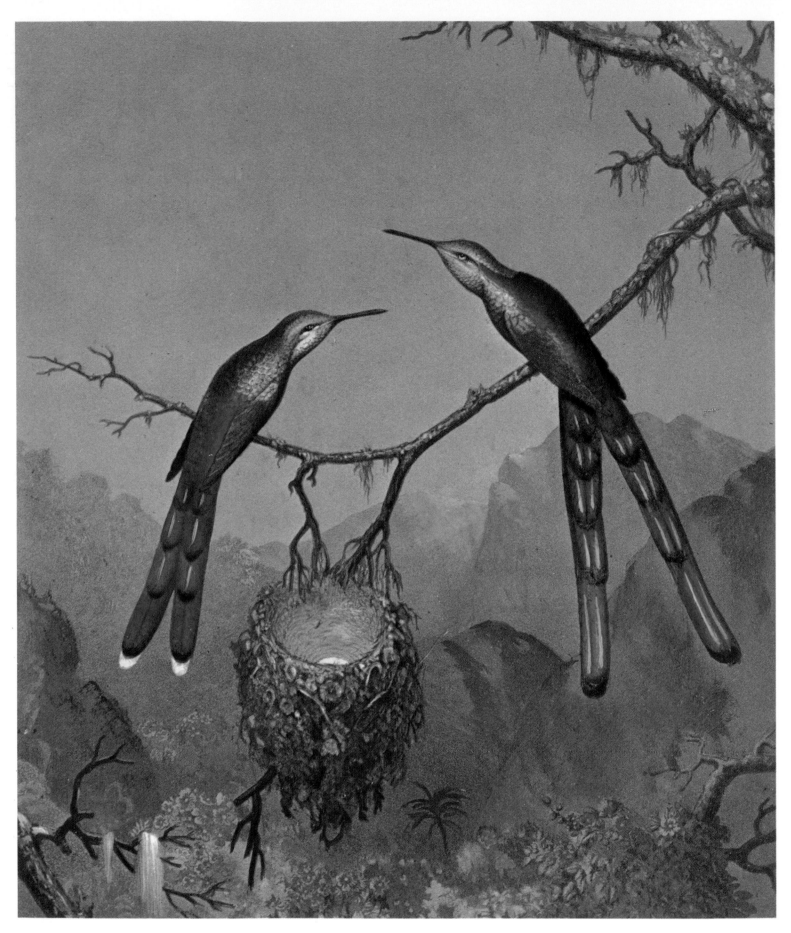

Brazilian Hummingbirds I. *Ca. 1864. Chromolithograph touched with oil, 12″ × 10″.*

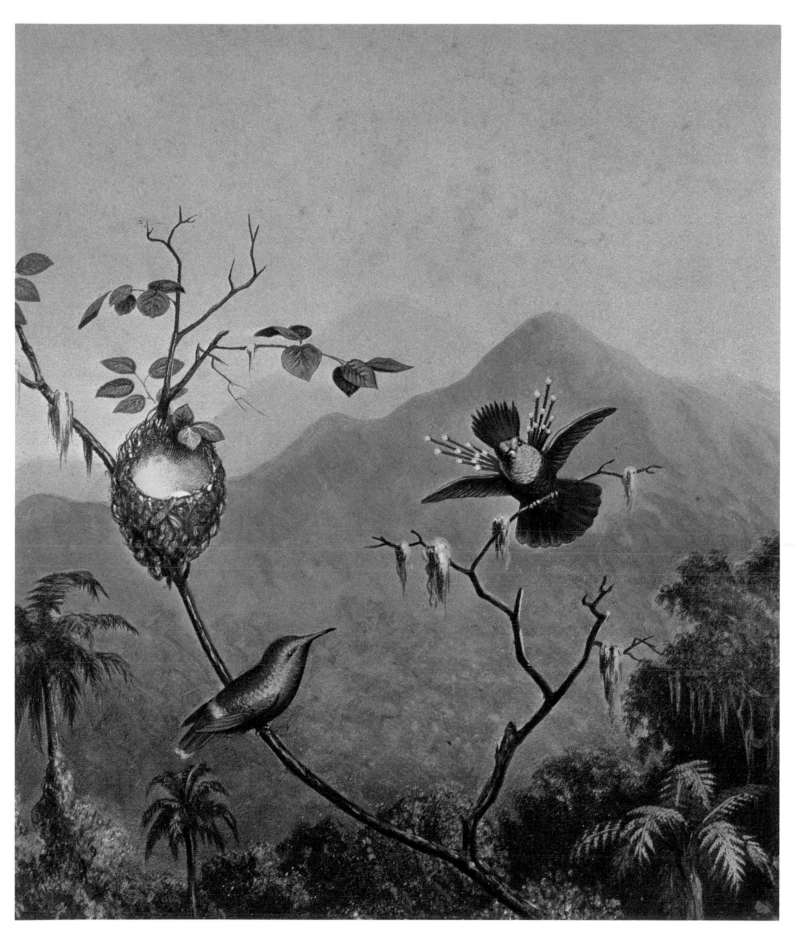

Brazilian Hummingbirds III. *Ca. 1864. Chromolithograph touched with oil, 11 3/4″ × 10″.*

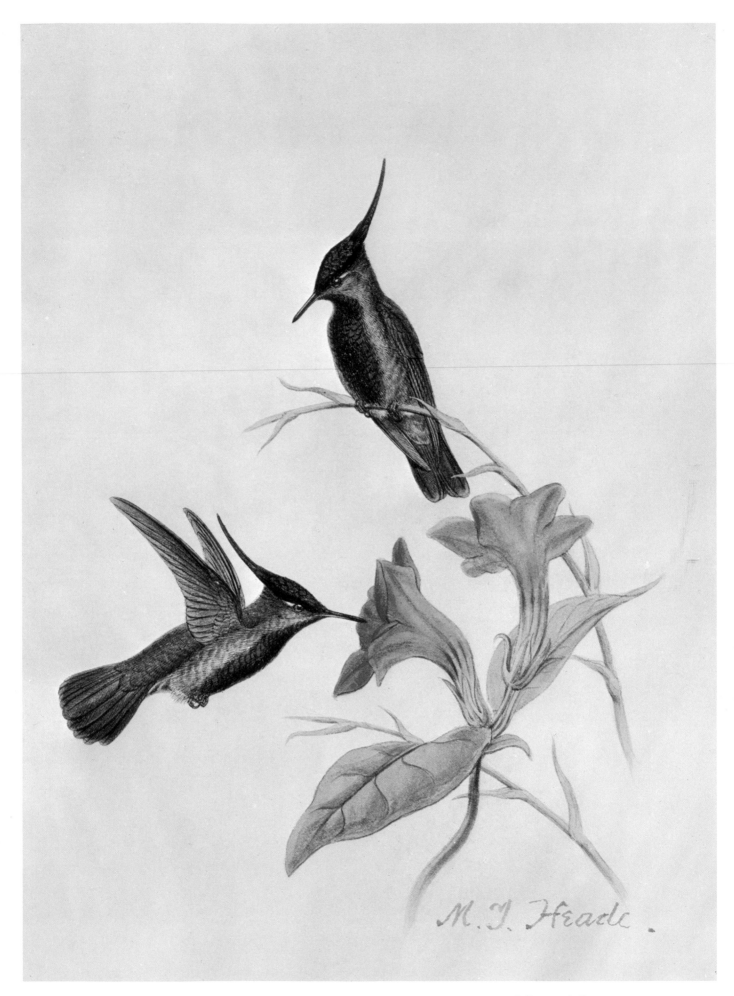

Two Hummingbirds and Spray of Flowers. *N.D. Pencil, pen, and watercolor on paper, 11 3/8″ × 8 3/8″.*

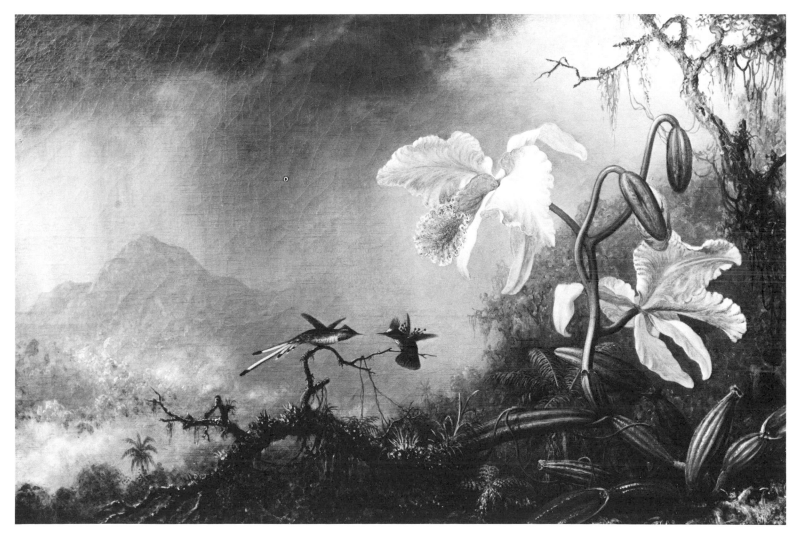

Two Fighting Hummingbirds with Two Orchids. *1875. Oil on canvas, 17 1/2″ × 27 3/4″.*

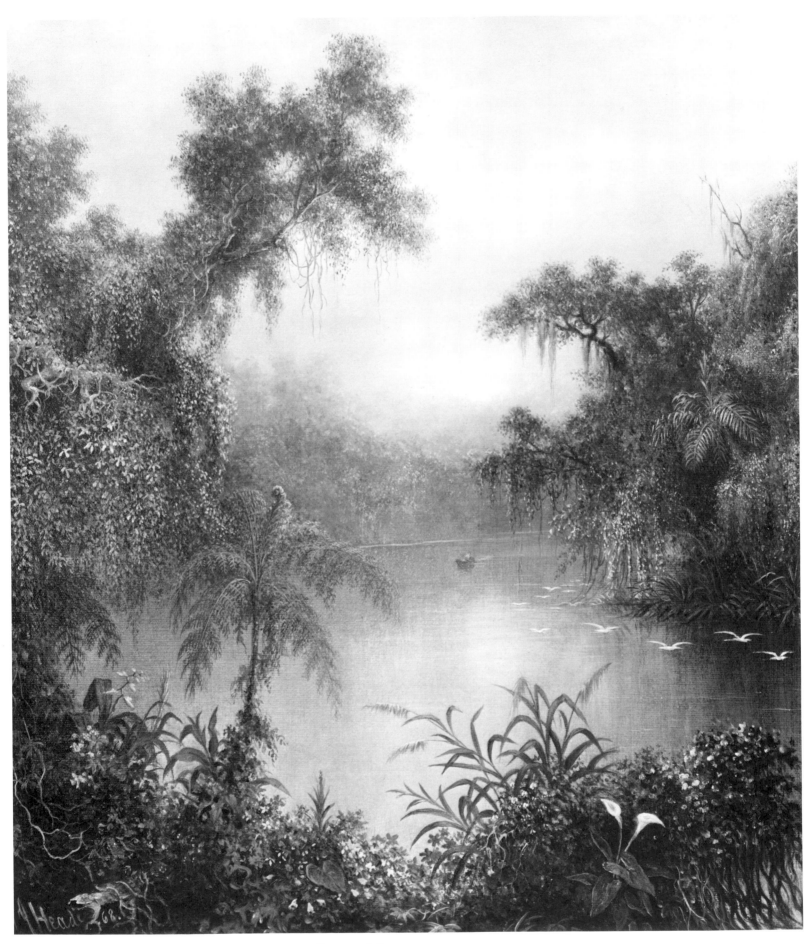

South American River. *1868. Oil on canvas, 26" × 22 1/2".*

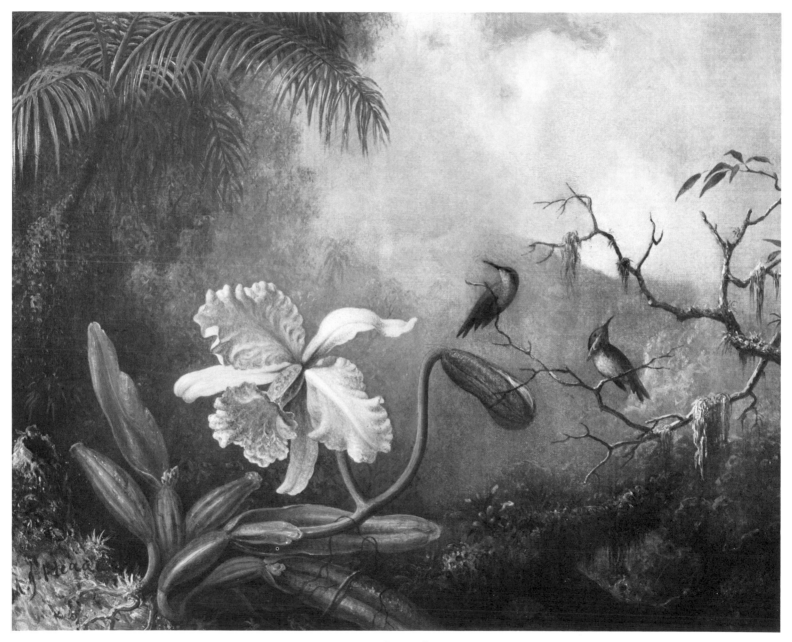

Orchids and Hummingbirds. *Ca. 1885–95. Oil on canvas, 16″ × 21″.*

Abbott Handerson Thayer
1849 · 1921

THE WORK of Abbott Thayer and his son Gerald is another example of the intense commitment by an artist to the advancement of scientific knowledge. Known as a fashionable portraitist and a painter of ideal feminine beauty, Abbott Thayer was at the same time actively pursuing scientific studies focused on the understanding of the primary principles of animal coloration.

Abbott Handerson Thayer was born August 12, 1849, in Boston, Massachusetts. His father, Dr. William Henry Thayer, was a physician at Massachusetts General Hospital. Thayer's youth was spent at Newton Centre outside Boston; at Woodstock, Vermont, while his father taught at Vermont Medical College; and at Keene, New Hampshire, his mother's home. Dr. and Mrs. Thayer were active Unitarians and were very interested in public works and natural science. While at Newton Centre, they organized a Tree Society to protect the rural character of roadways, a book club for the circulation of new reading materials, and a Lyceum for winter lectures where Ralph Waldo Emerson and Oliver Wendell Holmes spoke.

Both at Newton Centre and at Woodstock, Abbott and his sister Ellen roamed freely in the wooded areas near their home. When they moved to Keene, Abbott was seven, and he began his collection of bird eggs and his study of Audubon's work about this time. He was eleven when he started a journal listing the bird nests and species of birds he found. He also hunted birds, which he stuffed and wired in lifelike positions in much the same way as Audubon had worked. He drew these birds and other animals, working primarily in pencil and watercolor; he seems to have had a talent for drawing, which he developed through these animal sketches. Thayer's love of hunting was encouraged during these years by his contact with his uncle, Henry Handerson.

In 1864 Abbott was enrolled in Chauncy Hall School, the Boston school founded by Abbott's grandfather. Dr. Thayer hoped that Abbott would be a civil engineer, and he felt that Chauncy Hall was a better college preparation than Keene High School. Thayer boarded in Dorchester and during June 1865 he met Henry D. Morse, a Boston jeweler and competent amateur painter who had a studio in his home in Dorchester. Thayer visited him to ask for advice concerning his animal paintings, and Morse was lavish in his praise of Thayer's youthful efforts. He encouraged Thayer to give up watercolors and to apply himself to oils, with which, he assured Thayer, he would have great success. Abbott was so overwhelmed by the effusiveness of Morse's praise that he was ready to devote his life to animal painting; however, his parents encouraged him to remain in school and continue painting in his spare time. While at school he worked on his painting, receiving a number of commissions to do portraits of dogs, for which he was paid up to $50.

By 1867 it was evident to his parents that art was Thayer's field, not civil engineering. At the end of the school term, Thayer joined his parents in Brooklyn, New York, where his father was now a Sanitary Inspector for the Metropolitan Board of Health. A painting of a female wood duck that Thayer painted in 1866 had been exhibited in Brooklyn and brought Thayer a $100 commission for a study of three wild fowl the summer he left school. Thayer also hired a studio and joined the Brooklyn Art School for classes drawing from antique casts. He continued to earn money from dog portraits, but at the same time he began to expand the field of his vision—working on landscape drawings, usually with cattle, producing numerous sketches and finally attempting to transfer these drawings to canvas. Even so, his primary interest remained with animals. He moved his studio and studies to New York City, taking more drawing classes at the National Academy of Design, yet he

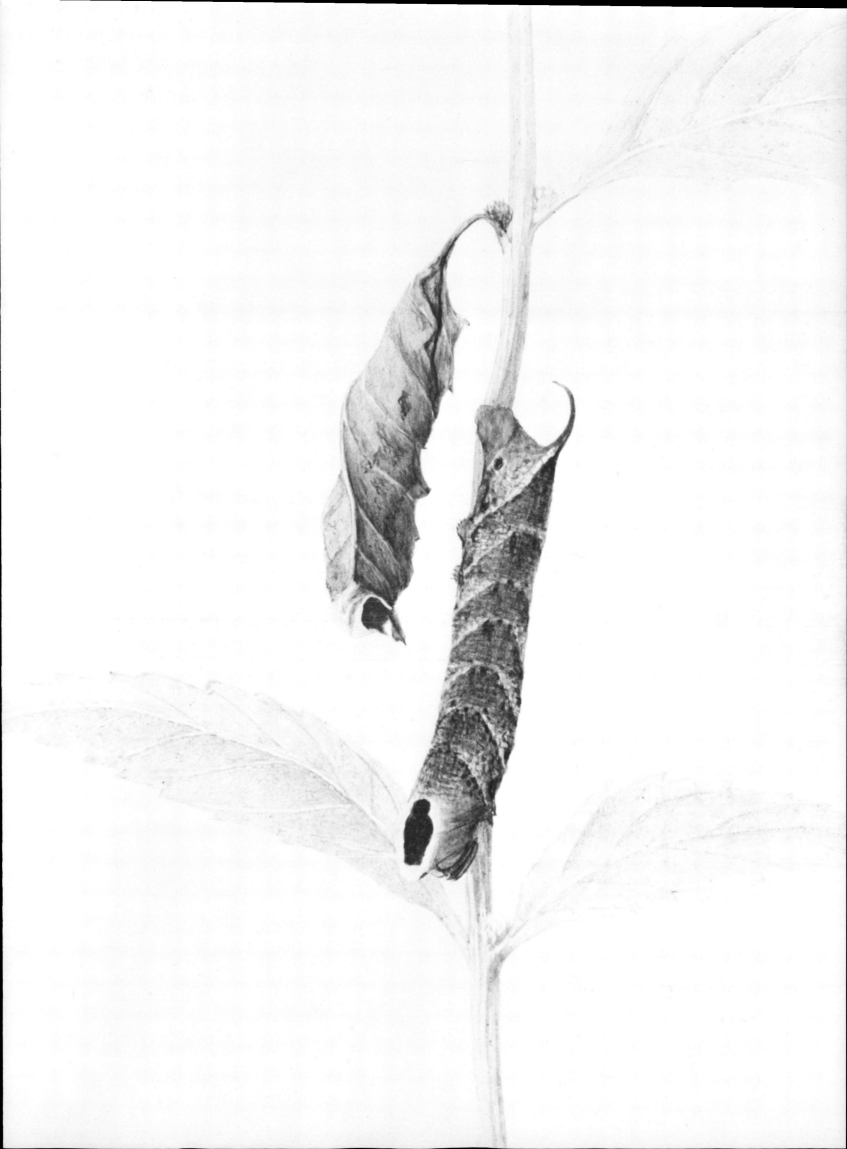

spent much of his time in Central Park sketching the animals in the zoo. At the school he became friends with Maria Oakey (who later married Thomas Dewing), George deForest Brush, and Daniel Chester French.

In June 1875 he married Kate Bloede, a friend of Maria Oakey, and with money from several commissions they sailed to Europe, bound for Paris where Thayer planned to study. The next four years they spent in Paris; during the summers, they traveled in the country and Thayer worked on developing his landscapes. At first he was only able to gain admittance to Lehmann's drawing class—where he worked again from the cast—but the following April, the month after his daughter Mary was born, Thayer was accepted into the Life School under Jean Léon Gérôme at the Ecole des Beaux-Arts. Thayer would often stress how very important were the discipline and direction he found while studying with Gérôme. To him, this was the sound basis upon which the rest of his painting career was built.

When Thayer and his wife returned to America in 1879, he began painting portraits. He became an established portraitist and was in considerable demand. During the 1880s Thayer and his family—now including his daughter Mary, born 1876 in Paris; his son Gerald, born 1883 in Cornwall, New York; and Gladys, born 1886 in South Woodstock, Connecticut—moved several times. They always lived near New York City, where Thayer had a studio and taught in the winter months, and spent summers away from the city in Connecticut, New Hampshire, or other areas in New England.

In the summer of 1890, Thayer was inspired to start a picture of his daughter Mary after seeing her pose as a Madonna in a tableau given to benefit the Dublin, New Hampshire, Library. This painting, *The Virgin Enthroned* (National Collection of Fine Arts), was completed in 1891 and was the earliest of a long series of paintings of the ideal woman Thayer did, using his daughter Mary, his neighbor Elise Pumpelly, or his daughter-in-law Alma as the central models. Thayer's reputation as an artist was based as much on the popularity of these ideal figures as it was on his other work in portraiture, landscape, or still life.

By 1890, however, Thayer was devoting nearly as much time to his collecting and hunting as he was to his painting. Thayer had occasionally taken time away from his painting to relax on hunting or collecting trips, but the split in his activity became more pronounced as his son Gerald became older. The time Thayer spent in the woods began to assume an added significance for him, since his closeness to nature was both deeply satisfying and beneficial to him. Thayer tended to expend his energies on his painting to an extreme degree, working until a painting would lose from his attention. He often said that he could work about three days at a time, and then he needed to get away from his canvases so the first flash of his vision would not be ruined. He said walking in the woods, hunting, or working on his bird skins allowed his "imp" to become ready before he went to his studio to work more. He also felt that the close observation of nature was his true color study, and it was this that allowed him to paint as he did. It disturbed Thayer that even many of his friends did not understand the close relationship between his art and his scientific studies. To him, the two fields were as two children, each holding one of his hands. Neither child could run too far ahead without his bringing the second child as far, or one of the two would be beyond his reach. It is impossible to truly understand Abbott Thayer if one ignores his scientific work, since the science was a major part of more than half his career.

The Thayer children's upbringing was patterned after their father's; they shared his free, outdoor

Blue Jays in Winter. *Ca. 1900–9. Oil on canvas, 22 1/8″ × 18 1/8″. (Abbott Thayer)*

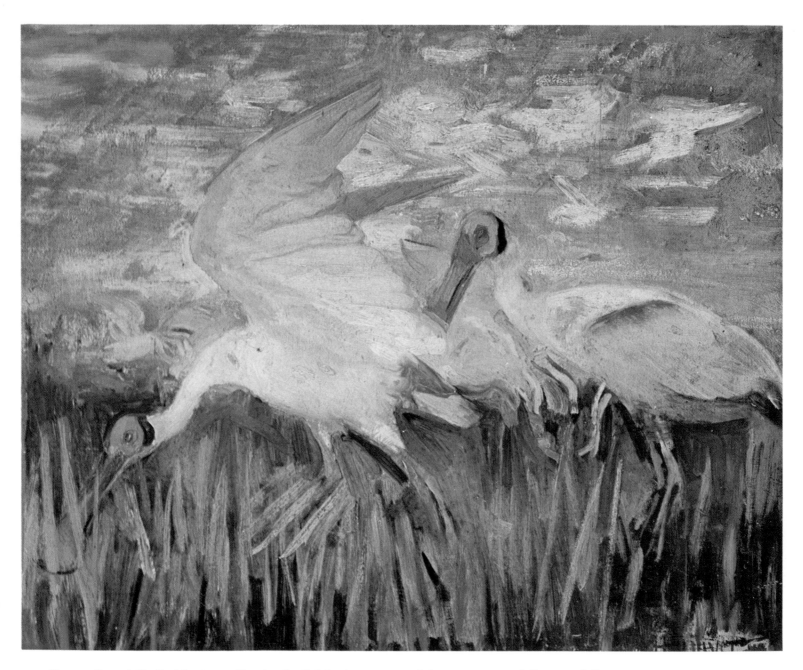

Roseate Spoonbills (In Morning or Evening Sunlight). *Ca. 1900–9. Oil on canvas, 22 7/8″ × 26 1/4″. (Abbott Thayer)*

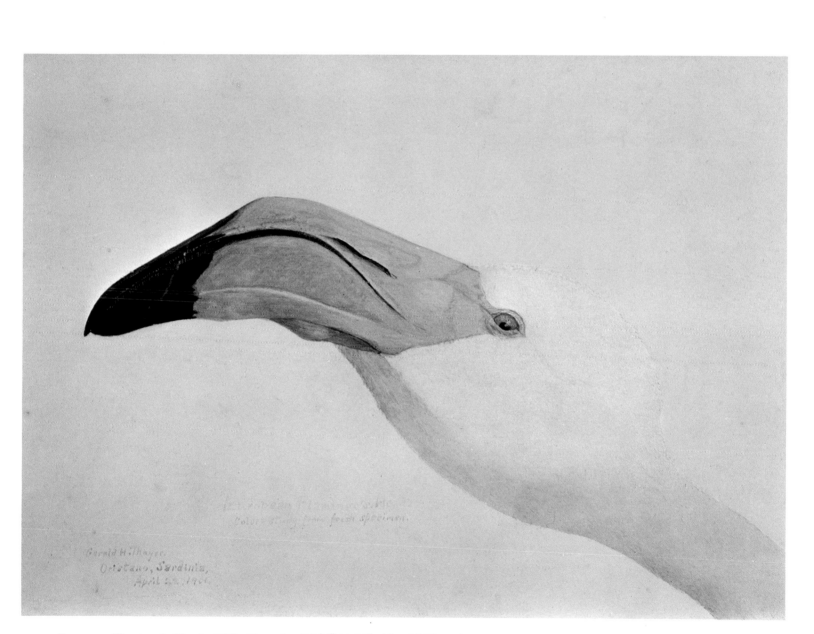

European Flamingo's Head. *1901. Gouache, 7 1/4″ × 10″. (Gerald Thayer)*

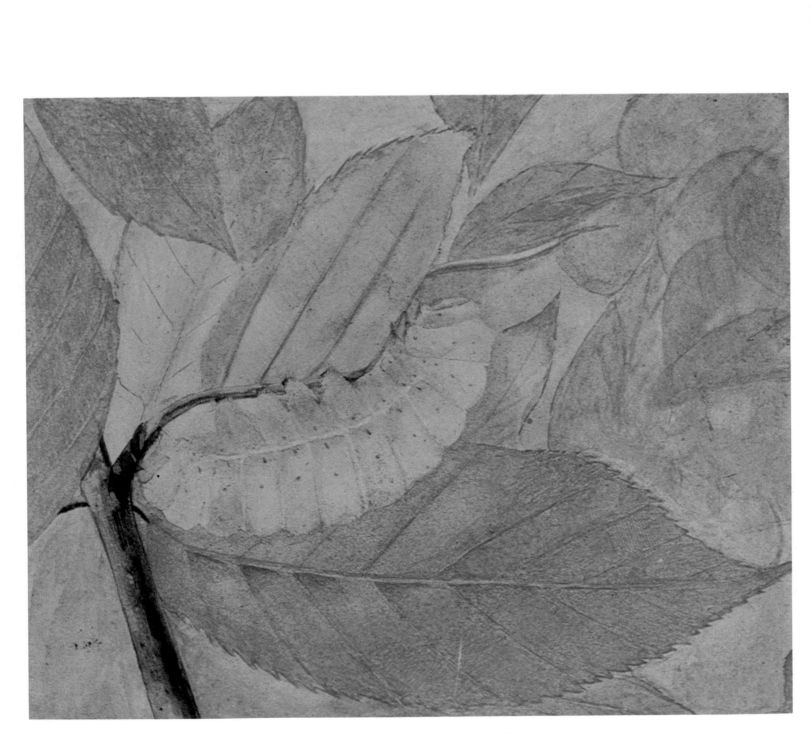

Luna Caterpillar in Position. *Ca. 1900–9. Watercolor on paper, 3 13/16" × 4 5/8". (Gerald Thayer)*

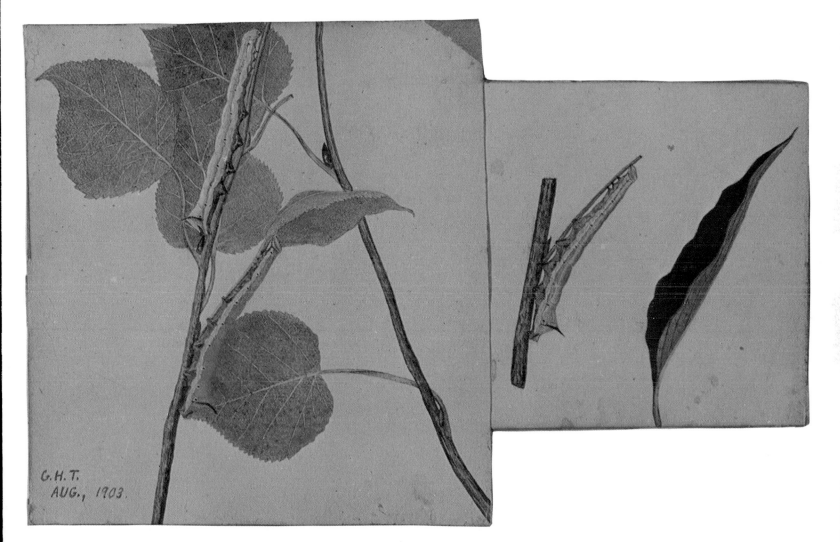

Mirror-Back Caterpillar Reflecting Sky-light, Leaf-green, and a Red Leaf. *1903. Watercolor on paperboard, 5 1/16″ × 7 7/8″ (irregular sheet)*.

Copperhead Snake on Dead Leaves. *Ca. 1900–9. Watercolor and pencil on paperboard, 9 9/16″ × 15 9/16″. (Abbott Thayer, assisted by his son Gerald, his wife Emma, and Rockwell Kent)*

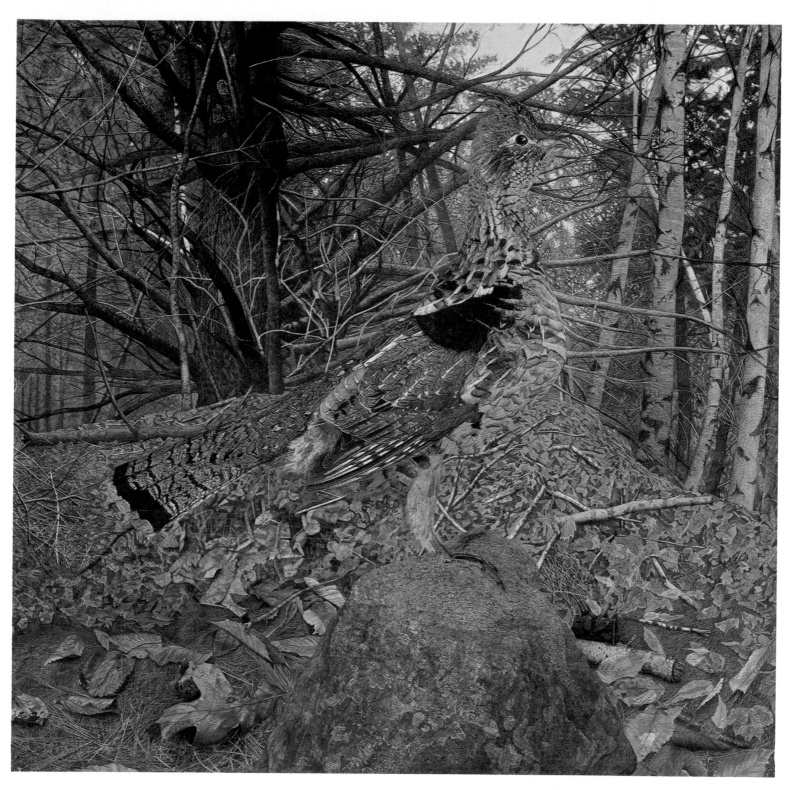

Male Ruffed Grouse in the Forest. *Ca. 1905–9. Watercolor on board, 19 3/4″ × 20″. (Gerald Thayer)*

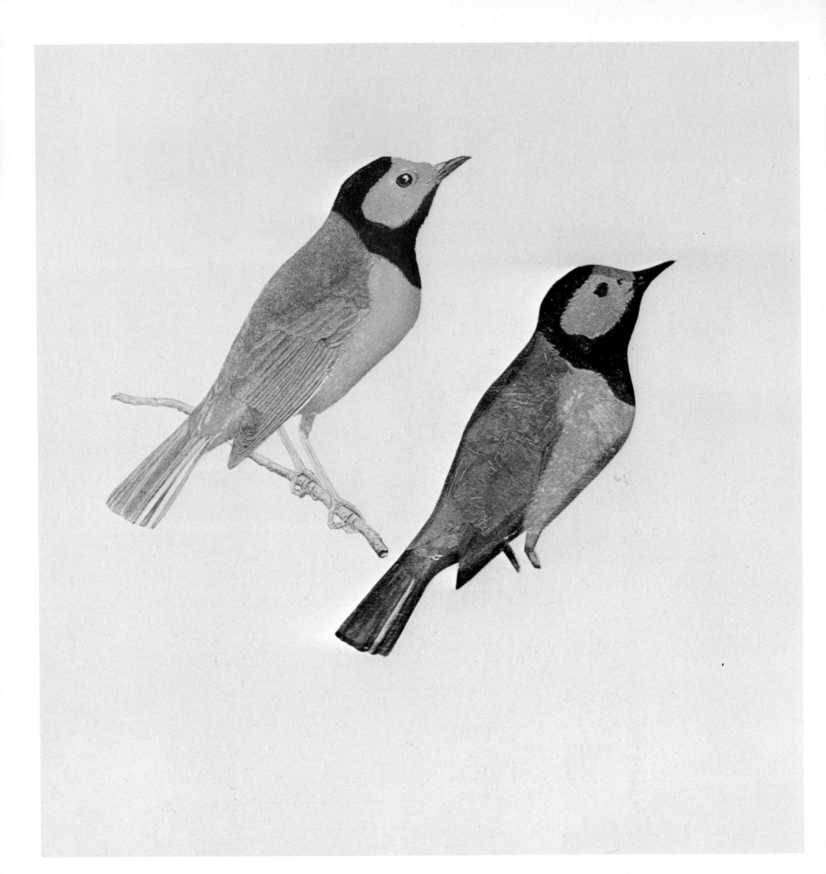

Hooded Warbler and Sunlit Foliage. *Ca. 1900–9. Watercolor on paper, stencil, and oil on wood, 11 9/16" × 9 7/8". (Gerald and Gladys Thayer)*

lifestyle. Gerald, particularly, was encouraged in his natural history interests, and he and his father collected a considerable number of bird specimens, which they identified, stuffed, and stored in flat drawered cases. It is from these specimens that Gerald began his watercolor studies of birds, painting the *Blue Jay* (p. 178) when he was about twelve, and the *European Great Snipe* (p. 179) and the *European Flamingo's Head* (p. 171) at age fifteen from specimens collected during the family trip to Europe in 1894.

During the early 1890s Thayer began to evolve his theory of concealing coloration. Although Thayer's work eventually culminated in a book published in 1909, his central basic principle was first published in 1896. His article "The Law Which Underlies Protective Coloration" appeared in *The Auk,* the journal of the American Ornithologists' Union (A.O.U.). This theory stated that an animal's concealing capabilities were not solely a matter of being colored like the animal's environment—mimicking—but hinged directly on the distribution of color on the animal's body. He proved conclusively that in many animals the basic concealing property was a product of being colored darkest where the animal is most exposed to sunlight and lightest where it's least exposed to sunlight (A). The strong light from the sun on the darker parts tends to lighten them, and the cast shadow reflected onto the lighter parts from the ground tends to darken them (B). Thus, the two

effects tend to cancel each other out and the animal appears invisible through the obliteration of its outline (C). The animal becomes an indistinguishable part of its environment. To take the theory one step further, Thayer adds the idea that an animal's body surface is patterned so that it becomes a picture of the background one would see if the animal were transparent, as shown in the *Male Ruffed Grouse in the Forest* (p. 175). Significantly, the animal's markings usually imitate those surroundings it would choose when involved in its most vulnerable activities, such as feeding or nesting. Of course, these protective markings conceal the animal from its natural predator's eye level, not from man's eye level. Even animals which appear to be brightly colored when removed from their environment, are actually patterned as if they were the sunlight and shadow foliage patterns of trees or shrubs.

Thayer used a number of devices to demonstrate his theories. A stencil technique is used in the *Hooded Warbler* (p. 176) to create what appears to be a bird on the right. This "bird," however, is actually just a portion of a painting of sunlit leaves. Similarly, the brightly patterned **Peacock in the Woods (p. 40)** and the *Copperhead Snake on Dead Leaves* (p. 174) seem to become a part of their surroundings. Thayer also painted settings as in the *Male Wood Duck in a Forest Pool* (p. 46) using only the color values found in the species' natural plumage. The entire series of caterpillar studies demonstrates reverse countershading, since most caterpillars hang from leaves with their backs away from the light. They also demonstrate a type of mimicry, with the caterpillars appearing to be a part of the plant or leaves on which they normally feed. The additional extensions of the basic counter-shading principle are detailed in Gerald's book *Concealing-Coloration in the Animal Kingdom,* covering virtually the entire range of species.

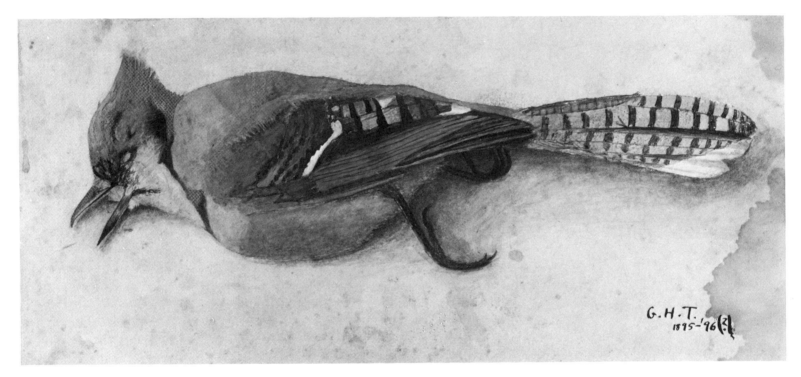

Blue Jay. *1895–6. Gouache, 6″ × 12 3/4″. (Gerald Thayer)*

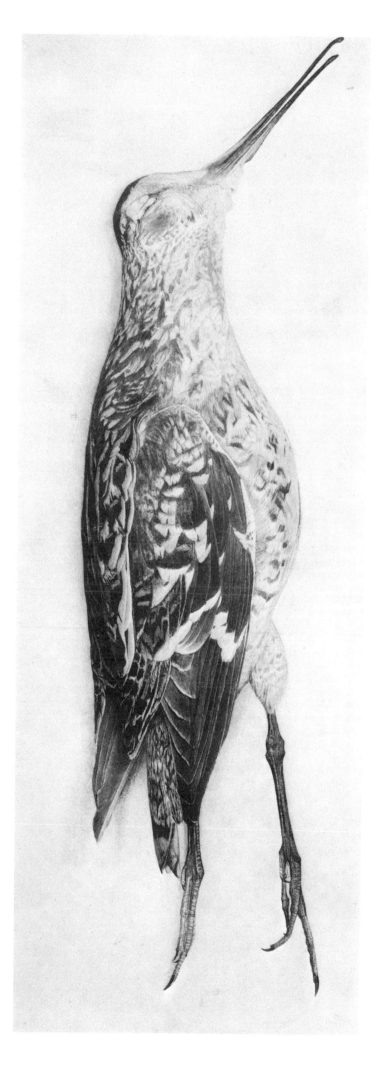

The initial reaction to Thayer's theories was generally favorable and his theory was further supported by Edward B. Poulton, an entomologist at Oxford University, who had noticed the counter-shading in caterpillars in 1886. Poulton credited Thayer with discovering the universal application of the principle in his essay "The Place of Mimicry in a Scheme of Defensive Coloration."

Frank M. Chapman, for many years a curator at The American Museum of Natural History, New York, and Associate Editor of *The Auk*, was also an early convert to Thayer's theories. He was one of the first to be tested by Thayer with counter-shaded duck decoys in the spring of 1896. At the November meeting of the A.O.U. that year in Cambridge, Massachusetts, Thayer demonstrated his theories to the entire group. This 1896 meeting was a crucial point not only for Thayer, but for Louis Agassiz Fuertes as well. This was the first A.O.U. meeting attended by Fuertes and his friendship with Thayer dates from this time. Fuertes would study and work with Thayer, and would become a close friend of Gerald Thayer. Fuertes also would assist with several of the insect studies for the book on concealing coloration.

Between the 1896 article and the 1909 book, Abbott Thayer became deeply committed to the universal truth of his basic theory. He insisted so strongly in its truth in all its applications that he alienated many, like Chapman, who could accept the theory in relation to many species, but not all. Thayer insisted, for example, that blue jays were the color of shadows on snow (*Blue Jays in Winter* p. 169) even though many jays inhabit areas with virtually no snow, and that flamingoes and roseate spoonbills are the color of the sky at sunset or dawn, when they feed (*Roseate Spoonbills* p. 170). The insistence on the universality of his theory not only cost Thayer some converts, but it also caused a deeply felt frustration over the years. In a letter

to *The Auk* in 1913, Thayer wrote that he was sending his periodic plea for understanding and acceptance of his theory. Even though he had spent so many years slowly formulating the theory by a thorough examination of nature, he found it difficult, if not inconceivable, that people could not immediately grasp the truth of his findings.

Throughout the years of work on concealing coloration, the most intense criticism Thayer received was from Theodore Roosevelt, who was given a copy of Thayer's book while working on his own, *African Game Trails*. In an appendix to that book, and a year later in an extensive 111 page article in the *Bulletin* of the American Museum of Natural History, Roosevelt blasted Thayer's theories. It was a case of two immovable forces meeting in a two-year word battle. Thayer felt that his theories were not open to discussion, and he told Roosevelt that not only was this the case, but that Roosevelt would be convinced of Thayer's theories if only he would come and see the demonstrations Thayer was giving. Roosevelt, on the other hand, credited what he called a mis-statement of the truth by Thayer to an enthusiasm occurring in people of a certain artistic temperament. Since Roosevelt had spent much time hunting big game and considered that he had more field experience than Thayer in many of the areas Thayer discussed, Roosevelt refused to accept anything he said. Thayer, meanwhile, demanded Roosevelt's total acceptance. The two men never met together, nor ever resolved their differences. Thayer found his support and his defenders elsewhere.

One of the most active periods for Thayer was during World War I. Thayer believed that his ideas regarding background picture patterns could be incorporated into camouflage techniques for men and machines, making it much more difficult to identify sniper placement, gun implacements, and other situations where secrecy would be im-

portant. Initially, Thayer had little luck convincing the authorities in Washington, D.C., or in London at the British War Office. Even with the help of his friends when he went to London in 1915–16, Thayer was not able to get his practices adopted early in the war. John Singer Sargent was one who carried Thayer's camouflage exhibits to various officials in London. Particularly upsetting to Thayer was the information he received indicating that the Germans had developed camouflage techniques using Thayer's theories, before the Allies would adopt his ideas. It was only during World War II that full-scale camouflage techniques would be developed, and in 1942 Herbert Friedman in *The Natural-History Background of Camouflage*, and Major Robert P. Breckenridge in *Modern Camouflage* would credit Thayer with developing the foundations of modern camouflage techniques. His ideas were more suited to the camouflage of land forces, both from land and air attack, even though Thayer centered most of his efforts on promoting his ideas on marine camouflage.

When the *Titanic* sank in 1912, Thayer wrote an article explaining the invisibility during the night of some white objects at sea, such as icebergs. Even though his idea to paint the ships white was not adopted—primarily due to constantly changing conditions in marine situations—the camouflage techniques for ships finally developed by the U.S. and England owe something to Thayer's ideas. One U.S. ship camouflage paint system using a blue-white color scheme was named Thayer Blue in honor of his work.

Thayer's theories were given more widespread publicity through an exhibition of concealing coloration studies shown in many cities beginning in 1918. The exhibit included all the work by the Thayers reproduced here except the *Male Ruffed Grouse in the Forest* (p. 175), which had already been acquired by The Metropolitan Museum of

Sphinx Caterpillar in Position. *Ca. 1900–9.*
Watercolor and pencil on paper, 4 3/4″ × 3 5/16″.
(Gerald and Emma Thayer)

Sphinx Caterpillar Inverted. *Ca. 1900–9.*
Watercolor and pencil on paper, 3 15/16″ × 3 9/16″.
(Gerald and Emma Thayer)

Unspotted Beech-Leaf-Edge Caterpillar in Position and Detached. *Ca. 1900–9. Watercolor on paper, 3 15/16″ × 6 1/8″. (Gerald and Emma Thayer)*

Crumpled-Leaf Caterpillar in Position, Back-View and Side-View *(center)*; Crumpled-Leaf Caterpillar Detached *(lower left)*. *Ca. 1900–9. Watercolor and pencil on paperboard, 4 5/8″ × 3 3/4″. (Gerald and Emma Thayer)*

Art in 1916. Also included in the exhibit were "paintings" created entirely with bird feathers, as well as many more examples of Thayer's stencil techniques and paintings, all illustrating his concealment theories. The exhibit, with a short essay in the catalog referring to camouflage, was still being circulated in 1922, and the theories were further explained by Gerald Thayer who often lectured for professional and amateur artistic and scientific groups on "Camouflage In Nature and In War."

Abbott Thayer's interest in wildlife did not extend solely to concealing coloration and its application to camouflage techniques. Thayer was instrumental in setting up a warden system to patrol breeding areas of sea birds during a period when commercial usage of bird plumage was at its peak, particularly for use as decorations on ladies' hats. Thayer raised over $12,000 toward a fund to pay the wardens to enforce the laws already passed for the protection of nesting birds from Massachusetts to Virginia. William Dutcher, a member of the A.O.U. Committee on Bird Protection, hired the wardens and paid them from the Thayer Fund between 1900 and 1905, at which time the National Association of Audubon Societies was able to provide financing to continue the program under its direction. The money Thayer raised was also used for publicizing the need for better bird protection laws and comprehensive protection was passed in most coastal states as a result.

Gerald and Abbott Thayer also undertook in 1910 an attack on several people who were trying to buy property that included a nearby mountain, Monadnock, the source of many of Abbott Thayer's landscape paintings and the place where he made many of his observations leading to his theories on concealing coloration. With the aid of the Society for the Protection of New Hampshire Forests, Gerald and Abbott Thayer were able to trace the original owner of the property, and from his descendents they acquired about 700 acres of the land for a forest reservation. The area included the northeast portion of the mountain and its summit, and was to be preserved by the Society as a wild forest for generations to come.

Thayer continued to devote his energies to his painting and scientific studies. He seemed to always expend more of himself than was practical, and in May 1921, Thayer suffered a stroke; he died on the 29th. Abbott Thayer had strongly disliked both undertakers and the clergy, and he left strict instructions which his son Gerald and his friends followed in making the arrangements for Thayer's cremation. Gerald then scattered the ashes at the summit of Monadnock to fulfill Thayer's last request that in death he be allowed to rejoin the mountain which had been such an important part of his life.

Louis Agassiz Fuertes
1874 · 1927

Louis Agassiz Fu

(Preceding page)
Mallard and Black Duck. *Pub. 1918.*
Watercolor on paperboard, 10 7/8" × 14".

Arctic Tern. *Ca. 1900.*
Ink wash on paperboard,
14 5/8" × 11".

THE MAN in whom all the elements of artist and naturalist would combine in perfect balance was born on February 7, 1874, in Ithaca, New York. Louis Agassiz Fuertes was the son of Estevan Antonio Fuertes, a respected consulting engineer hired as a Professor of Civil Engineering at Cornell University the year before, and of Mary Stone Perry, a woman of considerable musical ability. It was ironic that Fuertes chose to name his son for the brilliant naturalist Louis Agassiz, who had been a visiting professor at Cornell and had died the December prior to Louis Fuertes' birth.

Early in his childhood, Fuertes developed an intense interest in nature and particularly in birds. He and one of his sisters kept a zoo that included a variety of creatures, and Louis studied the birds he found, both delighting in their activities and trying to understand the intricacies of their form. He felt he was extremely fortunate to be exposed at quite an early age to Audubon's *The Birds of America*, which was housed in the Ithaca Library. The grandeur and lifelike qualities captured by Audubon increased Fuertes' longing for knowledge of the birds; it seemed to Fuertes that Audubon shared his own feelings regarding the exquisite form and beauty of a bird. Fuertes began sketching birds in his early teens, making accompanying notes as a means of study. Throughout his high school years he continued to accumulate these drawings, and his carefully collected observations were to qualify him for associate membership in the A.O.U. when he was only seventeen. His drawings, though still somewhat crude, captured the spark of life even in his very early attempts, as he was guided by what he actually saw, not by rules on how to draw learned in a classroom.

When he graduated from high school, Louis was enrolled at Cornell in the College of Architecture. His father wanted him to study for a career as a civil engineer or architect. Louis thoroughly enjoyed his college days. He reveled in the company of others; he was a gifted story teller and a great lover of jokes and of interesting conversation and companions. Although he did not receive high grades except in courses such as Zoology and Drawing, he participated actively in his fraternity, Alpha Delta Phi, and also in the Glee Club, having inherited his mother's musical abilities.

It was through a friend in the Glee Club, Charles Henrotin, that Fuertes' future would take a new direction. Henrotin was the nephew of Elliott Coues, one of the foremost ornithologists of the period, and he arranged a meeting between Coues and Fuertes during a Glee Club trip to Washington, D.C., in December 1894. The meeting changed Fuertes' life, for from that moment he was determined to become a professional painter of birds. Coues was extremely impressed by Fuertes' work and decided to help him establish his career. The support of Coues was invaluable, as Fuertes' father did not encourage his work and resisted Fuertes' attempts to make a profession of ornithological illustration.

Though Fuertes was not able to attend, Coues took about fifty of Fuertes' paintings to exhibit at the A.O.U. meeting in 1895. The exposure resulted in commissioned drawings for Florence Merriam's oook *A-Birding on a Bronco* and for the new periodical *The Osprey*. Coues also secured a commission for Fuertes to illustrate *Citizen Bird*. This was a substantial commission for a young man, as the book written by Coues and Mabel Osgood Wright contained 111 illustrations. Even at this early point in his career, the strength and beauty of Fuertes' work was so great that he was being heralded as the equal or the superior of John James Audubon.

Of more crucial importance to his development as an artist, however, was his attendance at the November 1896 meeting of the A.O.U. in Cam-

Gambel's Quail. *Pub. 1905. Pencil and ink wash heightened with white on paperboard, 9 1/8″ × 7 3/8″.*

Jackrabbit. *Ca. 1903. Ink wash on paper, 7 7/8″ × 10 1/2″.*

bridge. It was here that Fuertes met Abbott Thayer when he was first making known his coloration theories. At the meeting Fuertes expressed views on coloration which interested Thayer, and so he wrote to Fuertes and asked him to come and visit and talk of coloration. It was only later, when he read the account of the meeting in *The Auk*, that Thayer realized Fuertes was an artist; he then offered to take Fuertes into his home, teach him, and help him develop his already considerable talent. Thayer was a firm believer in the value of academic training in developing one's ability to see, and wanted to train Fuertes to see in such a way that he could paint the truth without reshaping it.

During the summer of 1897, following his graduation from Cornell, Fuertes went to Dublin, New Hampshire, to stay with the Thayers. He spent the mornings painting and the afternoons wandering with Abbott and Gerald Thayer in the country. The Thayers lived a free, and at the same time ordered, life, with an emphasis on outdoor and group activities. Music, plays, and reading — particularly the works of Robert Louis Stevenson — enlivened their evenings.

The following year Fuertes was invited to join Abbott and Gerald Thayer and another young artist-naturalist, Charles R. Knight, on a six-week collecting trip to Florida to study migrating birds. This was Fuertes' first experience working in the field and was a foretaste of how he would later spend most of his career. With Thayer helping him to develop artistically and Coues assisting him professionally, Fuertes also continued to develop additional contacts through the annual A.O.U. meetings. In 1899 Edward Harriman sponsored an Alaska Expedition, and C. Hart Merriam suggested that Fuertes be one of the artists included in the large group of scientists and family and friends of Harriman's who would be traveling together for more than two months. Ex-

tended scientific expeditions and collecting trips were an extremely important aspect of developing scientific knowledge at the turn of the century. Fuertes saw, collected, and drew many birds on this trip, such as the *Arctic Tern* (p. 189) and the *Rosy Finch* (p. 48). He witnessed for the first time whales spouting and saw the nesting areas of thousands of sea birds. He met and worked with a number of important naturalists, including John Burroughs, whose official report for the expedition published in 1901 contained sixteen of Fuertes' bird drawings.

Fuertes spent the remaining months of 1899 drawing illustrations for Elliott Coues' *Key to North American Birds*. Although Coues died in December 1899, he had already completed the book. It was published, with more than 200 drawings by Fuertes, in 1903.

Some of Fuertes' most beautiful field studies were executed in 1901, when he accompanied H. C. Oberholser and Vernon Bailey on a U.S. Biological Survey (now U.S. Fish and Wildlife Service) study of the fauna of southwest Texas. It was here he saw the *Roadrunner* (p. 209), *Jackrabbit* (p. 191), and *Vermilion Flycatcher* (p. 193), and at the Grand Canyon of the Rio Grande he drew the *Black Phoebe* (p. 49). Whereas the Alaskan trip had been relatively comfortable and a pleasurable large company, this three-month trip was filled with harsh moments. The heat was incredible and they often lacked water. Traveling by mule, horse, or on foot, they collected specimens both day and night. They slept on the ground and ate their food from the back of a wagon. The trip was enlivened somewhat by a visit to the Painted Caves of the Rio Grande, and Fuertes was able to see the famous Judge Roy Bean when they passed through Langtry.

One of Fuertes' most vivid experiences on the trip involved the collection of a specimen of *Zone-tailed Hawk* (p. 208). Once he had sighted

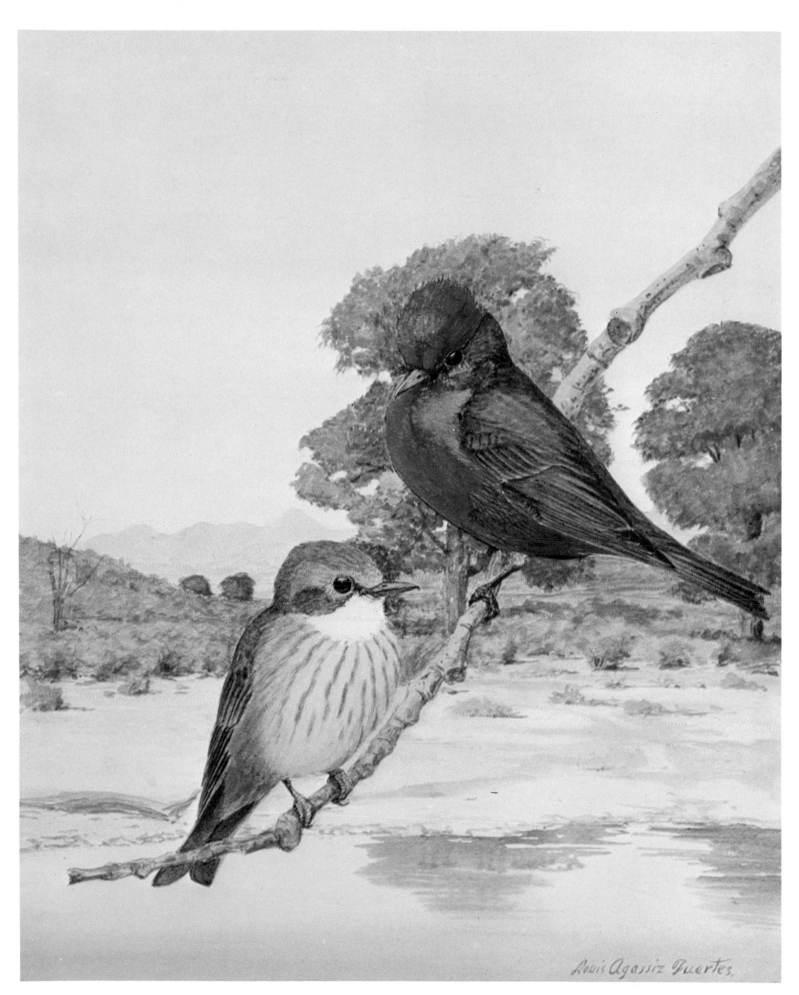

Vermilion Flycatcher, male and female. *Ca. 1901. Watercolor and pencil on paper, 11" × 8 3/4".*

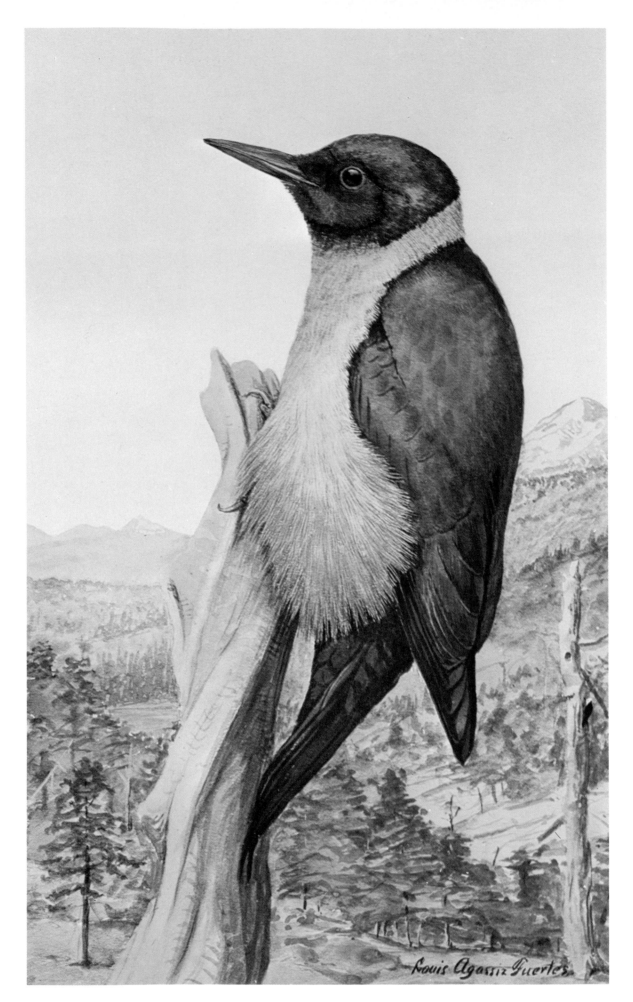

Lewis' Woodpecker. *Pub. 1911. Watercolor and pencil on paper, 11 9/16" × 7 1/8".*

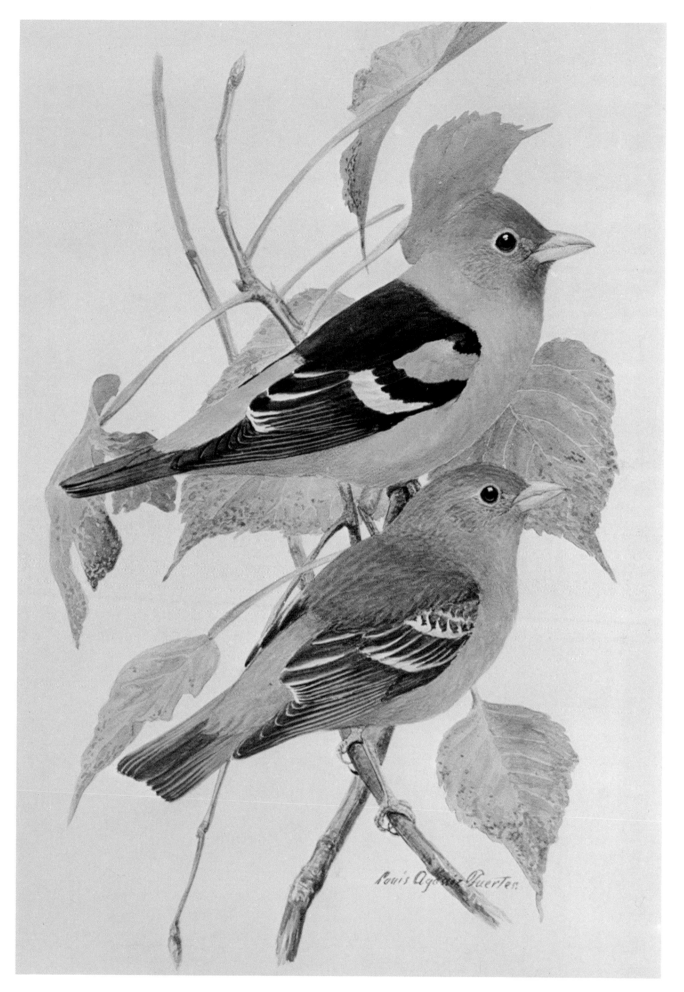

Western Tanager, male and female. *N.D. Watercolor and pencil on paper, 11 7/16" × 7 11/16".*

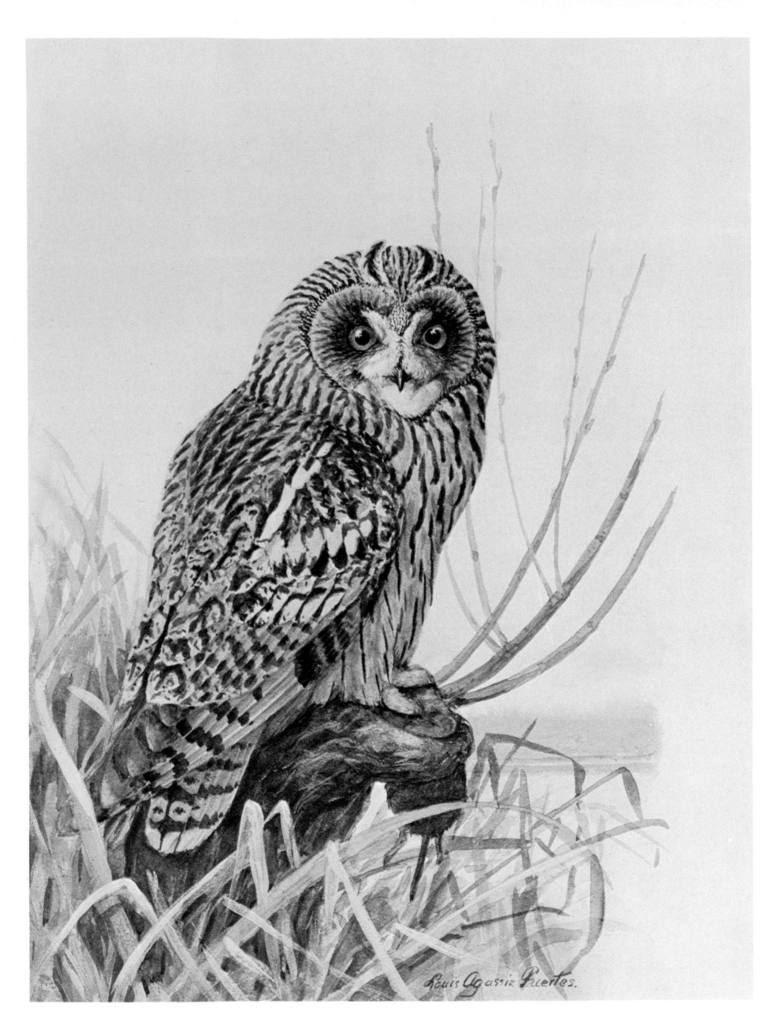

Burrowing Owl. *N.D. Watercolor and pencil on paperboard, 14″ × 10 3/4″.*

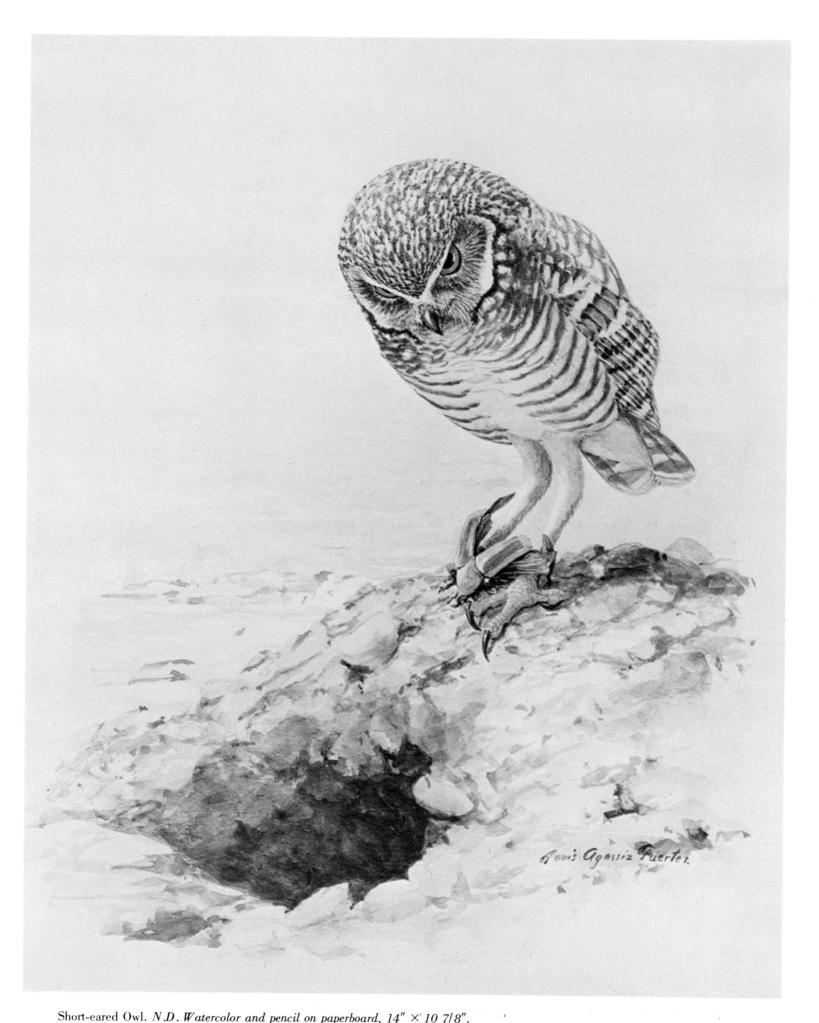

Short-eared Owl. *N.D. Watercolor and pencil on paperboard, 14″ × 10 7/8″.*

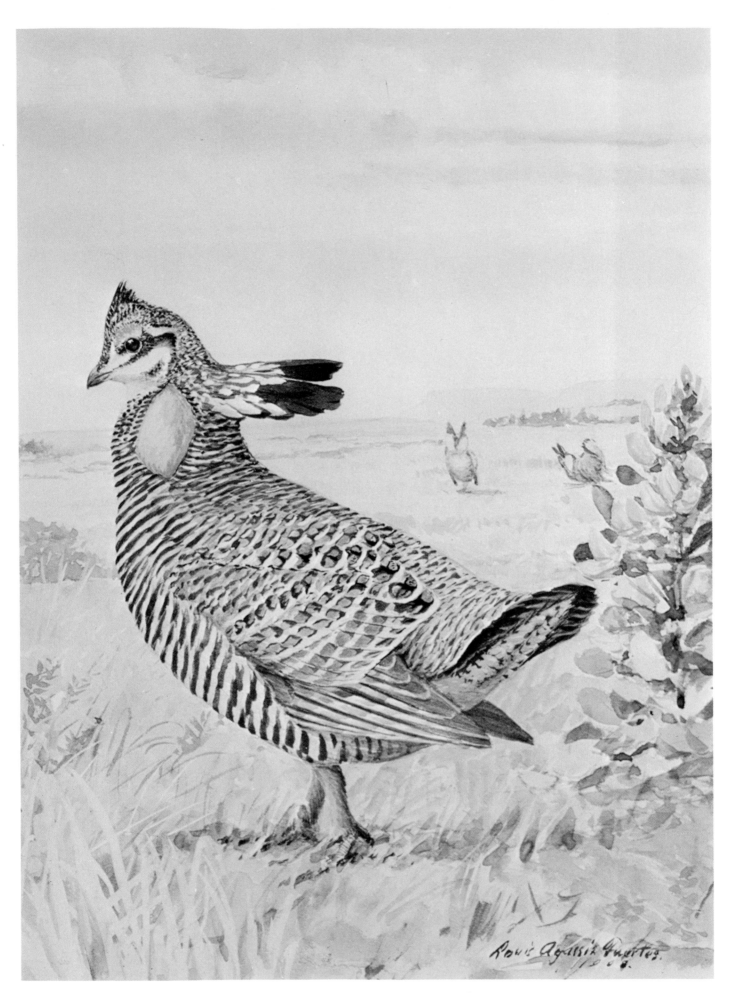

Greater Prairie Chicken. *1908. Watercolor and pencil on paper, 10 7/16″ × 7 5/8″.*

Within the illustration, handwritten:

Aquila-rapax raptor
N'Jabarra, Gojam.
-Mar. 23, 1927-
-(living bird)-

Tawny Eagle

Abyssinian Tawny Eagle. *1927. Pencil and watercolor on paper, 14″ × 10″.*

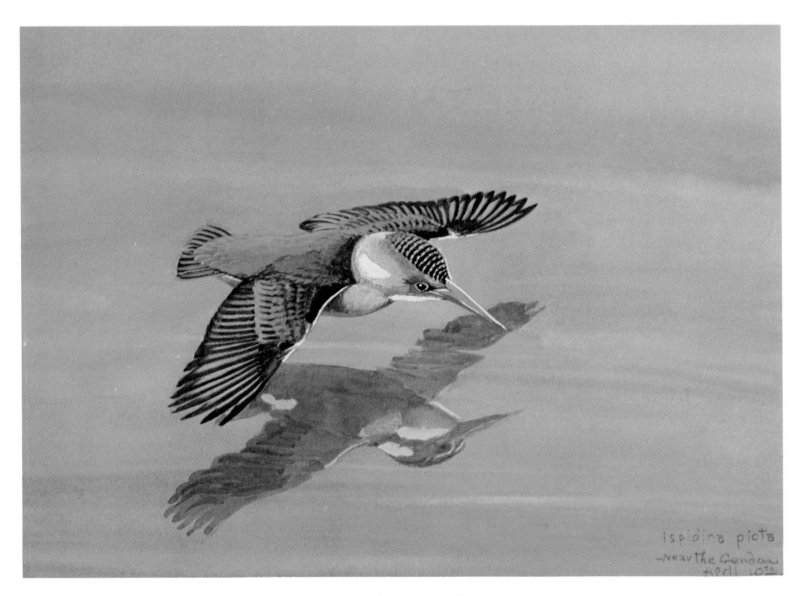

Pygmy Kingfisher. *1927. Pencil and watercolor on paper, 9 3/4" × 12 3/4".*

the hawk, Fuertes was determined to add it to his collection. When he finally was able to shoot the bird after hunting it for three days, the bird's body fell to a ledge part way down a 600-foot cliff. Fuertes went after the specimen and became stranded on the cliff face. Although he had to wait while Oberholser went after a rope to enable him to climb up the cliff with his prize, Fuertes spent the hour singing and watching the lizards and birds on the cliff around him.

The winter following this trip Fuertes spent with the Thayers, relaxing in their company, working on several new commissions, and refreshing himself before his next major trip to the Bahamas with Frank Chapman in 1902. Chapman was trying to gather specimens for the habitat exhibits he was organizing for the Hall of North American Birds in the American Museum of Natural History. Fuertes went with Chapman to make field sketches of the landscape for use in the backgrounds of these displays, as well as to make color studies of the birds as they were caught in the field. Fuertes painted a large mural of nesting flamingos from drawings made on this first trip; the painting still hangs in the museum. Although this trip was shortened when Dr. Chapman became sick with measles, it was only one of many trips Fuertes made with Chapman, continually expanding the habitat groups. Following the A.O.U. meeting in San Francisco, they traveled the Western states in 1903, went to Canada in 1907, to Florida in 1908, to Mexico in 1910, and to Colombia in 1911 and 1913.

Louis Fuertes' life changed very little when he married Margaret Sumner in June 1904. His honeymoon was combined with a collecting trip to Jamaica, during which the bride saw little of her husband. Louis spent the mornings hunting birds and the afternoons skinning and preparing them. This was the only time Margaret accompanied Fuertes into the field. Later, she preferred to stay at home with their son, Sumner, born in 1905, and their daughter, Mary, born three years later. Fuertes was a serious naturalist who was distracted by virtually nothing when he was working, and virtually nothing could sway him in his devotion to his task. He did, however, write long, running letters relaying the news and items of interest from his trips; these he would mail home whenever the opportunity arose. Combined with his journals, Fuertes' letters are a rich treasure of written material describing the work in which he was involved.

Between these trips with Chapman, Louis completed work on many commissions, most of which were for bird guides or periodicals. A major series of works was completed between 1913 and 1920 for *National Geographic Magazine*. The same illustrations that Fuertes executed for a U.S.D.A. Farmers' Bulletin, "Fifty Common Birds of Farm and Orchard," which appeared in June 1913, were reused in May 1914 for Henry Henshaw's article in *National Geographic Magazine*, "Birds of Town and Country." In August 1915 Fuertes produced a large group of drawings to accompany "American Game Birds," another article by Henshaw. To complete hhe series, between 1916 and 1920 Fuertes illustrated two articles on the larger and smaller mammals of North America, both written by Edward Nelson. He also produced illustrations for articles on "The Warblers of North America" and "Our Common Dogs." In December 1920, however, "Falconry, the Sport of Kings" appeared, an article that he both wrote and illustrated. Throughout his career, Fuertes often spoke of the special pleasure he derived from watching birds of prey. Their grace and beauty in combination with their rapacious behavior attracted him strongly. In his portrayal of the *Duck Hawk* or peregrine falcon (p. 213), and in his drawings of the *Burrowing Owl* (p. 196) and *Short-eared Owl* (p. 197), he captured this mixture of characteris-

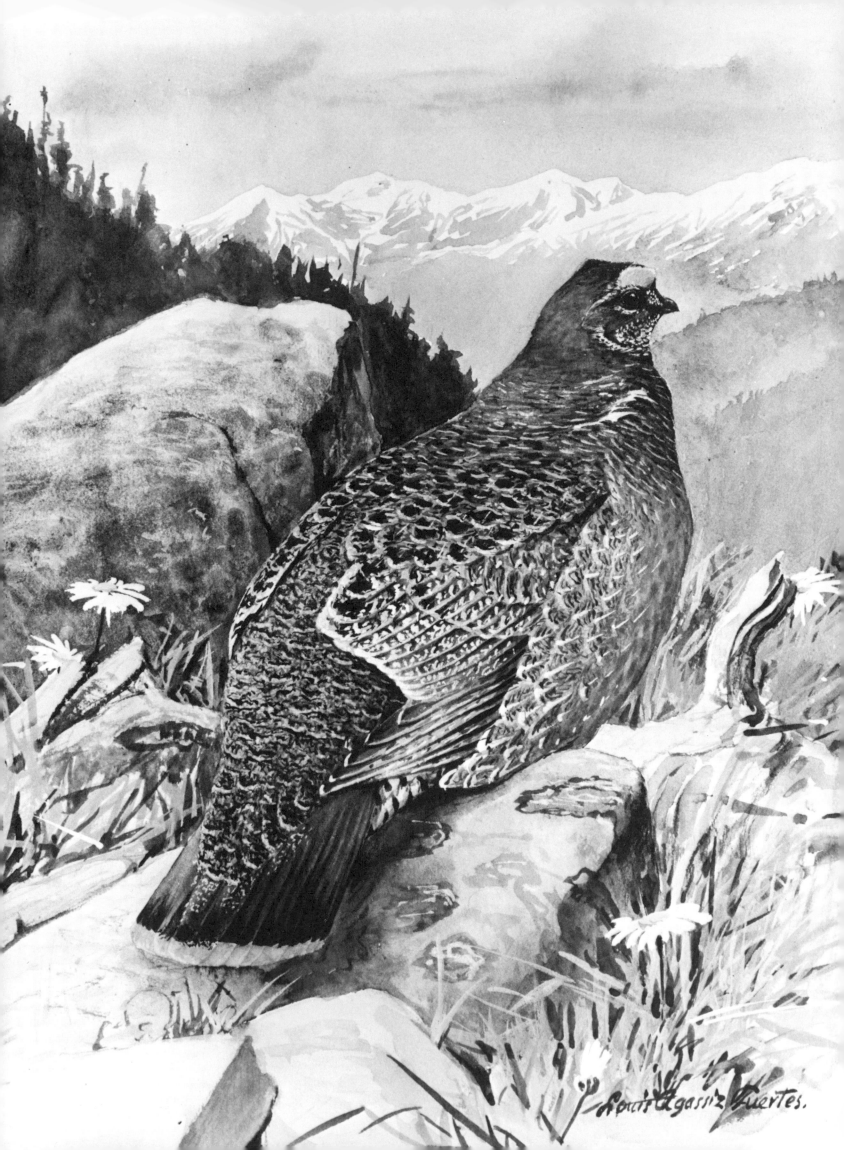

Louis Agassiz Fuertes.

tics, without emphasizing the bloodshed and gore that is an integral part of these predator's lives.

Though the work was demanding, tiring, and time consuming, Fuertes loved it and expended his energies with abandon. He did not have time to paint very much for himself since he had so many commissions to fill, and this was probably his only regret. He enjoyed the change provided by his mammal studies for *National Geographic Magazine,* as he had always felt he might not be able to succeed in portraying animals with the same degree of success he had in portraying birds. He never ceased his studies and was vastly excited by each new bit of information acquired or a species seen for the first time.

One of the high points of Fuertes' career came when he was named a member of the Field Museum of Natural History-Chicago Daily News Abyssinian Expedition. With Wilfred Osgood of the Field Museum, and James Baum, the originator of the expedition, Fuertes sailed to Jibuti, French Somaliland, and traveled from there overland by train to Addis Ababa, Abyssinia (now Ethiopia). The territory was relatively unknown to Americans, and during this extended field trip from October 1926 through April 1927, the expedition collected and recorded practically everything they encountered. The experience was so rich for Fuertes and his excitement was so great that he reacted to the stimulus by producing a breathtaking and varied series of color studies and sketches. The *Tawny Eagle* (p. 199) is portrayed in regal repose, whereas the *Pygmy Kingfisher* (p. 200) is depicted in action, skimming lightly over the water. In his bold, free style, Fuertes recorded the essence of the myriad species of exotic birds, such as the *Long-Crested Hawk-Eagle* (p. 216) that he encountered for the first time. This series of more than 100 drawings he considered to be the best set of field sketches he ever produced on one trip. His journal, published with Wilfred Osgood's in *Artist and Naturalist in Ethiopia,* documented their daily adventures.

Shortly after he returned to America, on August 22, 1927, as Fuertes and his wife were driving home from a visit to the Chapmans', Fuertes' car was struck by a train at a grade crossing, killing him instantly. The Abyssinian drawings which he had taken to show Chapman were somehow thrown clear of the wreck and remained undamaged.

Although his life was cut short by this tragic accident, Fuertes had already achieved a phenomenal success in his profession. Fuertes' greatest achievement was his ability to portray each creature in a manner so true to its actual appearance that it was immediately recognizable. This ability —which every artist-naturalist since Mark Catesby had tried to attain—Fuertes felt he had developed primarily through his years of examining and recording birds in the field. He was also assisted in his work by his knowledge of taxidermy and his facility for preparing specimens in a manner that retained their lifelike qualities. In addition, he made use of his musical talents to reproduce a considerable number of bird songs — not only for entertainment, but to identify or to lure birds to himself in the field. In 1913–14 he prepared six papers based on some of his studies, titled "Impressions of the Voices of Tropical Birds."

Fuertes also utilized his talent for communicating with others to educate as many as possible in natural history. Though he was offered a teaching position at Cornell University, he would only accept a position as Lecturer in 1922, promising a series of ten talks each year. Fuertes stressed in his lectures, and to those who came or wrote to him for advice, the same precepts taught to him by Abbott Thayer—use your eyes, look, study what you actually see, and use the knowledge acquired to produce your work so that the truth of nature will pass through you without change.

Lesser Yellowlegs. *Pub. 1910.*
Ink wash on paperboard,
14 3/4" × 9 7/8".

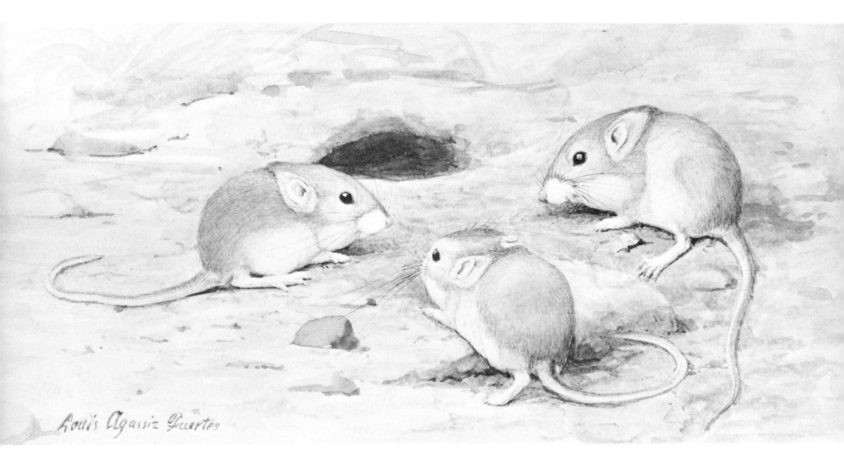

Mice. *1902. Ink wash on paper, 3" × 6 1/2". (Fuertes)*

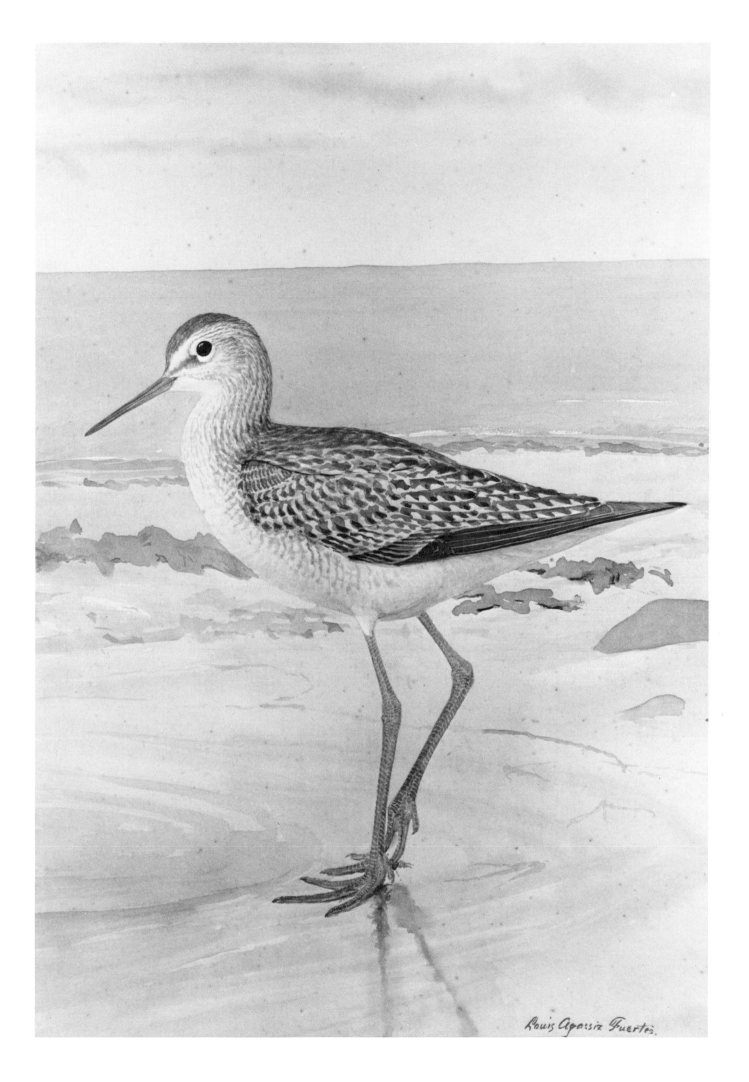

Louis Agassiz Fuertes.

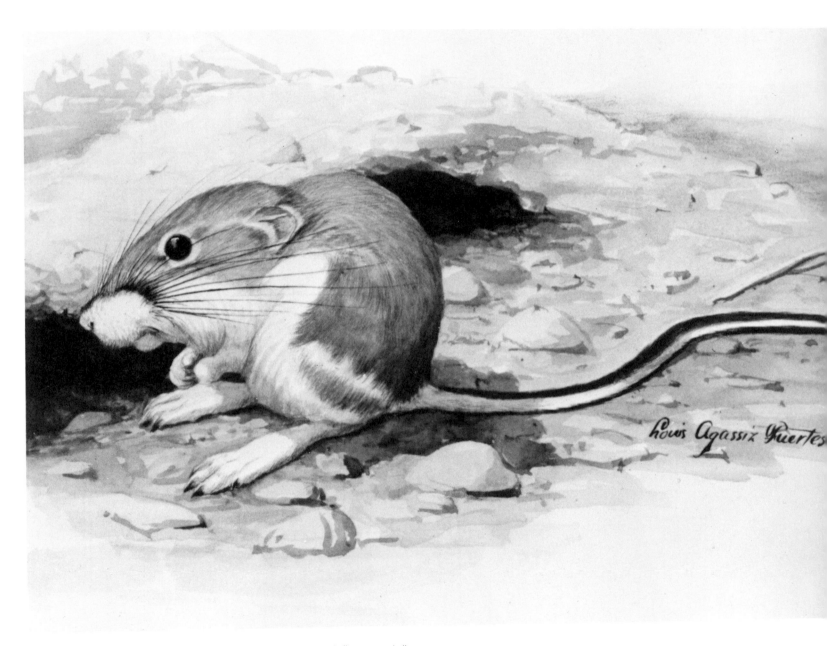

Kangaroo Rat. *Pub. 1922. Ink wash on paper, 6 1/8″ × 12 5/8″.*

Since much of his work was illustrations for bird guides or for handbooks, it was sometimes difficult for him to make the Thayers understand that he was a firm believer in the principles of concealing coloration. Fuertes felt it was best to first detach birds and animals from their backgrounds so the public would become familiar with their appearance, and then, after people had learned to look, educate them in the more complex aspects ff coloration theory.

Louis Fuertes virtually created the contemporary profession of artist-naturalist. By succeeding superbly as both a field naturalist and as an artist-illustrator, Fuertes provided the example many would follow. He passed on to numerous young people both his enthusiasm for his work and his affection for the birds and animals he painted. Louis Fuertes was not the last of America's wildlife artists; he was the first of many modern professional field artists continuing to record the rich variety of American wildlife.

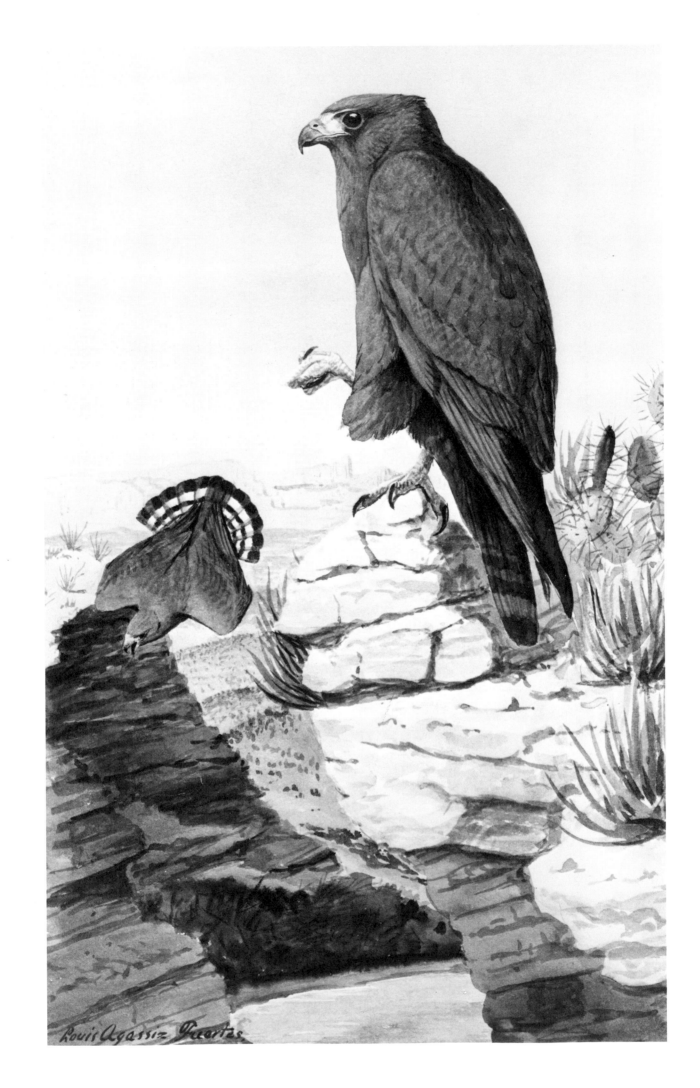

Louis Agassiz Fuertes

Zone-tailed Hawk. *1901.*
Ink wash on paper, 10″ × 6 1/8″.

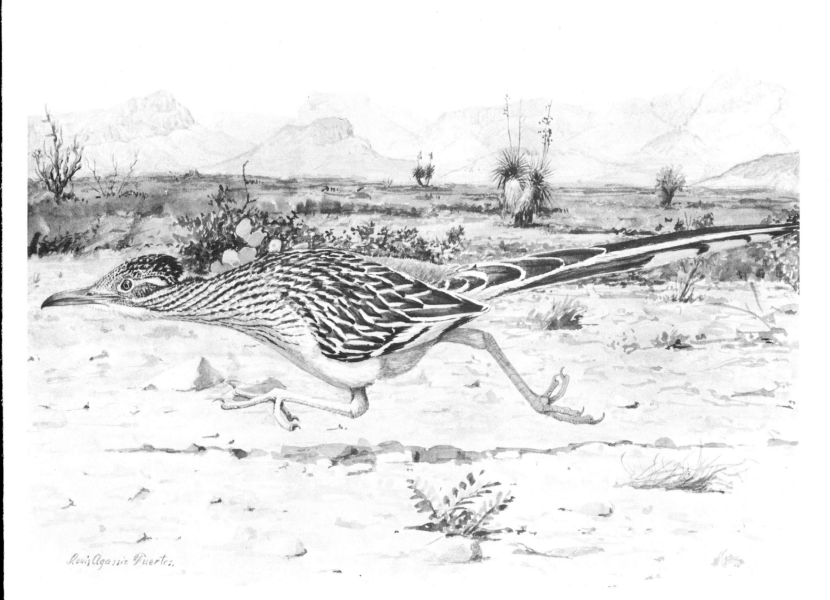

Adult Texas Roadrunner. *Ca. 1901. Ink wash on paper, 8 5/8″ × 11 7/8″.*

House Sparrow. *N.D. Ink wash on paper, 9 11/16″ × 11″.*

Brewer's Blackbird. *Pub. 1910. Watercolor on paperboard, 10 15/16" × 14 7/8".*

Duck Hawk. *Ca. 1910.*
Watercolor and pencil
on paperboard, 13 3/4" × 10 3/4".

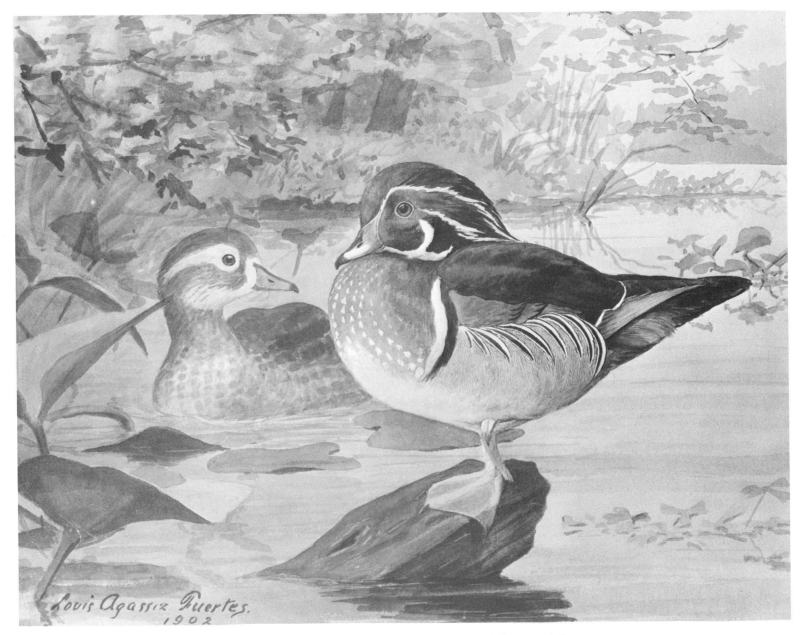

Wood Duck. *Pub. 1911. Ink wash and pencil heightened with white on paper, 8 1/8" × 10 3/4".*

Louis Agassiz Fuertes.

Pied-billed Grebe. *Pub. 1924. Ink on paperboard, 7 3/16" × 9 15/16".*

Skunk. *N.D. Ink heightened with white on paperboard, 10 3/4" × 11 1/2".*

Greater Flamingo. *1927.*
Pencil and watercolor on paper
mounted on tempera on paperboard,
16 3/4" × 10 1/8".

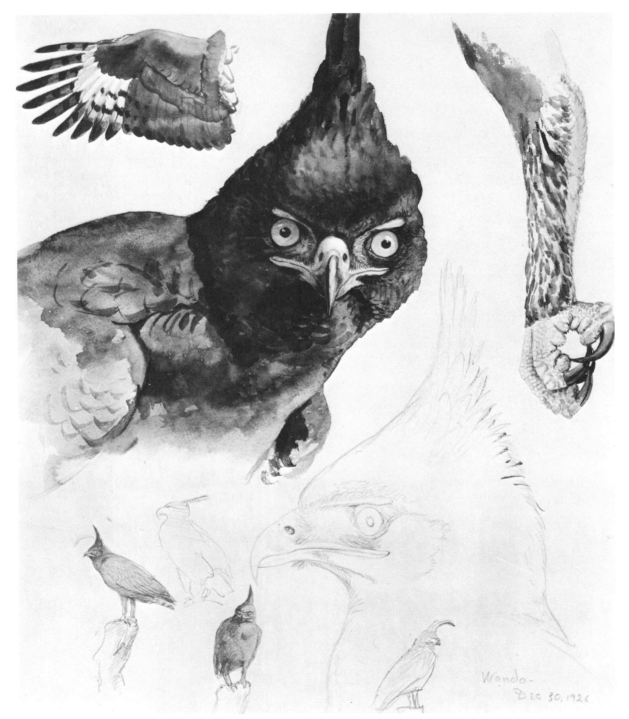

Long-Crested Hawk-Eagle. *1926. Pencil and watercolor on paper, 12 7/8" × 10 7/8".*

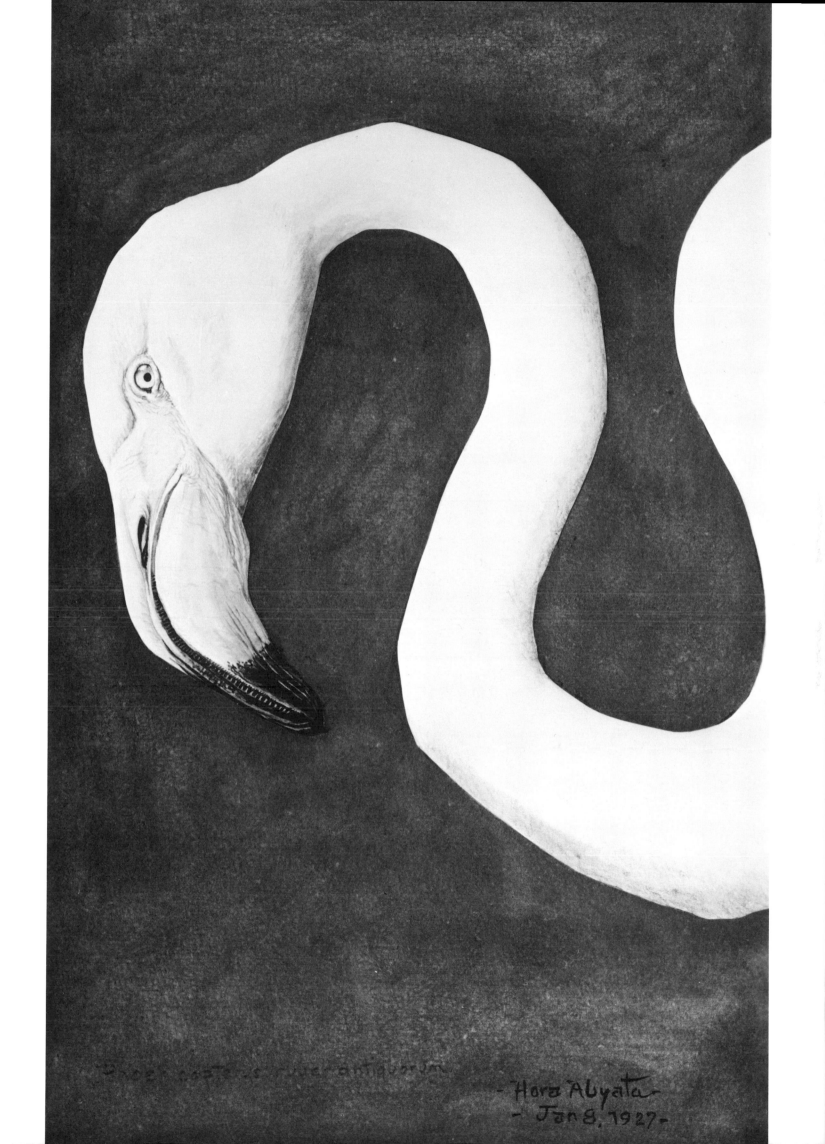

Phoenicopterus roseus antiquorum

- Hora Abyata -
- Jan 8, 1927 -

Selected Bibliography

Academy of Natural Sciences of Philadelphia. Manuscript Collections 15, 39, 47, 52, 71, 79, 173, 364, 420, 427, 450, and 498.

————. *John J. Audubon*. Exhibition Catalog, 1938.

Allen, Elsa Guerdrum. "The History of American Ornithology Before Audubon." *Transactions of the American Philosophical Society* 41 (1951): 386–591.

————. "Jaques Le Moyne, First Zoological Artist in America." *The Auk* 55 (1938): 106–111.

Allen, Francis H. "Remarks on the Case of Roosevelt Vs. Thayer, With a Few Independent Suggestions on the Concealing Coloration Question." *The Auk* 29 (1912): 489–507.

American Correspondent. "A Review of Bird Prints With Particular Reference to Catesby and Audubon." *The Connoisseur*, March 1948, pp. 47–52.

American Heritage. *The Original Water-Color Paintings by John James Audubon for The Birds of America*. 2 vols. New York: American Heritage Publishing Co., Inc., 1966.

American Ornithologists' Union. *Fifty Years' Progress of American Ornithology 1883–1933*. Rev. ed. Lancaster, Pennsylvania: American Ornithologists' Union, 1933.

Audubon, John James. *The Birds of America*. 4 vols. London: Published by the Author, 1827–1838.

————, and Bachman, John. *The Viviparous Quadrupeds of North America*. New York: Published by J. J. Audubon, 1845–1848.

Audubon, Maria R. *Audubon and His Journals*. 1897. Reprint. 2 vols. New York: Dover Publications, Inc., [1960].

Boynton, Mary Fuertes. "Abbott Thayer and Natural History." *Osiris* 10 (1952): 542–555.

————, ed. *Louis Agassiz Fuertes, His Life Briefly Told and His Correspondence*. New York: Oxford University Press, 1956.

Breckenridge, Robert P. *Modern Camouflage*. New York: Farrar & Rinehart, Inc., 1942.

Burns, Frank L. "Alexander Wilson. I. The Audubon Controversy." *The Wilson Bulletin* 20 (1908): 3–18.

————. "Alexander Wilson. II. The Mystery of the Small-Headed Flycatcher." *The Wilson Bulletin* 20 (1908): 63–79.

————. "Alexander Wilson. III. The Unsuccessful Lover." *The Wilson Bulletin* 20 (1908): 130–145.

————. "The Mechanical Execution of Wilson's American Ornithology." *The Wilson Bulletin* 41 (1929): 19–23.

————. "Miss Lawson's Recollections of Ornithologists." *The Auk* 34 (1917): 275–282.

Cantwell, Robert. *Alexander Wilson: Naturalist and Pioneer*. Philadelphia: J. B. Lippincott Company, [1961].

Catesby, Mark. *The Natural History of Carolina, Florida and the Bahama Islands: Containing the Figures of Birds, Beasts, Fishes, Serpents, Insects, and Plants: Particularly, the Forest-Trees, Shrubs, and other Plants, not hitherto described, or very incorrectly figured by Authors. Together with their Descriptions in English and French. To which, are added Observations on the Air, Soil, and Waters: With Remarks upon Agriculture, Grain, Pulse, Roots, Etc. To the whole, Is Perfixed a new and correct map of the Countries Treated of*. 2 vols. London: Printed at the Expense of the Author, 1731–1743.

————. *The Natural History of Carolina, Florida and the Bahama Islands*. Introduction by George Frick. Notes by Joseph Ewan. Savannah, Georgia: The Beehive Press, [1974].

Chapman, Frank M. *Autobiography of a Bird-Lover*. New York: D. Appleton-Century Company Incorporated, 1933.

————. "Fuertes and Audubon—A Comparison of the Work and Personalities of Two of the World's Greatest Bird Artists." *Natural History* 39 (1937): 204–213.

————. "In Memoriam: Louis Agassiz Fuertes 1874–1927." *The Auk* 45 (1928): 1–26.

————. "Louis Agassiz Fuertes 1874–1927." *Bird-Lore* 29 (1927): 358–368.

————. "Louis Agassiz Fuertes—Painter of Bird Portraits." *Bird-Lore* 17 (1915): 277–284.

————. "Memories of Louis Fuertes." *Bird-Lore* 41 (1939): 2–10.

Christy, Bayard H. "Alexander Lawson's Bird Engravings." *The Auk* 43 (1926): 47–61.

————. "Wilson's Ohio River Journey." *The Cardinal*, July 1925, pp. 6–12.

Corcoran Gallery of Art, Washington, D.C. *Pictures Illustrating Protective Coloration in Nature and Concerned with the Origination of Camouflage in War*. Exhibition Catalog, 1918.

Cumming, William Patterson, Skelton, R. A., and Quinn, David Beers. *The Discovery of North America*. New York: American Heritage Press, [1972].

Detroit Institute of Arts. *Exhibition of American Birds and Their Painters and Sculptors*. Text by E. P. Richardson. Exhibition Catalog, 1945.

Eckelberry, Don Richard. "Birds In Art and Illustration." *The Living Bird*. Second Annual of the Cornell Laboratory of Ornithology, 1963.

Faxon, Walter. "John Abbot's Drawings of the Birds of Georgia." *The Auk* 13 (1896): 204–215.

Ford, Alice. *Audubon's Butterflies, Moths and Other Studies*. New York: The Studio Publications, Inc., [1952].

————. *John James Audubon*. Norman: University of Oklahoma Press, [1964].

————, ed. *Audubon, By Himself*. Garden City, New York: The Natural History Press, [1969].

————, ed. *Audubon's Animals: The Quadrupeds of North America*. New York: The Studio Publications, Inc., [1951].

————, ed. *The 1826 Journal of John James Audubon*. Norman: University of Oklahoma Press, [1967].

Frick, George Frederick, and Stearns, Raymond Phineas. *Mark Catesby, The Colonial Audubon*. Urbana: University of Illinois Press, 1961.

Friedmann, Herbert. *The Natural-History Background of Camouflage*. Smithsonian Institution War Background Studies Number Five. Washington, D.C.: Smithsonian Institution, 1942.

Fries, Waldemar H. *The Double Elephant Folio: The Story of Audubon's "Birds of America."* Chicago: American Library Association, 1973.

Fuertes, Louis Agassiz. *Album of Abyssinian Birds and Mammals*. Chicago: Field Museum of Natural History, 1930.

————. "American Birds of Prey—A Review of Their Value." *The National Geographic Magazine* 38 (1920): 460–467.

————. "Falconry, The Sport of Kings." *The National Geographic Magazine* 38 (1920): 429–460.

————. "Impressions of the Voices of Tropical Birds." *Bird-Lore* 15 (1913): 341–344; 16 (1914): 1–4; 96–101; 161–169; and 342–349.

————. "Review of *Concealing-Coloration in the Animal Kingdom*," *Science* 32 (1910): 466–469.

————, and Osgood, Wilfred Hudson. *Artist and Naturalist in Ethiopia*. Garden City, New York: Doubleday, Doran & Company, Inc., 1936.

Gardner, Dorsey. "Wilson, the Ornithologist." *Scribner's Monthly* 11 (1876): 690–703.

Greenway, J., Jr. "A Jefferson Letter of Historical and Ornithological Interest." *The Auk* 48 (1931): 175–180.

Harriot, Thomas. *A Briefe and true report of the new found land of Virginia*. 1590. Reprint. New York: Dover Publications, Inc., [1972].

Heade, Martin Johnson [Didymus]. "Hummingbirds." *Forest and Stream* 39 (1892): 158.

————. "Taming Hummingbirds." *Forest and Stream* 38 (1892): 348.

Henshaw, Henry W. "Birds of Town and Country." *The National Geographic Magazine* 25 (1914): 494–531.

————. "Fifty Common Birds of Farm and Orchard." *The National Geographic Magazine* 24 (1913): 667–697.

Herrick, Francis Hobart. *Audubon the Naturalist: A History of His Life and Time*. 2 vols. 1938. Reprint. New York: Dover Publications, Inc., [1968].

Hulton, Paul, and Quinn, David Beers. *The American Drawings of John White 1577–1590*. 2 vols. London and Chapel Hill: The Trustees of The British Museum and The University of North Carolina Press, 1964.

Huth, Hans. *Nature and the American, Three Centuries of Changing Attitudes*. Berkeley and Los Angeles: University of California Press, 1957.

Jordan, David Starr, ed. *Leading American Men of Science*. New York: Henry Holt and Company, 1910.

Lorant, Stefan, ed. *The New World*. Rev. ed. New York: Duell, Sloan and Pearce, [1965].

McDermott, John Francis, ed. *Audubon in the West*. Norman: University of Oklahoma Press, [1965].

McIntyre, Robert G. *Martin Johnson Heade, 1819–1904*. New York: Pantheon Press, [1948].

Marcham, Frederick George. "Louis Fuertes Revisited." *The Living Bird*. Second Annual of the Cornell Laboratory of Ornithology, 1963.

————, ed. *Louis Agassiz Fuertes and the Singular Beauty of Birds*. New York: Harper & Row, [1971].

Matthiessen, Peter. *Wildlife In America*. New York: The Viking Press, 1959.

Munson-Williams-Proctor Institute, Utica, New York; and The Pierpont Morgan Library, New York, New York. *Audubon Watercolors and Drawings*. Text by Edward H. Dwight. Exhibition Catalog, 1965.

Museum of Comparative Zoology, Harvard University, Cambridge, Massachusetts. Manuscript Collection 869.

National Collection of Fine Arts, Smithsonian Institution, Washington, D.C. *Artist-Naturalists: Observations in the Americas*. Text by Martina R. Norelli. Exhibition Catalog, 1972.

Nelson, Edward W. "The Larger North American Mammals." *The National Geographic Magazine* 30 (1916): 384–472.

———. "Smaller Mammals of North America," *The National Geographic Magazine* 33 (1918): 371–493.

Osgood, Wilfred H. "Louis Agassiz Fuertes." *Science* 66 (1927): 469–472.

Palmer, Theodore Sherman. "Abbott H. Thayer's Contribution to Bird Protection." *Bird-Lore* 23 (1921): 227–228.

Peattie, Donald Culross. *Green Laurels: The Lives and Achievements of the Great Naturalists*. New York: Garden City Publishing Co., Inc., 1938.

Peterson, Roger Tory. "Bird Painting In America." *Audubon Magazine* 44 (1942): 166–176.

Poulton, Edward Bagnall. "Art the Comrade of Science." *Nature* 84 (1910): 532–536.

Quinn, David Beers. *The New Found Land: The English Contribution to the Discovery of North America*. Providence, Rhode Island: The Associates of the John Carter Brown Library, 1965.

Roosevelt, Theodore. *African Game Trails*. New York: Charles Scribner's Sons, 1910.

———. "Revealing and Concealing Coloration in Birds and Mammals." *Bulletin of the American Museum of Natural History* 30 (1911): 119–231.

Smallwood, William Martin, and Smallwood, Mabel Sarah Coon. *Natural History and the American Mind*. New York: Columbia University Press, 1941.

Stevens, O. A. "The First Descriptions of North American Birds." *The Wilson Bulletin* 48 (1936): 203–215.

Stone, Witmer. "A Bibliography and Nomenclator [sic] of the Ornithological Works of John James Audubon." *The Auk* 23 (1906): 298–312.

———. "Mark Catesby and the Nomenclature of North American Birds." *The Auk* 46 (1929): 447–454.

———. "Some Early American Ornithologists: I. Mark Catesby." *Bird-Lore* 7 (1905): 126–129.

———. "Some Unpublished Letters of Alexander Wilson and John Abbot." *The Auk* 23 (1906): 361–368.

———. "Wilsoniana." *Cassinia* 17 (1913): 1–5.

Sutton, George Miksch. "Fuertes and the Young Bird Artist." *Audubon Magazine* 44 (1942): 82–85.

———. "Fuertes Remembered." *Audubon* 76 (1974): 58–67.

———. "Louis Fuertes at Work." *Audubon Magazine* 44 (1942): 37–40.

———. "Louis Fuertes, Teacher." *Audubon Magazine* 43 (1941): 521–524.

Thayer, Abbott Handerson. "Camouflage." *Scientific Monthly* 7 (1918): 481–494.

———. "Concealing-Coloration: A Demand for Investigation of my Tests of the Effacive Power of Patterns." *The Auk* 28 (1911): 460–464.

———. "Concealing Coloration, An Answer to Theodore Roosevelt." *Bulletin of the American Museum of Natural History* 31 (1912): 313–321.

———. "Further Remarks on the Law Which Underlies Protective Coloration." *The Auk* 13 (1896): 318–320.

———. "The Law Which Underlies Protective Coloration." *The Auk* 13 (1896): 124–129.

———. "Letter to the Editor of *The Auk*." *The Auk* 30 (1913): 471.

———. "Letter to the Editors of *The Auk*." *The Auk* 28 (1911): 146–148.

Thayer, Gerald Handerson. *Concealing-Coloration in the Animal Kingdom: An Exposition of the Laws of Disguise Through Color and Pattern: Being a Summary of Abbott H. Thayer's Discoveries*. New York: The Macmillan Co., 1909.

University of Maryland. *Martin Johnson Heade*. Text by Theodore E. Stebbins, Jr. Exhibition Catalog, 1969.

Washington County Museum of Fine Arts, Hagerstown, Maryland. *Mark Catesby: Naturalist-Artist*. Text by Mrs. George B. Green. Exhibition Catalog, 1967.

Welker, Robert Henry. *Birds and Men: American Birds in Science, Art, Literature, and Conservation, 1800–1900*. Cambridge, Massachusetts: The Belknap Press of Harvard University Press, 1955.

White, Nelson C. *Abbott H. Thayer: Painter and Naturalist*. Peterborough, New Hampshire: Noone House, William L. Bauhan, [1951].

Williams, George Alfred. "Robert Havell, Junior, Engraver of Audubon's *The Birds of America*." *The Print-Collector's Quarterly* 6 (1916): 226–257.

Wilson, Alexander. *American Ornithology: Or the Natural History of the Birds of the United States*. 9 vols. Philadelphia: Bradford and Inskeep, 1808–1814.

Wilson, James Southall. *Alexander Wilson, Poet-Naturalist*. New York: The Neale Publishing Company, 1906.

Wood, Charles B., III. "Prints and Scientific Illustration in America." In *Prints in and of America to 1850*, edited by John D. Morse, pp. 161–192. Charlottesville: The University Press of Virginia, [1970].

Credits

The following organizations and individuals gave permission to reproduce the plates in this book and supplied the photographs and color slides. Their cooperation is gratefully acknowledged:

Page

Academy of Natural Sciences of Philadelphia Lawson Manuscript Collection	24, 25, 26, 28, 36, 84, 86, 87, 89, 90, 91, 92, 99, 101, 103, 104, 105
The American Museum of Natural History	107
The Charleston Museum	12, 19, 20, 21, 34, 35, 55, 59, 62, 63, 67, 69, 70, 71, 72, 76, 77, 78, 79
Colonial Williamsburg Foundation	18, 27, 57, 58, 60, 65, 66, 74
The Detroit Institute of Arts	143 (Gift of Dexter M. Ferry, Jr.)
Field Museum of Natural History	199, 200, 216, 217
Houghton Library, Harvard University	94, 95, 96, 102, 113, 135
Library of Congress	125, 126, 127 (John T. Bowen, engraver) 83, 100 (John G. Warnicke, engraver)
The Metropolitan Museum of Art	43 (Gift of Albert Weatherby, 1946) 175 (Rogers Fund, 1916)
Museum of Comparative Zoology Harvard University	99
Museum of Fine Arts	146, 147, 155, 156, 158, 159, 160 162, 163 (M. and M. Karolik Collection) 153 (Bequest of Maxim Karolik)
National Collection of Fine Arts Smithsonian Institution	93 (Alexander Lawson, engraver) 40, 44, 45, 46, 165, 167, 169, 170, 172, 173, 174, 176, 180, 182, 183
National Gallery of Art	31, 138, 140 (Robert Havell, engraver; gift of Mrs. Walter B. James)
The Newark Museum	163
The New-York Historical Society	39 (Robert L. Stuart Collection) 29, 32, 38, 42, 111, 114, 115, 116, 117, 118, 119, 120, 121, 122, 123, 128, 130, 133, 136, 139, 141
North Carolina Collection	11, 13, 14, 17 (Reproduced from the Page-Holgate facsimilies of the original John White paintings in the North Carolina Collection of the L. R. Wilson Memorial Library of the University of North Carolina, by permission of the University of North Carolina Press)
The Pierpont Morgan Library	41, 124
Shelburne Museum, Inc.	157
Victor D. Spark	145
U.S. Fish and Wildlife Service	33, 37, 47, 48, 49, 51, 53, 187, 189, 190, 191 193, 194, 195, 196, 197, 198, 202, 204, 205 207, 208, 209, 210, 211, 212, 213, 214, 216
Whitney Museum of American Art	154 (Gift of Mr. and Mrs. Robert C. Graham, in honor of John I. H. Baur) 161 (Gift of Henry Schnakenberg, in memory of Juliana Force) 171, 178, 179 (Gift of Mr. and Mrs. G. Macculloch Miller)
Yale University Art Gallery	148

Index

Note: *Page numbers that appear in italic refer to illustrations.*

Abbot, John, 97
A-Birding on a Bronco (Merriam), 188
Abyssinian Tawny Eagle, 199, 203
The Academy of Natural Sciences (Philadelphia), 132
Adult Texas Roadrunner, 209
African Game Trails (Roosevelt), 181
Aitkin, John, 82
America (De Bry), 12
American Bison, 19, 73
American Egret, 128
American Flamingo, 123, 132
"American Game Birds " (Henshaw), 201
The American Museum of Natural History (New York), 179, 201
American Ornithologists' Union, 30, 179, 188, 192, 201
American Ornithologists' Union Committee on Bird Protection, 185
American Ornithology: Or the Natural History of the Birds of America, 22, 85, 88, 97, 129
American Philosophical Society, 132
American Sparrow Hawk, 23
The American Swallow, 21, 75
Arctic Tern, 189, 192
Arkansas flycatcher, 120, 132
Artist and Naturalist in Ethiopia (Osgood), 203
Ash-Colored Hawk, 88, *98*
Audubon, Jean, 108
Audubon, John James, 107–141
Audubon, John Woodhouse, 112, 132, 137
Audubon, Lucy, 112, 113, 132
Audubon, Rose, 112
Audubon, Victor Gifford, 108, 132, 137
The Auk, 30, 177, 179, 181, 192

Bachman, John, 132, 137
Bachman, Maria, 132
Bailey, Vernon, 192
Bakewell, Thomas, 112
Bakewell, William, 108
Barn Owl (detail), *81*
Bartram, John, 17, 64, 85
Bartram, William, 17, 85
Baum, James, 203
Bean, Judge Roy, 201
Belted Kingfisher, 108, 135
Bewick, Thomas, 129
Bierstadt, Albert, 144

Bird-Lore magazine, 30
"Birds in Miniature" (Audubon), 137
The Birds of America (Audubon) 22, 129, 131, 132, 137, 188
"Birds of Town and Country " (Henshaw) 201
Black-bellied Darter, **112, 138**
Blackfoot Indians, 137
Black Hawk, 88, 95
Black or surf Duck; Buffel-headed duck; Canada Goose; Tufted duck; Golden eye; Shoveller, 88, 96
Black Phoebe, 49, 192
Black-throated Sparrow, 47
Bloede, Kate, 168
Blue Jay, 177, 178
Blue Jays in Winter, 169, 181
Blue Jay; Yellow-Bird Or Goldfinch; Baltimore Bird, 89
Bowen, John T., 137
Bradford, Samuel, 85, 88
Brazilian Hummingbirds, 149, 157
Brazilian Hummingbirds I, 149, 158
Brazilian Hummingbirds II, 146, 149
Brazilian Hummingbirds III, 149, 159
Brazilian Hummingbirds IV, 147, 149
Breckenridge, Major Robert P., 181
Brewer's Blackbird, 210
A Briefe and true report on the new found land of Virginia, 15
British War Office, 181
Brooklyn Art School, 166
Brown, Joseph, 88
Brown Booby, 14
Brown, or Norway Rat, 126, 137
Brown Pelican, 140
Brush, George de Forest, 168
Bryant, William Cullen, 22
The Bulletin of the American Museum of Natural History, 181
Burns, Robert, 82
Burrowing Owl, 196, 203
Byrd, William, 56

Camouflage In Nature and In War (Thayer), 185
Canada Goose, 136
Cardinal Grosbeak; Female and Egg; Red Tanager; Female and Egg, 90
Carolina Cuckoo; Black-billed Cuckoo; Blue Yellow-backed Warbler; Yellow Red-poll Warbler, 87
Carolina Parrot, 108, *109*

Carolina Parrot; Canada Flycatcher; Hooded Flycatcher; Green, black capt Flycatcher, 92
Catesby, John, 56
Catesby, Mark, 55–79
Chapman, Frank M., 179, 201, 203
The Chatterer, 34
Chuck-will's-widow, 112, 114
Church, Frederic, 22, 144
Citizen Bird (Coues), 188
Clark's Crow, 50
The Coach Whip Snake, 75, 78
Cocke, William, 56
Collinson, Peter, 64
Common Goldeneye, 110
Common Mouse, 127
Common Raven, 131, 141
Concealing-Coloration in the Animal Kingdom (Thayer), 30, 179
Copperhead Snake on Dead Leaves, 174, 177
Cornell University, 188, 192, 203
Coues, Elliott, 188, 192
The Crested Jay, 65, 75
Crumpled-Leaf Caterpillar in Position, Back View and Side View; Crumpled-Leaf Caterpillar Detached, 184
Curled-Dead-Leaf-Mimicking Sphinx Caterpillar in Position, 167
The Cushew Tree, 72

Dare, Virginia, 15
De Bry, Theodor, 12, 15
Dewing, Thomas, 168
Didymus. *See* Heade, Martin Johnson
Double-crested Cormorant, 132, 139
Duck Hawk, 203, 213
Duncan, William, 82
Dutcher, William, 185

Ecole des Beaux-Arts, 168
Edwards, George, 17, 85, 88
Embargo Act of 1897, 108
Emerson, Ralph Waldo, 23, 166
European Flamingo's Head, 171, 177
European Great Snipe, 177, 179

Fairman, Gideon, 129
"Falconry, the Sport of Kings, (Fuertes), 201
Field Museum of Natural History, (Chicago), 203
The Field Museum of Natural His-

tory-*Chicago Daily News* Abyssinian Expedition, 203

"Fifty Common Birds of Farm and Orchard," (article in a 1913 U.S.D.A. Farmers Bulletin), 201

Flamingo (Catesby), *74*

Flamingo (White), *13*, 15

Fletcher, Reverend James C., 144

The Flying Squirrel, 75, *20*

Forest and Stream (magazine), 31, 152

Fort Caroline, 12

Fort Union, 137

French, Daniel Chester, 168

Friedman, Herbert, 181

Fuertes, Estevan Antonio, 188

Fuertes, Louis Agassiz, 187–217

Fuertes, Mary, 201

Fuertes, Sumner, 201

Gambel's Quail, 190

A General Synopsis of Birds (Latham), 88

George IV, King of England, 131

George II, King of England, 56

Gérôme, Jean Léon, 168

Goldfinch; Blue Jay; Hanging Bird, 84, 88

Gould, John, 149

Goupy, Joseph, 61

The Great Booby, 55, *75*

Greater Flamingo, 217

Greater Prairie Chicken, 198

Great Gray Owl, 119

Great Horned Owl; Barn Owl; Meadow Mouse; Red Bat; Small-headed Flycatcher; Hawk Owl, 101

Handerson, Henry, 166

Hariot, Thomas, 15

Harriman, Edward, 192

Harris, Edward, 129, 137

Havell, Robert, Jr., 131

Havell, Robert, Sr., 129, 131

Heade, Martin Johnson, 143–163

Henrotin, Charles, 188

Henshaw, Henry, 201

Holmes, Oliver Wendell, 166

Hooded Warbler and Sunlit Foliage, *176*, 177

Hortus, Britanno-Americanus (Catesby), 73

House Sparrow, 201

House Wren, 42

Hummingbird and Passion Flowers, *43*, 152

Hummingbirds and Orchids, 143

Hummingbirds with a Nest, 144

"Impressions of the Voices of Tropical Birds " (Fuertes), 203

Jackrabbit, 191, 192

Jagged-Leaf-Edge Caterpillar in Position, 45

Jefferson, Thomas, 17, 82, 85

Jekyll, Elizabeth, 56

Jekyll, Nicholas, 56

Jungle Orchids and Hummingbirds, 148

Kalm, Peter, 73

Kangaroo Rat, 206

Key to North American Birds (Coues), 192

Knight, Charles R., 192

The Land Frog, 79

The largest crested heron; The Spotted Eft; The Chego; Scarabaeus capricornus minumus cutem penetrans; The Cockroach; Blatta maxima fusca pettata; Scarabaeus Pettatus, 61, 76

Largest White Bill'd Woodpecker, *66*, 73

Latham, John, 88

Lawson, Alexander, 88, 98, 129

"The Law Which Underlies Protective Coloration " (Thayer), 177

Lehman, George, 131, 132

Le Moyne, Jacques, 12

Lesser Yellowlegs (Audubon), *118*, 132

Lesser Yellowlegs (Fuertes), *205*

Lewis and Clark Expedition, 98

Lewis, Meriwether, 98

Lewis' Woodpecker and Clarks Crow (Wilson), *24*, 88

Lewis' Woodpecker (Fuertes), *194*

Little Blue Heron, 38

Little or Saw-whet Owl, 88, *94*

Lizars, William Home, 129

Loggerhead Turtle, 15, 16

Long-Crested Hawk-Eagle, 203, *216*

Louisiana Heron; Pied Oyster-Catcher; Hooping Crane; Long billed Curlew, 26

Louisiana Tanager; Clarks Crow; Lewis's Woodpecker, 36

Luna Caterpillar in Position, 172

Lyceum of Natural History (New York), 129

Macgillivray, William, 131, 132

McNab, Mary, 82

Magnificent Frigatebird, 117, 132

The Maho-Tree, Phalaena Fusca, 69

Male Ruffed Grouse in Forest, *175*, 177, 185

Male Wood Duck in a Forest Pool, *46*, 177

Mallard and Black Duck, 187

Mangrove Cuckoo, 116, 132

Martin, Maria, 132

Mason, Joseph, 112

Merriam, C. Hart, 192

Merriam, Florence, 188

The Metropolitan Museum of Art (New York), 185

Mice, 204

Minnie's Land (Audubon estate), 137

Mirror-Back Caterpillar Reflecting Sky-light, Leaf-green, and a Red Leaf, 173

Mississippi Kite; Tennessee Warbler; Kentucky Warbler; Prairie Warbler, 104

Mocking Bird; Egg; Male and Female Hummingbird, nest and eggs; Towhe' Bunting; Egg, 86

Moore, Dr. Henry D., 166

Moynet, Anne, 108

Murray, George, 88

National Academy of Design (New York), 144, 168

National Association of Audubon Societies, 185

National Geographic Magazine, 30, 201, 203

The Natural-History Background of Camouflage (Friedman), 181

Natural History of Carolina, Florida and the Bahama Islands (Catesby), 17, 56, 61, 73, 85

Nelson, Edward, 201

Nicholson, Colonel Francis, 56

Norway, Brown, or Common House Rat, 124

Notes on the State of Virginia, (Jefferson), 17

Nuttall, Thomas, 132

Oak-Leaf-Edge Caterpillar in Position, 180

Oberholser, H. C., 192

"Of Birds of Passage " (Catesby), 64
"Oration on Liberty " (Jefferson), 82
Orchids and Hummingbird, 151
Orchids and Hummingbirds, 163
Orchids and Spray Orchids with Hummingbirds, 152, *155*
Orchids, Passion Flowers, and Hummingbirds, 152, *154*
Ord, George, 22, 98, 112, 129, 131
Ornithological Biography (Audubon), 132, 137
The Ornithologist, 197
Orr, Charles, 85
Osgood, Wilfred, 203
The Osprey (periodical), 188
"Our Common Dogs " (article in *National Geographic Magazine*), 201
Oxford University, 179

Passion Flowers and Hummingbirds, 156
Peacock in the Woods, 40, 177
Peale, Rembrandt, 112
Perry, Mary Stone, 188
Peto, Sir Morton, 149
Philadelphia Academy of Fine Arts, 144
Phinney, Charles, 61
The Pied-Bill Dopchick, 62, 75
Pied-billed Grebe, 214
The Pigeon of Passage, 58, 73
Pike Expedition, 85
The Pilgrims (Wilson), 97
Pine-Tuft Caterpillar, Back-View and Side-View, 165
Pinnated Grous; Blue-green Warbler; Nashville Warbler, 93
Pirrie, Eliza, 112
"The Place of Mimicry in a Scheme of Defensive Coloration " (Poulton), 179
Porcelain-White Spider Suffused with Green Light Amid Foliage, 44
Poulton, Edward B., 179
Pumpelly, Elise, 168
Purple Gallinule, 112, *113*
Pygmy Kingfisher, 200, 203

Rabine, Jeanne, 108
Raleigh, Sir Walter, 12–15
Rankin, Dr. Adam, 108
Ray, John, 56
Red mottled Rock crab, Rough-Shelled Crab, 77
Red River Survey Expedition, 112
Red-winged Blackbird, 29, 112
The Red-Wing'd Starling, 27
Red-winged Starling; Female; Black-poll warbler; Lesser Red-poll, 28
Rees' New Encyclopaedia, 85, 88
Roadrunner, 192, *209*
Roosevelt, Theodore, 181

Roseate Spoonbills (in Morning or Evening Sunlight), 170, 181
Rosier, Ferdinand, 97, 108
Rosy Finch, 48, 192
Round-crested Duck, 18
Rowland, Elizabeth, 73
Royal Institution of Liverpool, 129
The Royal Society of London, 17, 64, 131
Rufous Hummingbird, 122, 132

The Sand Crab, 35
Sargent, John Singer, 181
Scissor-tailed Flycatcher and Painted Bunting, 33
Shark, or Land Mills Detected, 82
Sharp-shinn'd Hawk; Redstart; Yellow-rump, 105
Sherard, William, 56
Short-eared Owl, 197, 203
Sierra Grouse, 202
Skunk, 215
Sloane, Sir Hans, 15, 17, 56, 64
The Small Bittern, 57
Smith, Captain John, 15
Smith, Elizabeth, 152
Snow Owl; Male Sparrow Hawk, 101
Society for the Protection of New Hampshire Forests, 185
Society of American Artists, 30
The Sole, 67
South American River, 144, *162*
Sphinx Caterpillar in Position, 182
Sphinx Caterpillar Inverted, 182
Spotswood, Governor Alexander, 56
Stevenson, Robert Louis, 192
Study of an Orchid, 39
Sullivan, Joshua, 82
Sumner, Margaret, 201
Swainson, William, 131
Swainson's Hawk, 121, 132
Swallow-tail Butterfly, 11, 15
Swift Fox, 125

Tanner, Benjamin, 88
Thayer, Abbott Handerson, 165–185
Thayer, Ellen, 166
Thayer, Gerald, 166, 168, 177, 179, 185
Thayer, Gladys, 168
Thayer, Mary, 168
Thayer, William Henry, 166
Thoreau, Henry David, 22
Titanic, S.S., 81
Titmouse, 51
Townsend, John, 132
Traill, Dr. Thomas, 129
Traill's Flycatcher, 112, *130*
Travels Through North and South Carolina (Bartram), 17
The Tree Society, 166
Trumpeter Swan, 31
Tufted Puffin, 32

Two Fighting Hummingbirds with Two Orchids, 152, *161*
Two Hummingbirds and Spray of Flowers, 160
Two Hummingbirds with a Nest and Fledglings, 145
Tyrant Flycatcher; Great crested Flycatcher; Small green crested Flycatcher; Pe-We Flycatcher; Wood Pe-We Flycatcher, 91

U.S. Biological Survey, 192
U.S. Department of Agriculture, 30, 201
Unspotted Beech-Leaf-Edge Caterpillar in Position and Detached, 183

Vallance, John, 88
Vermilion Flycatcher, male and female, 192, *193*
Vermont Medical College, 166
Vesper Sparrow, 115, 131
The Virgin Enthroned, 168
The Viviparous Quadrupeds of North America (Audubon), 137

"The Warblers of North America " (article in *National Geographic Magazine*), 201
The Water Frog, 68
Watty and Meg, or the Wife Reformed (Wilson), 82
Western Grebe, 53
Western Kingbird; Scissor-tailed Flycatcher: Say's Phoebe, 37, *120*
Western Museum of Cincinnati College, 112
Western Tanager, male and female, 195
Whip-poor-will, male, female, and young, 88, *102*
White, John, 15
The White Curlew, 66
White-headed Eagle, 103
White-winged Scoter, 52
Wild Turkey Cock, 129, *133*
Wilson, Alexander, 81–105
Wilson, Alexander (Sr.), 82
The Wilson Bulletin, 30
The Wood-Chuck, 41
The Woodcock of America, 70, 73
Wood Duck, 212
Wood Ibis; Scarlet Ibis; Flamingo; White Ibis, 83
The Wood Pelican, 63
Wright, Mabel Osgood

Yellow and Black Pye, 71
The Yellow-brested Chat, 59, 75
Yellow-throated Vireo, 111, 112
Young Raccoon of this Year, 107, 137

Zone-tailed Hawk, 201, *208*